LIVE SOULS

LIVE SOULS

Citizens and Volunteers of
Civil War Spain

SERGE ALTERNÊS
& ALEC WAINMAN

RONSDALE PRESS

LIVE SOULS: CITIZENS AND VOLUNTEERS OF CIVIL WAR SPAIN
Copyright © 2015 Serge Alternês & Alec Wainman

RONSDALE PRESS
3350 West 21st Avenue, Vancouver, B.C. Canada V6S 1G7
www.ronsdalepress.com

Typesetting: Julie Cochrane, in Granjon 11 pt on 15
Cover Design: Julie Cochrane
Cover Image: Alec Wainman, Republican militiamen (Sept. 1936)
Photo Captions: Serge Alternês
Paper: Ancient Forest Friendly 80 lb. Matte White, FSC Recycled, 100% post-consumer waste, totally chlorine-free and acid-free.

Ronsdale Press wishes to thank the following for their support of its publishing program: the Canada Council for the Arts, the Government of Canada through the Canada Book Fund, the British Columbia Arts Council, and the Province of British Columbia through the British Columbia Book Publishing Tax Credit program.

Library and Archives Canada Cataloguing in Publication

Wainman, Alec, 1913–1989, author, photographer
 Live souls: citizens and volunteers of civil war Spain / Serge Alternês & Alec Wainman.

Includes bibliographical references and index.
Issued in print and electronic formats.
ISBN 978-1-55380-437-6 (print)
ISBN 978-1-55380-438-3 (ebook) / ISBN 978-1-55380-439-0 (pdf)

 1. Wainman, Alec, 1913–1989. 2. Canadians — Spain — History — 20th century. 3. Volunteer workers in medical care — Canada — History — 20th century. 4. Volunteer workers in medical care — Spain — History — 20th century. 5. Spain — History — Civil War, 1936–1939 — Personal narratives, Canadian. 6. Spain — History — Civil War, 1936–1939 — Medical care. 7. Spain — History — Civil War, 1936–1939 — Pictorial works. 8. Spain. Ejército Popular de la República — History. I. Alternês, Serge, 1961–, writer of supplementary textual content II. Title.

DP269.47.C2W24 2015 946.081'7 C2015-902979-1 C2015-902980-5

At Ronsdale Press we are committed to protecting the environment. To this end we are working with Canopy and printers to phase out our use of paper produced from ancient forests. This book is one step towards that goal.

Printed in Canada by Friesens, Manitoba

to the memory of Alec
and his Spanish soul,
who made
Live Souls possible

There is no speech nor language,
where their voice is not heard.

— PSALM 19

Acknowledgements

• • •

I am grateful to Renée, my good friend and companion, for her ongoing support and encouragement throughout the writing and editorial process. She had the patience and keen insight to make many suggestions and helped keep me on track. I want to thank the Rondsale team — Ronald Hatch for his belief and guidance, and notable editorial prowess — Julie Cochrane for her artistic flair in the design of the book and presentation of the many photographs — Meagan Dyer for her commitment and administrative support — and Estefania Navarro Estévez for her help with translation. I wish to acknowledge Sarah Hillier for providing some family perspectives of her uncle Alec and the Spanish refugees whom she vividly remembers, Nick Arbuthnot for reading the manuscript and giving valuable feedback, Gerrit and Judy Buntrock for their excellent advice on preserving photographic wartime memory, and Sonia Elmlinger for her comments which gave me a truly Spanish and French perspective confirming my purpose with *Live Souls*. The guidance of Michael Petrou, Alan Twigg, and Margaret Reynolds has been helpful and is appreciated. Also, thanks to Jeanne Griffiths for preserving Alec Wainman's collection of Civil War Spain photographs. Lastly, I would like to thank my family and friends for sharing their varied viewpoints on the subject, which I value greatly.

Contents

• • •

Preface

. . .

"'Alejandro,' the people of the village of Valdeganga shouted as they rushed up to me. . . . When the car first drew up the children had run out of the houses to see who had arrived. It was like a scene from the Pied Piper. We were given milk to drink, and take-away presents included red peppers (you know how much I like them!), pears, quinces and a chicken. . . . I have just re-visited the hospital at Valdeganga. It is beautifully run. At present it has 70 convalescent patients. Many of the patients are learning to read and write for the first time. So are the girls who do the housework. Shortly, the hospital staff will open a school for the children living nearby. Otherwise they would have to walk several miles to the nearest village."

Alec Wainman wrote this description in a letter to his mother in England on September 20, 1937, while he was a volunteer ambulance driver, interpreter and medical administration officer with the British Medical Unit (BMU) in loyalist Republican Spain during the Civil War.

As a young man of twenty-three when he volunteered in August 1936 for the BMU, Alec was full of hope and ideals, like so many of the young men and women who chose to join the struggle for liberty in the Spanish Republic. Alec was also an amateur photographer and had a keen interest in the people caught up in the Spanish Civil War, whether they were the local citizens, the array of political groups, or the many volunteers from around the world. He captured the spirit of the people through the lens of his Leitz Leica camera. A linguist, fluent in many languages, Alec attained a special affinity with those he photographed by conversing with them in their own language. His choice of photographic material was not the sensational pictures that grab headline attention or depict the atrocities of war; he wanted his photos to evoke respect and contemplation in the viewers and to allow them to reflect on the humanity of those he portrayed.

Alec described himself in Spain as an apolitical

"Quaker." His pacifism and respect for others came from his Quaker ideals and Anglican upbringing. In defending the liberty of the Spanish Republic he followed in the footsteps of his Pennsylvanian kinsman who had defended liberty in the American Revolution. Samuel Wheeler, his great grandfather, was an ironmaster and inventor who was requisitioned by George Washington to build a chain to stop the British navy sailing up the Hudson River.

After losing his father in the First World War, Alec spent some of his formative years in Canada on a ranch in Vernon, British Columbia, with his mother and three brothers. The family returned to England in 1929 where he completed his education at Oxford University. After his Spanish Civil War experience, he served as an intelligence officer in the British Army during World War Two. In 1947, Alec returned to Canada to take up a professorship at the University of British Columbia (UBC) in Vancouver. British Columbia became his haven, reminding him of his youth before the suffering of the Spanish Civil War and a decade of war-torn Europe.

Alec was discreet about his time as a humanitarian volunteer, interpreter, and press officer in Republican Spain, the result of the personal dangers during the conflict and the professional stigmatization thereafter. He shared the trauma of the Spanish Civil War with very few. For many the taboo was too great. He would, however, have avid discussions with a few close friends and a fellow UBC professor, George Woodcock, with whom Alec collaborated on a CBC documentary, and of

course when he was meeting with Spanish refugees.

Alec was a friend to many people and spent much of his life helping refugees who were the victims of dictatorships (whether fascist or communist). In 1939, following his two-year period in Republican Spain, he facilitated the safe passage of refugees from the dangerously unsanitary improvised camps on the beaches of France to the United Kingdom. Hundreds of thousands of Spanish Republican refugees had crossed from Spain to France during the *Retirada* (or "retreat" subsequent to the capitulation of the Spanish Republic). These included theatre director José (Pepe) Estruch in the Barcarès Camp, and numerous other Spanish notables. Testimonials have emerged of Alec's courage in helping these Spanish refugees. At this time, following the victory of Franco's Nationalist rebellion, Alec also returned to the Basque country in Spain to visit families of refugees whom he was helping in England.

After the death of Franco in 1975, Alec felt compelled to write his story of Civil War Spain. The plight of the citizens of the Spanish Republic and their struggle for liberty was etched in his mind. The collection of his photographs would bring him back to his time as a medical volunteer, his aeronautical interpreter role between Russian and American experts, and finally his post as press officer in the last government of the Republic. At that time, in 1937–38, the government of Prime Minister Juan Negrín was fighting for survival after a de facto arms embargo during the countdown to the Second World War. Alec's competen-

cies as a linguist were valued by his superiors in Spain, who believed that the Non-Intervention Agreement between Britain and France could be changed. Alec witnessed the progressive erosion of the Republic, the systematic nature of Nationalist violence that would continue well after the war, and the exodus of Spanish refugees. He felt compelled to help wherever he could. His captivating story and exceptional collection of photographs, along with his identity and security passes that document all his movements, animate a unique "behind-the-lines" perspective of memorable and evocative moments during the civil war in Spain.

Very little published material exists on Alec. Masha Williams, a fellow colleague and personal friend, who was an interpreter with the Allied Commission for Austria, devotes a chapter to him called "Trips with Alec" in her book *White among the Reds*. Her first chapter describes him in the following manner:

"He had a kind face, a gentle smile, and was most unmilitary-looking. . . . At heart he was a pacifist. . . . He had a cheerful grin on his face . . . was often funny and witty but equally contemplative and respectful. . . . He always empathized far too deeply with the pain of others. Fortunately, I knew he was also quick to share their joy."

In the spring of 1975 Alec was contacted to publish his Spanish Civil War collection of photographs. Unfortunately, publication never happened. A small selection of his photos made their way into print copies, and are exhibited by the Imperial War Museum in London. Some photos were also included in the 1983 Granada Television documentary. A few dozen of his photographs have been used, without credit, in numerous books, especially those featuring the British Battalion taking the train in Benicàssim, and those showing the Ebro Front hospital trains.

Alec battled with Alzheimer's illness from 1981 until his death in 1989, and he never saw his collection again. It was deemed lost. Almost 40 years later, by chance and sheer determination, I contacted Jeanne Griffiths who had corresponded with Alec concerning publication of his collection of photographs. Again, by chance, she had rescued Alec's photo collection from the home of a retired, and since deceased, Soho publisher, and had stored and preserved the collection in a suitcase. Remarkably, this was similar to what happened when over 4,500 photos by war correspondents Robert Capa (André Friedmann), Gerda Taro (Gerta Pohorylle), and Chim (David Seymour) were discovered, also in a suitcase, and published in the well-known volume, *The Mexican Suitcase*.

Dreaming of a free and democratic Spain four decades before its realization, Alec chose to defend liberty as a humanitarian volunteer. Finally, in 1982 he witnessed a liberated Spain after the Franco era, in the cultural and artistic experiments of La Movida Madrileña (characterized by the films of Pedro Almodóvar), with Spain's newly discovered freedoms and night-long crowds in the cities. He was deeply moved by his experience of the new Spanish post-Franco identity, and felt as though the ideals for which he had volunteered in the Spanish Civil War were finally being realized.

Historical Outline of the Spanish Civil War

• • •

1931 Following colonial and political defeats, the Spanish King Alfonso XIII leaves Spain, and the Second Spanish Republic is proclaimed. The documentary film *Mourir à Madrid* states: "At this time half of the Spanish population is illiterate, one third is in poverty, two million peasants own no land, and half the country is owned by 0.1% of the population. The new republic is a beacon of hope for the have-nots."

October 1934 The miners' revolt in the Asturias is violently suppressed by the government. General Francisco Franco, a young army officer of the repression, emerges as a leader.

Spring 1936 The Popular Front Coalition (republicans and socialists supported by other left forces) wins the Spanish general election. Social turbulence and some degree of political polarization follow.

July 1936 A Nationalist army rebellion, headed by General Mola and General Franco with the support of the political right against the Spanish Republic, leads to the Spanish Civil War. The Catholic Church hierarchy, except in the Basque country, supports the army rebellion. In the eyes of the conservative right, the Nationalist army rebellion is the "restoration of order by means of the sword and the cross" (Rossif & Chapsal).

The Moroccan Africa Corps of the Spanish Army, a well-trained fighting force, underpins the rebellion against an unarmed, untrained loyalist Republican militia of the Spanish Republic.

Nazi Germany and fascist Italy decisively support the Nationalist rebels militarily. They continue to do so throughout the conflict, preparing a staging ground for the Second World War. German transport airlift Franco's Army of Africa rebel troops from Morocco to Spain. The war in Spain is the inaugural *guerre totale*, a transition from trench warfare of the First World War to the "modern" warfare of the Second World War with carpet bombing and tanks.

August 1936 Hungarian and German photojournalist refugees Robert Capa and Gerda Taro leave Paris for Spain to support the anti-fascist cause of the Spanish Republic.

September 1936 The British Medical Unit (BMU) is among the first to be deployed, with four to five thousand international humanitarian volunteers to follow. The volunteers come to support the healthcare administration of the Spanish Republic, which has very few trained nurses and which lost many of its doctors to the Nationalist side. These humanitarians are early role models for the Médecins sans frontières and Médecins du monde who intervened later in civil-war conflicts such as those in Nigeria, Vietnam, Congo and the former Yugoslavia.

The first international military volunteers arrive to defend the Spanish Republic with over forty thousand to follow from 50 countries.

The largest civilian (non-governmental) support comes from France, Germany, Italy, Yugoslavia, Britain, USA, Canada, Poland, Latin America and Bulgaria.

Initially, Republican Spain has the partial help of the Soviet Union that keeps it "afloat" (Graham). Mexico supports the Republic throughout the war, and accepts the majority of its refugees.

There are conflicts on the Aragon Front around Huesca and Grañén.

October 1936 Madrid is besieged and bombed by the Nationalists, with German Condor Legion pilots/bombers, galvanizing international public opinion in support of the Spanish Republic.

International Brigades start global recruitment and formation, mainly under the leadership of the Comintern (Communist International) to defend Republican Spain.

November 1936 Madrid is heroically defended by its inhabitants and the International Brigades. The slogan is *¡No pasarán!* ("they shall not pass").

Winter 1936 The American Abraham Lincoln Battalion of the International Brigades as well as Ernest Hemingway and Martha Gellhorn arrive in Spain in support of the Spanish Republic.

Spring 1937 Dr. Norman Bethune and his Canadian Blood Transfusion Unit and Dr. Reginald Saxton of the BMU collaborate on blood transfusions and refrigerated blood trucks, making medical history. The mobile transfusion units help the Spanish Republic support its 1,000-km front.

April 1937 Guernica, the historical village of the Basque people, is bombed by the German Condor Legion. Pablo Picasso depicts this in his famous painting, mobilizing international opinion against fascist aggression. After the bombing, around 4,000 children are brought from Spain to Britain on the *Habana* by Leah Manning, co-founder of the BMU. Approximately 400 stay in the UK after the Spanish Civil War.

May 1937 Armed conflict flares up between various factions of the Republican governmental Popular Front in Barcelona with the political cleansing and persecution of the anarchists and their revolution (with the assassinations of Andreu Nin, former secretary of Leon Trotsky, and Italian Camillo Berneri).

July–November 1938 The Battle of the Ebro is decisive in that this Nationalist victory cuts Republican Spain in two between Catalonia in the north and the area between Madrid and Valencia in the centre.

Fall 1938 The international volunteers are sent home. Many from countries such as Germany, Austria, Italy, Hungary and the Soviet Union end up in concentration camps.

February 1939 — The majority of the half a million exiles cross from Spain to France in the *Retirada* (retreat) during the defeat of the Spanish Republic and are often interned in improvised and unsanitary camps.

March 1939 — The Nationalists finally enter the capital, Madrid.

April 1939 — Absolute victory is declared by General Franco, who thereafter creates a one-party state with presidency for life and Roman Catholicism as the State religion.

At this time it is estimated that Spain has half a million destroyed homes. In three years there have been some one million violent deaths, half a million exiles (Rossif & Chapsal).

November 1975 — After more than 35 years in power, Franco dies, having ensured his succession with King Juan Carlos I.

July 1976 — Adolfo Suárez is chosen by King Juan Carlos I of Spain to ensure a transition to democracy.

December 1978 — A new democratic constitution is ratified.

February 1981 — An attempted Spanish military coup fails.

October 1982 — The Partido Socialista Obrero Español (PSOE), the social democratic party, wins the election under Felipe González, completing a full restoration of democracy.

ALEC'S
STORY

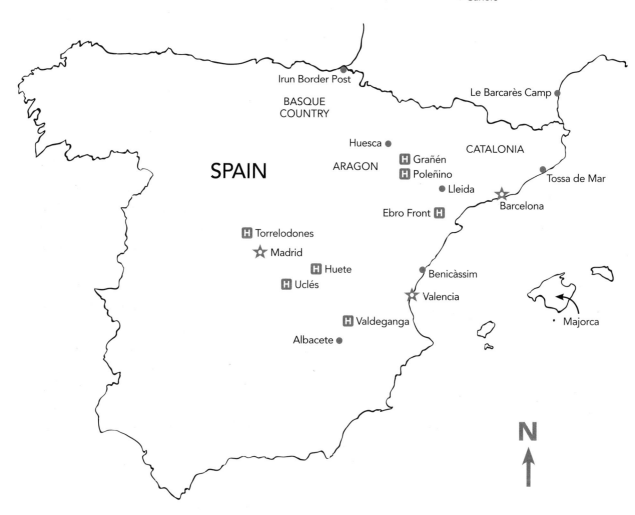

Map of Civil War Spain

FRANCE

- Brive-la-Gaillarde
- Cahors

SPAIN

BASQUE COUNTRY

Irun Border Post

Le Barcarès Camp

CATALONIA

Huesca

ARAGON

H Grañén
H Poleñino

Lleida

Tossa de Mar

Ebro Front H

Barcelona

H Torrelodones

☆ Madrid

H Huete

H Uclés

Benicàssim

☆ Valencia

Majorca

H Valdeganga

Albacete

N

H Hospitals supported by the British Medical Unit (BMU) 1936–1938

CHAPTER 1
Why Defend Liberty?

• • • (JULY 1936 TO JANUARY 1937)

"Who the devil handed me this can of water in-stead of gas?" the driver shouted out in disgust. An awful thought came over me as I watched the last few drops of precious drinking water disap-pearing into the neck of the gas tank and realized that I was the culprit.

Here we were with our convoy of ambulances and supply vehicles stranded in the midday sun of late summer 1936 amid the arid wastes of inland Catalonia, and all because I had tried to be over-helpful and save a few precious minutes by run-ning ahead with what I had mistakenly supposed to be a reserve can of fuel. I was surprised by the forbearance of the driver concerned who, after the initial outburst, now crept resignedly under his truck to drain the water before pouring in the con-tents of a real gas can.

Had more been said about the matter, I might have been sent home in disgrace for enlisting un-der false pretences in the British Medical Unit (BMU) to Republican Spain. But luck turned out to be on my side just as happened with regard to language. For, apart from my claim to be a quali-fied driver, I had also stated in my application that I had a fair knowledge of Spanish. I soon realized, however, that reading the language in a textbook is very different from using it in everyday conver-sation. I was to pass through several weeks or even months of apprenticeship, often in situations where misunderstanding a message or command might have led to dire consequences, before I could claim to have achieved real fluency. During this period I somehow managed to get by without any disaster occurring.

How was it that I, at the age of twenty-three found myself involved in a civil war that, on the

face of it, did not directly concern me? Yet, in the coming two years, I was to undergo an experience which, as I write these lines over forty years later, is still marked indelibly on my mind.

My first brief contact with Spain had taken place nine years earlier in December 1927 when the widow of an American cousin, with whom we were spending the winter in Saint Jean de Luz in the southwest of France, decided to go over to Rome and felt a need to confess to the Irish prior of the Carthusian monastery of Miraflores on the outskirts of Burgos, Spain. My mother and I went along for the trip. Some details of this experience remain vividly with me to this day: the Guardia Civil with their three-cornered hats marching slowly in pairs up and down the border station platform at Irun; the Pyrenees rising behind them covered with a fresh mantle of snow; the bitter cold wind sweeping across the plains of old Castile, the Hotel de Londres y del Norte where all was in mourning as the owner had recently died; and the image of my mother, tigress-like, pacing up and down outside the dining room which, true to Spanish tradition, did not open its doors for the evening meal until 10 p.m.

This was still Spain under the monarchy, an institution of which we were to have a fleeting glimpse on November 29, 1927, that very same winter of 1927–28. We had just weathered the roughest of Channel crossings and were lining up unsteadily to disembark at Calais when the crowd suddenly parted and somebody whispered: "The Queen of Spain!" And there she was the consort of Alfonso XIII and granddaughter of Queen Victoria followed by the two teenage *infantas* simply clad and wearing berets.

From this momentary impression my thoughts delved deeper into the past and there arose before me the figure of a dashing cavalry officer, Major William Wainman, of the 14th Light Dragoons, my great-grandfather. He arrived in the Iberian Peninsula as a subaltern late in 1808 at the age of twenty-one and for the next six years fought with Wellington against the Napoleonic armies in Spain, Portugal and southern France. Since early childhood I can remember his Peninsula War medal, which still lives in a glass display case in our drawing room next to my father's Boer War and First World War medals. I learned by heart the names and dates of the battles engraved on its eight clasps: Talavera (1809), Bussaco (1810), Fuentes de Oñoro (1811), Salamanca (1812), Vitoria (1813), Pyrenees (1813), Orthez (1814), Toulouse (1814), recalling that the English, fighting in the Peninsular War, were the last bastion of freedom in a Europe dominated by the French Emperor. The name of Talavera must have had a special meaning for my ancestor, for it was his baptism of fire, and he was wounded there in July 1809 on the parched hills overlooking the River Tagus. Beside his medal, struck in 1848, only two years before his death, lay his silver watch, which had accompanied him throughout the campaign. This was a vital part of his military equipment, for, on occasion, he acted as aide-de-camp to Wellington, a task demanding scrupulous punctuality.

What had I in common with my cavalry ancestor? Put very simply we were both involved, while

still in our early twenties, in a struggle of freedom against tyranny and, if tyranny were to win, the whole of Europe would be enslaved.

As a young man still full of ideals I had been shocked by fascist Mussolini's invasion of Abyssinia [Ethiopia] the previous year (1935) and now Hitler was to side with General Franco's Nationalists, openly joining him against an all but defenceless Spanish Republic. It was with those thoughts in mind that I presented myself to the office of the British Medical Unit at 24 New Oxford Street in Central London. I did so with some trepidation, but to my surprise was immediately accepted without any checking of my credentials. Thenceforth events moved in rapid succession: a flying visit to my home in Oxfordshire to bid the family farewell and leave my mother the keys to my London flat so that she could dispose of my belongings; back to town to choose a khaki drill uniform for the expected heat of Spain; an evening rendezvous at Victoria Station, where I linked up with the rest of the latecomers; a midnight crossing of the Channel; and, finally, arrival via Dieppe in a still-sleeping Paris at 5:23 a.m.

Having met the main group of members of the BMU at breakfast at the Hôtel de la Gare du Nord, we took part in their hustle-bustle activities: arguments with the French customs at Batignolles, and sorting out our equipment for the journey south.

There were about 25 of us now that we had joined forces, mostly recently graduated doctors and nurses in their twenties, though some ambulance drivers were thirty or older. A month later we were to receive a welcome reinforcement in the shape of six more nurses and four other medical workers who relieved us henceforth from doing night duty after a full day's work.

All was done with the utmost haste because we were afraid the fighting would be over before we reached the front. The war had begun six weeks earlier on July 19, 1936, and to most of us it seemed unlikely that it would last much longer. This led to what turned out to be a rash decision on the part of our leaders to order us ambulance and truck drivers — there were about 10 of us — to start on our journey from Paris to Barcelona in the late afternoon and drive through the night, taking turns at the wheel. As a result, a young red-headed driver named Belcher — I can see him in my mind's eye even now — collided with a tree and ended up with a broken nose — our first casualty. Through this mishap we all lost 24 hours and Belcher, poor fellow, had to return to England. The remaining 15 or so of our personnel, including all the women, travelled south by train and reached Barcelona ahead of us, without any untoward incident.

This was the period of the Front Populaire in France, and everywhere we were greeted with the clenched fist salute. But while the attitude of the French was one of sympathy, the mood in Spanish Catalonia, and particularly in Barcelona, was revolutionary. We sensed this change as our little convoy slowly wound its way up the pass at Le Perthus before dropping steeply into Spain at La Jonquera. Anyone crossing the frontier here is immediately struck by the change in scene. The predominant greenery yields abruptly to the harshness of an

African-type landscape, a high plateau from which rise a succession of sierras or saw-tooth ranges.

On this occasion the arid appearance of the Spanish landscape was enhanced by a late summer heat wave. But if the heat was an obstacle to our progress towards Barcelona, it was not the only one. For, although we had provided ourselves with safe-conducts from various Republican authorities in France, we soon realized that they were not much help to us now that we were in Spanish territory.

In the revolutionary situation that had developed following the army rebellion, the loyalist Republican government's authority had been eroded and replaced by that of the political parties and the trade unions. Therefore, at the entry to and exit from every town and village through which we passed, our passes had to be re-examined and re-validated. At this stage, in Catalonia, most of the barriers were in the hands of the anarchists, FAI [Federación Anarquista Ibérica] and their trade union arm, CNT [Confederación Nacional de Trabajo], although the PSUC [Partido Socialista Unificado de Cataluña] and its trade union organization, UGT [Unión General de Trabajadores], were also conspicuous. These latter bodies embraced both socialists and communists. All the men manning the barriers had several days' growth of beard on their faces and resembled Ali Baba and the Forty Thieves. Except for their armbands it was impossible to distinguish who was who. We had not been in Spain for long enough to realize that any Spaniard who had not shaved for more than 24 hours resembled a ruffian.

As we had breakfasted early, by lunchtime we had developed wolf-like appetites. Our Catalan guides accordingly led us to a roadside farmhouse where a meal was prepared. I do not remember of what this consisted, but the taste of the delicious white wine remained long in our mouths. Fortunately we had been warned that Spanish wine is stronger than French, so we were able to control our thirst accordingly.

The vividness of the new impressions gathered en route was only surpassed by those of our arrival in Barcelona just as dusk was falling. As we drove up Las Ramblas, a former stream bed long since filled in and converted to a promenade, we suddenly became aware that it was bustling with men carrying rifles on their shoulders. One felt that the Nationalist rebellion of Franco had been crushed here only yesterday.

We drove to the Hotel Lloret where Las Ramblas widens into the Plaza Cataluña. This was to be the headquarters of our unit as long as we were in Barcelona. Prager, one of our drivers who had travelled with me from London, and I were billeted in the Fonda del Lince, a small pension in the side street around the corner from the Lloret. There was not a breath of fresh air in our room day or night and the heat was stifling.

The first morning I recall attempting to try out my Spanish by ringing and asking for breakfast. "*En seguida*," the maid assured me. "It will all be here immediately," I relayed. After half an hour had gone by and no breakfast appeared, Prager decided I did not know as much Spanish as I claimed. When, however, after an hour a tray of coffee and fresh rolls appeared, my self-confidence returned and we ate our breakfast with delight.

The next few days were spent in an argument as to where we would be most useful. Our leaders wanted to go to Madrid, which was receiving worldwide publicity, whereas the Aragon Front was barely mentioned in the foreign press. Nevertheless, the PSUC was equally determined that we should go to the latter sector which was, so to speak, in Catalonia's backyard. While this discussion was going on, we, the lesser members of the unit, had a chance to look around Barcelona. We went to a bullfight in the main Plaza de Toros, but, despite the colourful pageantry, I was not impressed and was even pleased when I heard soon afterwards that bullfights had been banned for the duration of the war to prevent large crowds from assembling and offering an easy target to enemy aircraft.

People who befriended us pointed out where on July 19th the anarchists had stormed the army positions on the Plaza de Colón, the waterfront square at the foot of Las Ramblas. Their only protection was huge bales of cotton behind which they crouched as they rolled them towards the machine-gun nests, armed only with hand grenades. When one anarchist fell, another would take his place. In this way the Nationalist rebels were gradually dislodged and this key area was captured by the workers. But, if this was history reported to us by a third party, we were soon to see history in the making with our own eyes.

Two or three days after our arrival, at twilight, we suddenly became aware of formations of disciplined, but weary-looking men marching up Las Ramblas. In reply to my question as to who they were, one of them told us they were the survivors of the Republican expeditionary force which had been sent to capture Nationalist-held Majorca. But they were driven back because the rebels were supported first by three and later six Italian Caproni bombers, whereas the Republicans had no air cover to protect them. After several days of constant punishment they were forced to evacuate their beachhead. This was an example of how little it took in these early days of the war to tip the scale to one side or the other. I never heard what happened to this brave group of men, but before he marched on with his colleagues my informant, gave me his sweat-bathed kerchief, which I have kept to this day, although I must admit it has long since been laundered. I felt a sense of foreboding as I watched them disappear into the dusk.

The Majorcan failure was indeed symbolic of the whole future course of the war. For lack of air support as well as tanks and guns, the two-thirds of Spanish territory initially in Republican hands were gradually being whittled away.

In the meantime, however, we were in Barcelona to help the war effort, not to give in to defeatism. After several days of argument, the PSUC had its way and within a week of our arrival we were en route to the Aragon front where we were deemed more necessary than in Madrid, which had short lines of communication and first-class hospitals within easy reach of the front. I clearly remember some of the details of that journey. After skirting Montserrat we stopped overnight in a small town, Igualada I believe, where we were greeted by the local citizens. This was the first time I heard Catalan spoken. Our interpreter was a German named Emerich, who appeared to me

to speak Catalan like a native. Weeks later the rumour reached us that he had been shot as a spy by the anarchists, although I never had this confirmed. But anything was possible in Catalonia at that time.

Next morning we headed for Lérida (Lleida in Catalan) whose fairy-tale-like castle rose higher and higher before us as we approached it across the parched plain. We drove on past the point where I began this narrative to find lunch provided for us in Sariñena, the first stop in Aragon, a province we were to get to know well in the next few weeks. It was here that we were shown how to handle a wine container known as a *porrón*, ubiquitous in this part of Spain. This glass vessel has a long spout from which one has to pour the wine into one's mouth and swallow it simultaneously. The novice almost invariably chokes at the first attempt, and it is therefore advisable to practise with white wine rather than red to avoid ugly tell-tale stains on one's clothing. It is, however, a very hygienic method for, as the *porrón* is passed man to man, the spout never comes into contact with the drinker's lips.

I mastered the trick at the first attempt and even today am able to hold my own when in the company of Spanish friends. We continued our journey after the midday pause, arriving in the late afternoon at the Aragonese village of Grañén, a few kilometres behind the front line, where we had been allotted a large farmhouse in which to set up our hospital. Although the property of the local doctor, who, at the outset of the rebellion, had fled to the nearby provincial capital of Huesca, it hardly came up to the medical standards demanded by the young doctors of our unit or by the highly trained Catalan surgeons attached to us. First and foremost the farmyard was full of dung piled two metres high.

When our leader, Dr. Kenneth Sinclair Loutit, asked the local anarchist leader, known as Pancho Villa after the Mexican guerilla fighter, to remove it, the latter appeared surprised, remarking that it had always been there. Meanwhile the manure continued to be a breeding place for flies and other insects until Rosita Davson, one of our most efficient unit members, suggested donning our gas masks, which now seemed unlikely to be needed for any other purpose, and shovelling the dung away ourselves. We had barely begun the Herculean task of cleaning the Augean stables when Pancho returned and offered his men to do the task for us. Despite this we still had the constant battle with the flies. I noticed they were especially fond of settling on a smelly parchment-like substance hanging on the wall of the mess. One day this substance disappeared and it was not until lunch appeared that we realized we were eating the old friend, now identified as *bacalao* or salted codfish, served up in a new guise. It took us several days to get rid of the taste. The Spaniards, on the other hand, when they heard there was *bacalao* for lunch said: "how delicious!"

Food was indeed a constant problem. While in Barcelona we had eaten everything put before us, except perhaps *carne de membrillo*, quince jelly, served in a loaf which had the consistency of a cat's tongue. Now here in Aragon quince jelly was the only thing we could eat without being sick to the

stomach. The biggest culprit was the rancid olive oil in which everything was cooked and which was doused on the otherwise edible tomatoes.

One day, while out on a walk, some of us came upon a field of Indian corn. We returned laden with golden cobs which we handed to the cook asking him to boil it for us. When at the next meal the long awaited corn failed to appear the cook explained that he thought we were joking: "Only cows and pigs eat that stuff," he remarked. The only solution was to supplement our Spanish food with parcels sent from home. Yet even these brought their let-downs. I remember the disappointed look on the face of Mary Slater, one of our best nurses from Lancashire, in her twenties, as she undid a packet of chocolate bars. "Why did they have to send me nut chocolate? They know I don't like nuts." In her Lancaster dialect the "nuts" became "noots."

I quite often did night duty with Mary. On one occasion there was a young boy in the ward who had undergone an operation for appendicitis and was not allowed any liquids. Mary came to me in consternation, "I've offered this fellow the bed pan three times, but he won't 'ave it." I asked the boy what he wanted. "*Agua, agua,*" he replied. I turned to Mary and said: "He wants water." Her reply: "Well why doesn't he say so then?"

If the British were fussy about their food, the same applied to the Spaniards and their mineral water. One day we ran out of the local variety of Vichy Catalán and, try as hard as I could, I was unable to persuade a young militiaman to drink tap water. Finally I hit upon a stratagem. Taking a teaspoon of Eno's fruit salts, I mixed it with the ordinary water and the patient drank it without more ado.

As time went by the members of the unit got to know each other better — together with their strengths and weaknesses. One of the young doctors was having an affair with a nurse at the time an inspection team arrived from London. A member of this latter was heard to remark: "If only he could take his boots off first." There was a growing tension between the members in Spain and the committee in London. One of the latter claimed he was ignored when he asked to be shown the lavatory: "And I, the chairman of the British Medical Unit, had to go out and make water on the grass."

Two of the British paramedical staff, who dossed down with me in the attic together with a group of Catalans, stand out in my mind at this period. First, there was Derry Atkinson from Keswick in the Lake District, a trained paramedic who had come through the Abyssinian campaign unscathed, but with invaluable experience. I felt closely drawn to his reassuring manner, not to mention his medical skills. I had already decided to attach myself to him in the field when one day a letter came from the British War Office in London recalling him because he would be needed in the worldwide conflict expected to break out before too long. I remember crying when he went.

Derry's departure left me at the mercy of the other worker, an ambulance driver named Emmanuel Julius. He came from an underprivileged background in London. Unlike Derry, who was apolitical, Julius was a convinced communist of the

aggressive type and a bully into the bargain. He had a knack of making anyone serving with or under him extremely unhappy. I felt I could not continue in his presence and even considered resigning and going back home. But relief came from an unexpected quarter, Julius himself, who one day announced that the medical unit was too tame for him — this was in fact one of the extended lulls on the Aragon front — and that he had joined the militia. How glad we were to see him depart and be able to wish him the best of luck. But there will be more of Julius later.

Most of the casualties at this time were due to sickness and not wounds. Venereal disease, gonorrhea, was the main enemy. It spread rapidly, largely owing to the presence of so many young women in the militia.

Pending an enemy offensive, which was not expected for the time being, two of our ambulances were stationed on the small sector of the front, held by the PSUC militia, facing Huesca, three or four kilometres away. I was one of the drivers sent there. A typical day was as follows: I awaken at dawn with acute lumbago after having slept in the uncomfortable stretchers in the farmhouse in which we have spent the night. There is an increasing noise of small arms fire accompanied by the bursting of an occasional artillery shell. Soon we hear the drone of aircraft overhead, Caproni bombers dropping their load on the anarchist positions of Vicién to our left. No damage reported. We then pay our morning call to German friends in the frontline trench: Lisl Carritt, the daughter-in-law of an Oxford don, and a young German fellow called Hermann. If we take the long way round under cover of the trenches there is no danger as bullets whistle harmlessly overhead. But the Spanish militiamen feel it more sporting to give the enemy a chance and cross an open field a couple of hundred metres wide as a shortcut. The fascist soldiers let fly with their machine guns and the militiamen are pinned to the ground. Eventually they crawl to safety. This pattern holds until about noon when the firing becomes more sporadic. By 1 p.m. it has ceased altogether. About 5 p.m. the siesta period is over and the firing is renewed until dusk sets in at around 6:30 p.m., after which nothing worthy of note happens until dawn the next day.

On occasion, however, people were wounded crossing that open field. One of these was an English nurse, Margot Miller, who had been led into danger by the militia, caught in the enemy fire and wounded in the leg. A few weeks later she appeared at the Albert Hall in London as a victim of fascist aggression and collected a large sum of money for the BMU. Some weeks earlier, Peter Spenser (the name used by Lord Churchill), one of our leaders, was being shown the Republican lines from a Spanish vehicle when he and his companions suddenly became aware that they were in no-man's land and found themselves looking down the wrong end of Republican machine gun barrels. Fortunately the driver knew the men holding that sector by name and called to them to hold their fire.

This was a period where friendships were made easily. We were on particularly good terms with Dr. Francesco Scotti, an Italian who later became an important communist figure in Milan, and with

the local signals unit consisting of a German, Micki, a young Catalan, Joaquín Xerta, and an Italian opera singer, Ennio Tofoni, who used to serenade the above-mentioned nurse, Margot Miller, from beneath her window, before she was wounded.

We also had occasional visitors to our unit. These included John Cornford, a young and promising poet from Cambridge who had taken part in the capture of Siétamo, a village east of Huesca and was on his way to the Madrid sector and was killed a few months later. Other visitors were an Englishman, Tom Wintringham, who brought with him two Germans, Gustav Regler and Ludwig Renn, all of whom were shortly to be involved in the formation of the International Brigades.

Occasionally we were involved in helping the civilian population. I recall being sent out around midnight to drive the local doctor, whose own car had been requisitioned by the militia, to a nearby village where a woman was having difficulty giving birth to her child. I spent the next few hours in the kitchen with the husband and his friend while in the bedroom next door the poor woman kept crying out, "*me muero*," I am dying. She did not die, but gave birth to a healthy child. Meanwhile I was obliged to listen to and speak Spanish uninterruptedly for four to five hours and, as far as I am concerned, this broke the back of learning Spanish for me, for never again did I have difficulty in understanding or even speaking the language.

There were, however, exceptions among Spanish speakers. One of them was a young Andalusian, nicknamed El Negus, perhaps because he

resembled the Emperor of Ethiopia, who, telling joke after joke in his southern dialect, was a constant source of delight to the Catalans with whom he shared the attic. It was several months before I was able to understand his rapid way of speaking.

We had just settled in for what we thought would be a long lull when the telephone call came. I knew by this time that I could understand a Spaniard speaking to me face to face, even if it were the Negus. But could I be certain of what an excited voice was saying at the other end of a static-laden telephone line? Yet somehow I felt sure I had understood. The voice excitedly announced that the enemy had attacked the village of Leciñena on the southern slope of the Sierra de Alcubierre and driven the militia and civilian population into that range of hills. I reported this news to the Spanish doctor on duty and immediately set out with him for the village on our northern side of the sierra from which the SOS had come.

Although it was long after dark when we arrived, refugees were still pouring into the village square. Women and children, their bare feet cut to ribbons, were crying out for medical attention. And with these refugees there came the inevitable horror stories of how the enemy, including Moroccan troops, had overwhelmed them without warning.

We could still hear the crackle of machine guns in the hills above us, but it soon became apparent that the attack had run its course, and the fascists did not intend to pursue the Republicans any further. In fact the latter mounted a counter attack the next day, and who should take part in it but

Emmanuel Julius, whom we had not seen since he left the BMU to join the militia several weeks before. I did not see him on this occasion, but an eyewitness described to me how he had watched him charge up a bare hillside only to be cut down a moment later in a hail of enemy bullets. If Julius was a controversial figure previously, he was truly heroic in death.

Among the frequent visitors of the hospital in Grañén were the members of the German Thaelmann Centuria (named after the German Communist leader later executed by the Nazis), who had enlisted in Barcelona shortly after the outbreak of the rebellion. They were political refugees from the Hitler regime, many of them Jewish. Though entirely new to the military life they soon became skilled manipulators of the small arms they bore. Two of them went by the name of Otto. One, the elder of the two, was a friendly little man, who spoke English. He was greying, in his middle fifties. The other Otto was a sensitive individual some 20 years younger. One felt he was not cut out for military life.

This company of men was employed as a shock force to hold or recapture strategic positions. One of their tasks was to storm the Ermita (Hermitage) de Santa Quiteria situated atop a spur southwest of the railway town of Tardienta. The Germans quickly captured their objective, which they handed over to the local Spanish militia to hold. The latter, however, promptly lost it in a fascist counterattack. At this point the Thaelmann group undertook the task of recapturing the position in the hour before dawn. It was at this juncture that our unit was called into play, as the second assault was much more costly in terms of wounded than the first, and eventually failed for want of surprise. I can see before me as if yesterday the dark figures of the Red Cross men silhouetted against the dawn, carrying back two of the wounded whom they loaded into my ambulance. Driving them back to Grañén was one long agony as the British-built Bedford ambulances were poorly sprung and not designed for use on the rough roads of Aragon. At every bump the wounded cried out in pain.

When the second ambulance arrived it was carrying Otto the elder, whose brain was protruding from the top of his skull. The loss of our good friend was a terrible shock to us all. We heard later that he had been sent to a sanatorium in the Caucasus in the Soviet Union, but I am sure he never fully recovered. The image of the gaping hole in his skull is with me even today.

This pattern of sporadic activity continued throughout that autumn of 1936. Occasionally there were bursts of shelling, which invariably caught us by surprise. One of the attacks struck at Tardienta, a small town on the Republican side of no-man's land. We had barely become aware of the distant shelling when a call asked for an ambulance to be sent immediately. It was my turn to go. I had fully expected to find wounded militiamen, but the only wounded person I could find in the whole of Tardienta was an elderly woman whose face and greying hair had been scorched by an exploding shell. She was obviously in shock, and one of her legs was hanging to her body by a thread.

To me this woman typified the millions of other Spanish women whose lives had been shat-

tered by the war. I drove her back to our hospital. She died the same night.

One day a strange patient was brought into our hospital. He was a Nationalist Moroccan cavalryman, who five days previously had been shot from his horse in a charge and had lain in no-man's land until his feeble cries were heard, and he was rescued by Republican stretcher bearers. The wretched man had a gangrenous wound in his thigh into which one could put one's fist. The stench was unbearable, and when I examined the hole in his leg more closely, I saw that it contained thousands of swarming maggots. Meanwhile, as our medical staff was preparing to amputate his leg, the local anarchists got into the act and demanded that the Moroccan be executed forthwith. Our doctors, however, insisted that equal treatment be accorded to all prisoners of war, including a Moroccan. Fortunately the matter never came to a head as the Moroccan died on the operating table.

When patients died in our hospital the bodies were driven to the gates of the cemetery in which cypress trees grow, located about a kilometre from the village. From this point the corpses were carried in on stretchers by four people and placed in the small mortuary chapel.

On the first occasion we did this, despite the bright moonlight, one of the leading stretcher bearers stumbled and fell into a ditch, with the dead body falling on top of him. The poor fellow nearly died of fright; we never let him go to the cemetery again.

The autumn passed without too much happening on the Aragon front. Our medical unit settled down to a routine of quiet efficiency. We had an excellent chief surgeon in the person of the Majorcan Dr. Aguiló while the young English doctors in the BMU were constantly gaining in experience. But it was the English nurses whose work was most appreciated. We were told that at the outbreak of the war there were only approximately half a dozen fully trained nurses in Spain. The wounded were cared for by semi-trained nuns. In many cases after a successful operation, patients died for lack of nursing care. The English nurses were thus worth their weight in gold. Let me here pay tribute to the Mary Slaters, the Annie Murrays, the Margaret Powells and the dozens of others for the unselfish service they gave as long as the unit was in Spain. As for the Spanish sick and wounded, they were impervious to noise. A racket that would have killed an English patient left them unmoved.

As a third side to the triangle of doctors and nurses I must mention the transport park or group of vehicles. We would have had a lot more trouble with our trucks and ambulances had it not been for the excellent maintenance job performed by Frank Farr. I myself was not cut out to be a mechanic either in the Spanish Civil War or later in the Second World War. I remember how years later, when I graduated from Sandhurst as an officer of the Royal Armoured Corps, I was given the following report: "His many years of study in other fields have made it difficult for him to absorb the material taught in this course. Nevertheless he has tried hard — C minus." Fortunately, Frank's practical knowledge of mechanics more than made up for my own deficiencies. Despite Frank's efficient maintenance programme, we

were permanently short of transport and what little we had we guarded jealously.

On one occasion an anarchist trade union leader from Barcelona had been killed at the front, and his fellow anarchists asked Loutit to lend them an ambulance to take the dead body to Barcelona for burial. This led to a hilarious argument between the two, which was half in bad French and half in Catalan, which Loutit won. The corpse was sent down next morning, not by ambulance, but by the daily train.

Only once was there an air battle over Grañén. This happened in September 1936 shortly after our arrival there. Hearing the rattle of machine gun fire, we looked up to see one plane chasing another and finally shooting it down. It crashed about a kilometre from the hospital, just outside the village. I drove to the scene in an ambulance and got out only to find the pilot advancing on me with a revolver drawn. I raised my hands to show I was unarmed. In the explanation that followed it transpired that the downed aircraft was Republican, and the pilot was afraid he had landed in enemy territory. He was only shaken, not badly injured, although his plane was a total wreck.

I had been at the Grañén hospital for some ten weeks when I was summoned back to Barcelona and asked to present myself to the PSUC. This austere body was housed in the Hotel Colón at the corner of the Paseo de Gracia and the Plaza Cataluña. All foreigners coming to work in Spain with the Republican side had to be vetted by one of the two high-ranking foreign communists: Fedeli, an Italian, and Scheier, a German. Both of these were

pseudonyms. I never discovered their real names.

After I was ushered into Scheier's presence, he told me I was needed for a key interpreting job. Soviet planes were beginning to arrive in the Republic and the engines had to be regularly overhauled, I would be working with a Russian engineer, Gurevich, and an American, Al Edwards. The testing of the engines would be done at the Elizalde and the Hispano Suiza factories in Barcelona. Gurevich also had an interpreter, Liza, who spoke Spanish as well as Russian. I would have to use Spanish, English and Russian. I had taken a degree in Russian and Italian at Oxford and used it intensively for a year while serving in the British Embassy in Moscow in 1934–35. Gurevich and Liza had a car at their disposal driven by a young Catalan, José Valldosera, as they had to pay frequent visits to the Soviet operational air base.

Of course I accepted my new assignment, which was offered to me following a security check. Some of the foreigners were not as readily accepted as I was. I remember the case of Millicent Sharples, a nurse from New Zealand. From the stamps on her passport Fedeli spotted that she had recently been in Italy and asked her what she thought of Mussolini. "He's doing well; he makes the trains run on time," she said. Fedeli, who had spent ten years on the Lipari Islands in one of Mussolini's jails, did not take such a benevolent view of the Italian dictator. The situation was only saved by another member of the BMU who explained that nurse Sharples was extremely apolitical and motivated purely by humanitarian considerations. She was eventually allowed to join the staff at Grañén.

When I arrived in Barcelona in November, the city had a different look compared with the few days I had spent there, ten weeks before. There were no longer armed men at every turn, and one had the feeling that the government at last had the situation under its control. I spent my evenings with friends sipping liqueurs in the cafés. Winifred Bates, the wife of an English novelist, told me she had been invited by a Catalan feminist, señora Mercader, to a woman's congress in Barcelona. "Will you make an interference or merely assist?" her would-be sponsor asked her. The latter was to gain notoriety as the mother of the alias Robert Jackson, the man who years later assassinated Trotsky in Mexico, under the orders of Stalin.

Winifred was busy practising for her Spanish driver's test. When the great day finally came, the examiner lined up all the candidates, climbed into his own vehicle, motioned to the others to follow him and drove at breakneck speed to the top of a hill several kilometres away. Those who kept up with him passed, whereas those who fell by the wayside failed.

By the time December came the weather in Barcelona was becoming distinctly chilly. Yet the only clothing I had was the khaki drill supplied by the BMU in London in August. The workers at the Elizalde plant looked at my bare legs with pity. "Poor fellow, he must be so cold." Soon, however, they found a remedy. One day they presented me with a smart new-looking suit. "We shot a fascist last night," one of them said, "and thought you may be able to use his suit." I must confess I never felt comfortable in the ex-fascist's ex-suit, which in any case was too small for me. Fortunately I soon went home on leave and was able to exchange it for some of my own more comfortable clothes.

Now that I am on the subject of clothes I have often thought of the story of Liza, the Russian interpreter. She told me that her mother had six children and they lived in a small Volga village. They were so poor that each child had only one dress and, on washing days, the mother wrapped all six of them in a blanket and left them there until the dresses were dry. "Now perhaps you can understand what the Soviet regime has meant to us." I often wonder whether Liza was one of the many "Soviet volunteers" purged by Stalin on their return from Spain.

Life among these Russians, however, was not all serious. Some of the pilots would fly up for a few days in Barcelona to break the monotony of their air base of Los Llanos near Albacete, formerly the hunting estate of a Spanish marchioness. One of the young fliers was particularly gullible and his fellows decided to play a trick on him. Sticking a sock in my mouth they made me imitate a long distance call from his commander ordering him to get ready to fly to Paris at a few hours' notice. The deception succeeded and within seconds he was in our room excitedly telling us the news. The moment of disillusion came, however, when I put through a second call cancelling the whole affair. I don't think the young pilot ever found out that it was all a hoax.

CHAPTER 2
Travelling by Air, Foot and Train

• • • (FEBRUARY TO MID-APRIL 1937)

On one occasion in early February of 1937 I happened to be returning to Barcelona with Al Edwards from a trip to the air base near Albacete. We had driven south in Gurevich's car with José Valldosera at the wheel, but were in a hurry to return. As luck would have it, at the Valencia Airport we ran into the head of the Republican Air Force, Ignacio Hidalgo de Cisneros, whose wife, Constancia de la Mora, was in charge of Prensa Extranjera [Foreign Press], the department catering to the needs of foreign journalists, whose staff, incidentally, I was to join a few months later. Colonel Cisneros kindly offered us seats in his aircraft and we took off heading for Barcelona. The plane was old-fashioned and slow, and I can well recall how we appeared to be crawling with relation to

the ground. The day was brilliantly clear and I remember thinking what a perfect target we offered to any enemy aircraft which might happen to be on patrol at the time. On our right, to the east, one could vaguely distinguish the hazy outline of the Balearic Islands with their Italian air base on Majorca, while on our left we could make out the approximate position of Teruel, the nearest enemy-held territory to the west. Much as I enjoyed the scenery I was truly thankful when the 90-minute flight came to an end and we landed safely at Barcelona's Prat de Llobregat airfield. That was my sole venture into the air during my two years in Spain, although I occasionally met Colonel Cisneros in his wife's office. They split up after the war. She went to Mexico while Ignacio took up

residence in Romania, where he died a few years ago.

• • •

I remember only one longish trip on foot. That was in March 1937 when I went for a weekend from Barcelona to the Costa Brava, a succession of rocky promontories interspersed by snug sandy coves extending from a few kilometres north of Barcelona to the French frontier. Coco (Francisco) Robles, a young friend from the Prensa Extranjera department, and I had been invited by Nancy and Archie Johnstone to their attractive new pension overlooking Tossa de Mar, a picturesque little fishing village defended by a medieval wall surmounted by an ancient defence tower overlooking the little bay.

We had hoped to arrive in Tossa late on the Friday evening, but on reaching Blanes by train around 10 p.m. we saw no sign of the Tossa bus, which we had expected to find awaiting us. On enquiring we were told there would be no bus until the next morning, so we set out for our destination on foot, a distance of around 20 kilometres.

The road wound now up among the coastal hillocks, now down beside the deeply indented bays. It was a calm moonlit night. We were amazed by the fact that here we were on a defenceless coastline with nothing between ourselves and the Balearic Islands, all of which, except Minorca, were in rebel hands, yet during the entire walk of over three and a half hours we saw no sign of a guard post or a sentry box. Nor did we see or hear

a single human being all the way from Blanes to Tossa. The Johnstones had anticipated our moves and left us a tray of refreshments, which revived us before we tumbled into bed.

The Johnstones had a reputation for hospitality. Nancy had inherited a small legacy two years before the Spanish Civil War broke out and, rather than settle down in England, they decided to build a pension catering mainly to the tastes of middle-class English people on the hillside above the village and bay of Tossa. Casa Johnstone soon came to represent an idyll of peace and quiet. With the outbreak of the Civil War, however, the Johnstones, like the natives with whom they had come to share the good and the bad things of life, were caught up in the tangle of politics. Archie became a war correspondent for his old newspaper the *London News Chronicle*, which, like the Johnstones themselves, was a staunch supporter of the Republic. He spent most of his time commuting between Tossa and Barcelona, and was well fitted for this task by his many years of experience as a Fleet Street journalist. Despite difficulties in obtaining food supplies, the Johnstones threw their house open to people in need of a rest like Coco and myself.

Having slept off the previous night's fatigue, we awoke next morning to look down on a peaceful fishing village set beside a small cove at the foot of rocky cliffs which here slope precipitously down towards the sea. The spring colours were unbelievable, and there were at least ten different shades of green besides the turquoise or purple tints of the Mediterranean, the brilliant white of

the houses and the mature sandy texture of the cliffs. The only discordant notes of this whole bucolic scene were the raucous voices of the Catalan women mending the nets torn by the weight of the night's catch. Up to that period Tossa had never known more than a handful of foreigners at a time, and even such as did come brought with them the intention, the will and barely sufficient means to make Tossa their home and to live as just another one of the village's two thousand inhabitants. Wealth was rare, throwing money around and bad taste not at all.

So it was that Tossa, in spite of the war, in spite of the cessation of the flow of foreign visitors to Spain, was able to continue its life almost as if nothing had happened, except perhaps for the loss of one of the village boys killed at the far-off Madrid front or the occasional drone of a seaplane hunting for submarines and mines as it swooped along the coast.

Like every other village in Republican Spain, Tossa felt for the besieged capital, Madrid. Several weeks earlier, twenty children had arrived, some without fathers, others without mothers, but all without a home. The German and Italian bombers had seen to that in their nightly visits to the sleeping capital. And with the arrival of these twenty children there came, strangely enough, a certain disappointment to the people of Tossa, not because they did not want to give them a home, but because forty families had volunteered to take a child and there were too few children to go round. Hospitality was more than a habit with the people of Tossa; it was their very nature.

In another way, too, Tossa was playing its part in helping Madrid. Twenty of its sons were already at the front, and fifty more were going the next week. "Yes," said the people of Tossa, "parting with our sons is hard, and death, if it comes, is even harder. But away over there is Madrid, and Madrid must not fall. Madrid" they said, "stands on the edge of a precipice, Madrid is the fortress of freedom, humanity and all that is good. But there beyond . . . it may mean our sons and our husbands, it may mean our womenfolk too, but even though it means death for every one of us, we prefer that to defeat and foreign domination."

Their minds may indeed be simple, but their understanding is great. And it is just these people of Tossa and those of the other villages of Spain who will provide the strength and courage to face the foe and win the war. Once death does not make them flinch, the people cannot lose.

• • •

Of all the methods of travel, I found trains, even if often the most uncomfortable, also the most exhilarating, for in a train one came closer to the Spanish people than in any other way. The journey from Barcelona to Valencia which I am about to describe took place in mid-April 1937. At that period trains were taking anywhere from 12 to 18 hours for the 400-kilometre journey. We struck a lucky day and it took us only twelve hours.

But the length of our trip did not prevent us from enjoying every minute of it. I was accompanying a group of medical volunteers just out from

England. Spain, for them, was quite a novelty. As there was at that time only one train daily, the crowd travelling was enormous. People stood in the corridor all the way and on the platforms between the coaches as well. At every little station the peasants came up and threw oranges to the passengers in the train, fruit which in the normal course of events would have found its way onto the markets of London or other European cities, but which now, were it not for this act of Spanish generosity, was destined to rot on the ground. The air was everywhere full of the fragrance of next year's blossom. Sometimes they simply emptied baskets of oranges into the windows.

Some of the more energetic travellers would dash into the packing houses located besides the stations and fill with oranges arms, pockets and handkerchiefs. There was then invariably a rush to catch the train during which half the "booty" was often dropped on the ground. The oranges, however, were only part of the entertainment. At one station a soldier got on with a minute monkey tied to his shoulder. He then proceeded to make a tour of the train, to the intense delight of the passengers. When the soldier drank water out of a clay pitcher, the monkey reached its mouth forward and did the same. In passing, the soldier gave a rose as a souvenir to one of the English nurses. Later a man with an accordion played as he walked up and down the train.

After we had passed from Catalonia into the Valencia region we noticed at every station country folk of colour, the men attired in broad-brimmed hats, as opposed to the caps worn by the locals. I discovered they were some of the 150,000 refugees from Málaga and the surrounding district, who had fled ahead of the rebel advance leading to the capture of Málaga in February 1937. They were later parcelled out among the coastal villages. One woman described to me how she and her family had escaped from Málaga to Almería, a distance of some 130 kilometres along the coast. It took them eight days to do this journey. While they were fleeing along the road, cut out in the cliff edge high above the sea, Franco's warships poured shrapnel at the panic-stricken women and children. To avoid this they had to take to the mountain trails, but here too they found no safety, for they were strafed by German and Italian planes. In one village they escaped only by wading across a river almost over their heads.

A month later I took a night train from Barcelona to Valencia as I naively thought it would be a way of saving time. When I got to the station I met two slight acquaintances from the Socialist Youth, and we decided to travel together. Although we arrived at the station nearly an hour before the train was due to leave we found there was not a single seat left. So we resolved to sit the whole night in the corridor on my suitcases, which had in a flash changed from being an encumbrance because of their weight and bulkiness to excellent sitting accommodation. By the hour scheduled for the train's departure, however, the crowd of seatless people had grown to such proportions that the railway officials decided to add an extra three carriages and eventually, as people continued to arrive, to run two trains.

It is not surprising that we left two hours after the scheduled departure time and arrived three hours late. But even this was a small penalty to pay for a ride in a train with Spaniards, who are wonderful travelling companions. They talk, sing and play musical instruments all the time. One group of people just beside me did not stop talking all night. But the Spaniards have an amazing quality of not minding noise. When they want to sleep, they sleep, and when they want to listen to what other people are doing and saying, they listen. They have, as it were, a switch which they can regulate to make their ears sensitive or insensitive to extraneous sounds.

In a hospital one notices the same thing. People do not whisper as in an English hospital. Everybody talks in their natural voice. The very ill patients, who in England would pass out if a door banged, could be listening for hours to loud talk and laughter mingled with a large number of other noises that one hears in every Spanish hospital, apparently quite untroubled by what is going on around them. I noticed this phenomenon time and again among the wounded at Grañén, and I have met the same thing everywhere else I have been. As for myself, I had become half-Spanish-trained and could often, but not always, sleep through a noise. It certainly was a useful thing to be able to do.

To return to the train: about three o'clock in the morning a man came to ask if I spoke French. I seemed fated to be picked upon as an interpreter wherever I went. Perhaps I had grown — a dreadful thought — to look like one. This time it was for a French woman in her early thirties who had gone mad in the train and insisted on trying to bite her wrists. I found two Spaniards holding her hands so that she could do herself no harm. "*Je veux une mort humaine*" (I want a human death), she kept repeating in that morbid voice that only the French can assume. A few stations further on she was taken off the train, and I last caught sight of her being led up the village street in the early morning light, yelling the phrase at the top of her voice. I think the reader will agree with me that it is rather discomforting when a woman goes mad in a train, especially a Frenchwoman in a Spanish train at night.

CHAPTER 3
The Siege of Madrid
• • • (MID-APRIL 1937)

It was April 18, 1937, and I had barely reached Valencia again after the unusual train trip which I have attempted earlier to describe, when I ran into Winifred Bates. She announced: "If you ever want to see Madrid you had better come along with me now. I am leaving in a few minutes."

The official reason for our trip was to visit the villa at Torrelodones, a weekend and summer resort for the well-to-do Madrileños (Madrid folk). It was approximately 30 kilometres northwest of the capital, which the BMU had chosen as a front-line hospital for use during the Republican counter-offensive expected in the early summer of 1937. Each of the various rebel offensives against Madrid beginning with July the previous summer — the Sierra de Guadarrama, the University City, Jarama, Guadalajara — had either been repulsed or stopped in its tracks, and now it was the Repub-

lican's turn to attempt to break the enemy's surrounding grip on the capital. This eventually crystallized into what became known as the Brunete offensive in July 1937. In the meanwhile we had expected the Madrid front to be undergoing a lull. But on the contrary, we arrived in a city under almost constant shelling which had lasted for the past eleven days, the main target being the central streets and in particular the Gran Vía. As I got out of the car I counted ten shells in the first minute, although the explosions were distant, probably coming from the Casa de Campo, a park held by the rebels, west of the city centre.

The shelling died down in the evening. The next morning, however, shells were bursting all around our neighbourhood. People laughingly asserted that the walls of the Hotel Florida in the Plaza del Callao at the western end of the Gran

Vía, where we were staying, were made of card-board. For, a few days previously, an American journalist had just left his bedroom there to shave in the adjoining bathroom when a shell passed right through the bedroom and landed in a nearby building before exploding. Fortunately our travel programme to inspect the villa at Torrelodones took us out of Madrid, which underwent heavy shelling during our absence in the daytime hours. The following morning, however, at 6 a.m. a terrific bombardment began; the shells were landing a stone's throw from our hotel. To add to the danger, our rooms were on the fourth floor, facing the west from which the rebel batteries appeared to be firing. The early morning shelling lasted about an hour with shells coming five or six to the minute. All of them fell within a half a kilometre of our hotel, many in the Plaza del Callao itself onto which our rooms looked.

The same afternoon, at about four o'clock, the shelling started all over again. When we thought it had quietened down, we made our way eastwards along the Gran Vía towards the Telefónica (Telephone) building, a favourite target of the enemy's artillery. Hitherto their guns had been placed in such a way that they could shell only one side of the Gran Vía, so pedestrians out of habit always kept to the other side. Now, however, they had set up a new battery firing directly down the street so one was safe nowhere. We were in the act of walking along the "protected" sidewalk when there was a whistle. I think I was as nimble as any Madrileño in dodging into the first house on my right. My English companions later told my mother that

they had never seen me move so fast. The shell burst some 20 metres away in the street. No sooner had I entered the house than masonry started falling through the skylight and landed at my feet. I picked up a piece of marble and put it in my pocket as a souvenir. Unfortunately I lost it later in the course of my travels. It had evidently come from the top of another building and fallen through the skylight of the house in which we had taken refuge.

After a few minutes the bombardment ceased, but we took no chances and dashed across the Gran Vía at a run until we found ourselves safely inside the Telefónica building, whose walls were too thick for any shell the enemy had to penetrate. We were glad to find dinner arranged for us, not in the exposed Hotel Florida, but a few metres away in the sheltered cellar of the Hotel Gran Vía. One of those present was Ernest Hemingway who, despite all the risks he took in the daytime, also preferred to dine unmolested by the disturbing noises above ground. This was the only occasion on which I met Hemingway, and I must admit that my brief meeting with him left no special impression on my mind. Later, a number of times, I talked to Martha Gellhorn, who was to become his third wife and found her a most charming woman. As far as we were concerned, the shelling was all but over, for we left for Valencia at 7 a.m. the next day.

To enter or leave Madrid at this period, one had to run the gauntlet of the rebel batteries situated on the high ground above the Jarama River. We passed this obstacle without incident. Later, how-

ever, we learned that soon after we left, the shelling of central Madrid was renewed with the same vigour. I have never been so glad to get out of a city as I was to leave Madrid.

• • •

If such was my reaction to being in a front-line city, it was not shared by the Madrileños. Their continuous exposure, first to bombing and now to shelling, had made them brave to the point of foolishness. They walked about the streets apparently just as carelessly as Londoners doing their shopping in peacetime, but at the first whistle they instinctively ducked and made for the nearest doorway where they stood watching the bombardment. Some people kept walking all the time and only quickened their pace when they crossed the Gran Vía to some building on the "dangerous" side. It was usually such people who were victims, quite unnecessarily, of the bursting shells.

One often saw two legs with no body, or sometimes a body with the head missing or more often a pool of blood and flesh representing what, a short while previously, had been a living person. One afternoon in two minutes I passed one dead horse and three dead mules lying in the street. Had I been a few minutes earlier I would have seen a much greater number of human beings in a similar condition. The end of a period of shelling gave one the impression of the passing of a thunderstorm. People made their way out of the houses, warily at first, but in steadily increasing numbers. A car horn or a backfire made them jump. And then the relief of the nervous tension caused them to laugh, almost against their will: "That wasn't one this time, thank God!" their faces seemed to say. Within five minutes of the bombardment we saw a small child playing in a newly dug shell hole just as if it were a sandpit, completely unconscious of any danger. If one went in the streetcar following a period of shelling, one heard people talking about the effects as dispassionately as about any topic of everyday importance: "Look, on that corner a woman was standing with her child in her arms," I heard one man say. "The woman was hit in the breast, but the child was unharmed." And then someone else told another similar story. It did one good to see such brave people, for every one of them was conscious that her or his turn might be next.

Yet it was the hardest thing in the world to induce the Madrileños, even the youngsters to evacuate Madrid. I spoke to a group of children who came up and peered into our car. They asked us if we had any food to give them. A bar of Cadbury's chocolate produced delight among them, although it meant only a couple of squares for each hungry child: "In Madrid," they said, "we eat only bread and rice. We very seldom get anything else. But we would rather eat that here than go away to Valencia and have plenty of everything." That is the spirit one met everywhere. It was perhaps a fatalistic attitude, but certainly not one of despair. For every one of those children had a spirit abounding in confidence and strength. They did not, by the way, look thin or underfed, as one would have expected. Their cheeks were rounded and they

showed no sign of being any the worse for their months of privation and hardship. They had not been to school for a long time. Not indeed since the previous November when a bomb fell on a school in Getafe, a southern suburb of Madrid, and killed over 70 children at one blow. "We play all day long," they told me.

In many respects the normality of life in Madrid surprised me. Despite the fact that the Hotel Florida was under constant fire from enemy guns, I had a hot bath night and morning. The Barcelona hotels had tepid water twice a week and cold water the rest of the time. And my first meal in Madrid consisted of soup, fish and meat, as well as a portion of bread double the size of the Barcelona restaurant ration. Again, the apparent lack of damage to Madrid struck me. Of course, those buildings hit directly by large incendiary bombs retained nothing but their shell. But the majority of the houses in the central districts were still standing and had been touched only by the shell fire.

The Telefónica building was way out in front, with a score, when I left Madrid, of 55 direct hits. Yet it remained just as tough a nut to crack as it had ever been. Nearly every other building on the Gran Vía had been hit at least once by shell fire, and in most cases, several times. Yet, unless one looked for it, the destruction did not meet the eye. Despite the war, Madrid still retained a great deal of that Spanish easy-going atmosphere which one found described on the first page of the Hotel Florida's booklet, advising one to come to Madrid for a rest. For example, the Spanish lunch hour had always lasted from one o'clock till four o'clock.

Now, in wartime, although the average Madrileño had relatively little to eat, let us say two courses instead of the former seven, people rarely got back to their offices before five in the afternoon.

Another trait in the character of the Spaniards which the war had failed to stamp out was their endless good humour. No matter at what hour of the day or night I met a sentry, he was always cheerful and smiling. In fact it was this side of the Spanish character which helped me bridge the psychological gap, when later, after the Spanish Civil War, I visited Franco's Spain.

CHAPTER 4

A Safe Haven for Both Camps

● ● ● (LATE APRIL 1937)

At the end of April 1937, soon after my return to Valencia from Madrid, I took the opportunity to go with a car destined to deliver a nurse to the BMU hospital at Poleñino on the Aragon front. This involved a trip of over 300 kilometres and took over seven hours. Until that moment such places as Alcañiz on the Saragossa front and Caspe had been mere names on a map for me or passing references in the daily war communiqué, but now I was to see them with my own eyes. The only discomfort was the dust, asphalt being limited to the section nearest Valencia. The road over which we passed led through a sparsely inhabited and almost untravelled part of Spain, for during the last 250 kilometres the only traffic we met amounted to two trucks. I was surprised here, as I had been on

the night walk to Tossa a month previously, by the thinness of the defended front. The most memorable sight was a beautiful old fortified town, Morella, perched on a mountain top with a fortress as its crown. The whole complex, town and fortress rising to the east of our road, was surrounded by a massive medieval wall. But even on this isolated route we were able to obtain a four-course meal, which would have been hard to find in any city restaurant.

At Poleñino, we arrived quite unexpectedly, for although a car journey from Valencia took only seven hours, a telegram took as many days. But in spite of this we met with the wonderful hospitality for which the Spaniards are justly famed. I could not resist the temptation, when invited by my old

friend Dr. Aguiló with whom I had worked at Grañén during my first two months in Spain, to stay over for an extra day, although I had intended leaving for Barcelona at dawn the following morning. Dr. Aguiló, as head of the BMU hospital, had long been recognized as a skilful surgeon and a first-class administrator. He came of an old Majorcan family, which I am told is of Jewish origin, although he never discussed his forbears with me.

Poleñino, strangely enough, despite the fact that it was barely 15 kilometres from the enemy lines, was the quietest spot I had struck for several weeks. There was not a sound of a shot or anything else to disturb the peace of these Aragonese villagers who continued to live their life as though war was a thing unknown to them. Only the arrival of one or two wounded daily reminded us that a decisive struggle was taking place.

During my day in the country I went swimming and riding, and breathed in the dry mountain air with relish. This was a welcome change after the hot sweltering climate of Valencia. It seemed a pity that such horrors as cities had to exist. On the second morning I caught the daily train to Barcelona. My travelling companion was one of the Spanish members of the staff from the hospital who told me some interesting facts about its work during the past few months. Altogether since the foundation of the original hospital in Grañén in September 1936 until the end of April 1937, the BMU had attended to more than 6,000 patients in Aragon alone, not to mention the much greater number of sick and wounded treated on the Madrid front where another BMU hospital had borne

the brunt of medical work in more than one major attack. By the way, the Poleñino hospital had the reputation of being the most efficiently run on the whole Aragon front. Records were kept of every patient: name, age, regiment, home address and full detail of wounds. Those who died were photographed and their pictures attached to their documents and forwarded to the Ministry of War.

As mentioned earlier, the English nurses had earned themselves a high esteem in Spain. In the first place they are considerably more efficient than most nurses from other countries, and secondly, up to the Spanish Civil War, a trained nurse was a luxury practically unknown in Spain. A thing unheard of in Spain was a night nurse. Patients were given a glass of water at bedtime and left alone for the night. If they wanted a "certain object," they did it in their beds. One may therefore imagine the surprise of the wounded when they found a nurse at their beck and call all night long.

After I reached Poleñino, the hospital staff was still agog with excitement over the attack recently launched by the Republican forces against the rebels in the neighbourhood of Saragossa. It was the first trial of strength of the new People's Army and the results were remarkable, considering the comparatively short period of training. One of these was the capture of over 200 rebel prisoners during the three days of the attack. Eighteen wounded rebel soldiers had been brought into the BMU hospital at Poleñino. It was about nine o'clock in the morning of the first day that the wounded began arriving in ambulances straight from the front. The Republican wounded carried with them

the joyful news that the Hermitage of Santa Qui-teria, which had been in the hands of the rebels since the preceding October, had been captured by the government troops.

As confirmation of this news came, nine wounded rebel soldiers arrived, one of whom was a fascist lieutenant of sixteen years of age. "It was interesting to see how the prisoners would be received," one of the nurses told me, first by the hospital staff which, with the exception of the six English nurses, were entirely Spanish and, sec-ondly, by the wounded Republican soldiers who, barely an hour before, had been mortal enemies of those men now lying helplessly at their side."

Dr. Aquiló gave the order that all wounded were to be treated equally, and in turn, according to their time of arrival, regardless of whether they were Nationalist rebels or Republican loyalists. These instructions were obeyed to the letter, and the next day one could see some of the Republican wounded chatting and exchanging experiences with the prisoners as they lay side by side taking the sun on the balcony.

"The physical condition of the prisoners was appalling," my English nurse informant told me. "They appeared not to have had a square meal since the war began." And indeed undernourish-ment was indirectly the cause of death of two of the more seriously wounded of them who, but for this, might have survived their operations. The nurse stressed the great contrast between the robust loyalist Republican soldiers and the weak-looking underfed Nationalist rebels. Although the loyal-ists' surprise at seeing the enemy wounded before

their eyes was considerable, the rebel's astonishment was even greater. The young lieutenant, whom we afterwards discovered to be the son of a Sara-gossa count, kept saying: "I can't understand why you don't kill me."

And indeed for the past nine months every one of them had had drilled into his head the fact that to be taken prisoner by the Republican govern-ment troops meant certain death. Naturally they could not believe their eyes when they found them-selves being given every attention in this frontline hospital by people they had visualized as ferocious "reds." When one of the nurses went to give an injection to a wounded rebel soldier, she noticed that he quickly drew away from it, with a look of terror in his eyes. Later she discovered he thought he was about to be poisoned.

Out of this first group of nine prisoners and the others who followed them, only three had any knowledge of the cause for which they were fight-ing. The remaining fifteen were peasants and workers, all of whom had been forced into Franco's army against their will. One of them actually had his socialist trade union card in his pocket and had seized the opportunity of the attack to desert to the Government side, receiving a slight leg wound as he came over. One of the things that astonished these wounded most was that the Republican tricolour was still the national flag. They had been told that a mad state of anarchy reigned in that part of Spain ruled by the Valencia government. It was apparent that every one of these men, even the fascists, had been grossly deceived.

These are some of the exciting facts which I

reviewed in my mind as the daily train chugged its way leisurely towards Barcelona. Little did I realize at that time that they were nothing in comparison with the momentous events and days that lay ahead.

May Uprising, Barcelona

• • • (EARLY MAY 1937)

In the late afternoon of May 3, 1937, I was walking up Las Ramblas from the Hotel Oriente towards the Plaza Cataluña. I had returned to Barcelona from the BMU hospital at Poleñino on the Aragon front only two days previously. As I mentioned earlier, my mission had been to accompany a newly arrived nurse from England who was being posted there from the BMU headquarters in Valencia and to report on the work of the Poleñino hospital and the part played by the English nurses in that institution.

At that period I was working for various organizations simultaneously. First, together with the Russian interpreter, Liza, I was compiling a trilingual aeronautical dictionary — in English, Russian and Spanish — for the use of pilots and aircraft mechanics. For this work I was based at the Hotel Oriente, where the Russians, Gurevich and Liza,

and the Americans, Al Edwards and his wife Rose, were staying and where we had all our reference material.

Secondly, there was a tacit understanding that, whenever needed, I was at the beck and call of the BMU. Here my main function was to deliver newly arrived nurses from England to their respective hospitals. The fact that I had been singled out for this task made me feel like a eunuch at the Sultan's palace in Constantinople. Thirdly, whenever needed, I stood in reserve for Richard Bennett, who was in charge of English language broadcasts organized by the PSUC in Barcelona. It was the combination of the second and third of these tasks that took me away from my work on the dictionary at the Oriente to the PSUC building, where I was to give, later that evening, a broadcast on the work of the hospital at Poleñino.

As I crossed the Plaza Cataluña I sensed a certain tension gripping those around me. Shopkeepers began hastily to lower their shutters, but not entirely, for they left enough room for would-be customers to enter and exit by bending almost to the ground. As was logical in a time of trouble I decided to head for the apartment where some of my English friends were staying at Paseo de Gracia number 33 and where, if necessary, there was a bed for me.

In crossing the Plaza Cataluña on the south side I had failed to notice the crowd gathered on the north side in the vicinity of the Telefónica, which the anarchists claimed had been treacherously seized from them by government forces a few hours before. Now, however, the signs of an approaching conflict — an internal war between the anarchists and the government forces — was unmistakable. Men and boys were already tearing up the wooden blocks of the roadway on the upper part of Las Ramblas and piling up on top the benches which they had unscrewed from their mountings. The number of barricades erected increased as the evening wore on and more and more anarchist patrols or "illegal" police, the so-called "uncontrolled ones," appeared in cars armed with rifles, and, in some cases, with machine guns. A nervous tension became apparent among the mass of ordinary people who happened to still be in the streets. But they behaved calmly and all one noticed was a quickening of their pace as they made their way homewards. The cafés and shops closed one by one.

In spite of the tension, the radio station was still open, and I was able to give the broadcast I had prepared about rebel prisoners in the Poleñino hospital. It was ironic that I should have to come all the way from the Aragon front to give a talk about the rebel Franco's troops when Barcelona was at the very moment teeming with its own insurgents of another ilk, really a civil war within a civil war. We then had a meagre supper in our flat — it was destined to be our last organized meal, a kind of symbolic Last Supper, for the next several days — and then made our way across the Paseo de Gracia to the headquarters of the PSUC, which had moved some weeks earlier from the Hotel Colón and was now located in the former Jockey Club almost exactly opposite our flat.

The PSUC had called for volunteers, and four of us answered the call. Meanwhile the anarchists were busy erecting barricades outside their CNT trade union offices one block down the street. The entrance to the PSUC building was well protected by sandbags. About 10 p.m. firing began in earnest. I thought we were in for a siege in the PSUC building, but apart from random firing throughout the night from passing anarchist cars, no attempt was made to assault it.

The shooting continued all night, though not in our immediate neighbourhood. We, a group of four English people, including a girl, lay on hard chairs or on the floor and got what little sleep we could. About five o'clock, soon after daybreak, when the night's firing had subsided, we walked across our flat and found Winifred Bates still dressed, for the shooting had kept her awake all night. Next day Barcelona was having a miniature

POSITION OF FORCES MAY 4, 1937
(based on sketch by Alec Wainman)

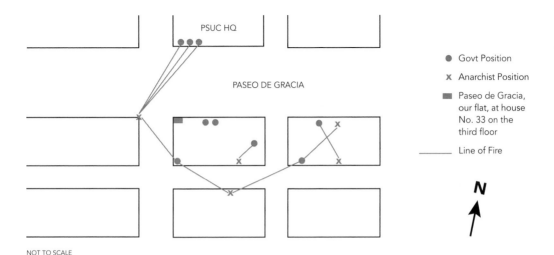

PSUC HQ

PASEO DE GRACIA

● Govt Position

✗ Anarchist Position

■ Paseo de Gracia, our flat, at house No. 33 on the third floor

——— Line of Fire

N

NOT TO SCALE

war within itself and we were right in the thick of it. We had always thought of our flat as being "nice and central." Now we knew damned well it was.

As nearly all the shooting was done from rooftops, and as none of it was very accurate, one can imagine how many stray shots hit the wall outside our windows and might just as easily have hit the windows themselves, and ourselves cowering behind them. Nearly every fortified building had at least one machine gun and often more, besides numerous rifles. Our French windows were on the large side for occasions like this, offering the minimum protection right down to floor level. As there was a menacing looking anarchist manning the turret of the house just across the street from my window, who kept firing his rifle wildly in the direction of the PSUC building, we decided to keep well away from the windows in the daytime

and, with the coming of nightfall, either to move our beds into the corridor or, failing that, to spread out our mattresses on the hard tile floor. We were no longer needed to man the defences of the PSUC, which were in more professional hands than the previous night. I was not sorry.

Of course, during all of this first day, May 4, we were not able to go out as our front door was under fire from both sides. So we were literally in a state of siege. By the afternoon the combatants — I do not know on which side — were using hand grenades and, some said, dynamite as well. Luckily the telephone was working, so we could exchange news with friends in other parts of the city. We learned, for example, that the lower Las Ramblas, including my friends in the Hotel Oriente, were still firmly in the grip of the anarchists, though nobody there had been harmed.

The general impression was that the fighting was increasing as the day wore on. By 7:30 p.m., however, the firing had become much less intense. It occurred to me that the fighters might be having their supper. There had also been an almost dead calm between one and two o'clock in the afternoon. This reminded one of the early days of the front when both sides knocked off for meals. Word came that the government had the situation well in hand and that the anarchists were only holding out in three or four buildings, while the police had absolute control of the streets. There was a government order forbidding anyone to go into the streets. The government expected the state of alarm to last three days at the most.

Nevertheless, on the second morning, May 5, shots outside our apartment house were just as frequent as ever. Barricades had made their appearance in the main thoroughfares as well. In our part of the city the government seemed to be in control of the streets, though the anarchists were still in several individual buildings firing at random on anyone they thought might conceivably belong to the other side. Our house still appeared enfiladed by machine-gun fire from all directions so it was impossible to go out. This is how I described subsequent events in a letter to my mother, which a friend took out of Spain and posted in France: "At one point our front doorbell rang and, when I opened it, I saw two men in berets, with rifles slung on their shoulders, emerging from the elevator. My first reaction was to take them for anarchists so I slammed the door in their face. They then began to knock loudly and announced they belonged to the government side. This incident thus passed safely by.

"Half an hour later there was a louder knock, this time at the back door, and two unshaven toughs appeared. They had just reached that two-day unshaven look by which one can usually identify anarchists. Each man had two bombs in his hand and they demanded to know what party we belonged to. Everyone present, except me, was a member of the PSUC, and hence considered a mortal foe by the anarchists. My friends called me out from my room, saying I had better deal with these intruders as I spoke the best Spanish. I realized that an answer either way could be fatal. Then finally an inspiration came over me and I said authoritatively: 'We belong to the British Medical Unit.' This satisfied them and they announced they were from the police and wanted the key to the roof, so that they could shoot from it at a neighbouring anarchist stronghold, presumably at the anarchist manning the turret opposite my bedroom window."

And indeed that is just what did happen. You cannot imagine the noise that followed. It sounded as if everyone was throwing hand grenades from all the roofs in the vicinity at once and in particular from our own.

After this episode the noise started to die down, and before long people began to come out on the streets to do their shopping. Spanish women make their purchases in small quantities, so in time of trouble the opposing sides feel obliged to declare a short unofficial truce so that families do not starve.

I took advantage of this lull to penetrate the

Ramblas area and pay a visit to my friends in the Oriente where I continued work on the dictionary. I spent the next few nights there. Although there was no firing as I walked down Las Ramblas, the anarchists with their black and red flags were still very much in evidence. I remember one youth carrying, literally, an armful of hand grenades. He seemed quite oblivious of the fact that if he had dropped one by mistake he could have blown up not only himself but also anyone else who happened to be passing by.

I do not remember seeing any sign of members of the POUM [the Workers Party of Marxist Unification] during the uprising, although at the Hotel Oriente I was only a stone's throw away from the headquarters of that body as described by George Orwell in his book *Homage to Catalonia*. At no time did I meet Orwell himself or even hear him mentioned while I was in Spain.

The next thing of note to happen was the arrival of the Guardia de Asalto [Assault Guard] from Valencia. The populace applauded them as they arrived in personnel carriers and spread out down Las Ramblas. And then the most Spanish of situations arose. The Guardias de Asalto began walking arm in arm with the people, male and female. The only thing different about them, apart from their uniforms, was the rifles slung over their shoulders. They gradually persuaded the anarchists to surrender their arms.

And so the May uprising gradually wound down to the point where it virtually ceased to exist. As a result of what had happened, however, the central government was taking no more risks

and shortly afterwards decided to move to Barcelona from Valencia. But more of that later.

The revolt, however, did have its amusing interludes. It was reported, though not actually confirmed, that the opposing forces manning two barricades facing one another, at a critical moment each ran out of ammunition to fit their own weapons. When they discovered that the other side had plenty of ammunition to fit their weapons, they made a swap and so were able to carry on firing at one another indefinitely. As the Italians would say: *Se non è vero, è ben trovato* (Even if it's not true, it makes a good story).

The other episode was indeed confirmed by Charlie Innocent of the BMU. During the lull of the fighting he, another male member of that organization and Sybil Clarke of the clerical staff were slowly crossing the Paseo de Gracia, a Barcelona version of the Champs Elysées, with white handkerchiefs waving in full view of the two opposing barricades. Suddenly a shot rang on from one end followed by a burst of fire from the other side. "Lie down Sybil," shouted Charlie. Sybil continued to stand motionless between the two barricades and looking puzzled, exclaimed: "Why should I? They're not firing at me!" until forcibly pulled to the ground by her male companions.

From Alec Wainman's diary:
May 14, 1937, Barcelona, Paseo de Gracia,

Things very quiet again; still some after-effects of trouble; people still throng streets in their leisure hours as much, if not more, than before. For, in

addition to the usual pleasure of a walk in Barcelona, there is the added interest of examining bullet holes and comparing them with those of July 19. A few days after the trouble had subsided, together with John Langdon Davies, an English correspondent, I visited the areas where we had been housebound. He had been unable to leave the Ritz Hotel while I had been confined for several days to our house (Paseo de Gracia 33). We had one bullet hole through a shop window on the ground floor of the latter while many must have hit the stone work on the floors above.

The government's authority had increased enormously as a result of its astute handling of the situation. The Valencia police, who came to put an end to the trouble, earned a wonderful name for themselves. One must not imagine them as police in the ordinary sense of the word, in other words, tall men in smart uniform, who club the civilian population at the least excuse. They are 90% of them workers and peasants recruited into the police force during the course of the war. In other words they are of the same mentality and same sympathies as the average man in the street.

Now, to illustrate this I was looking out of a hotel window a day or two ago and saw a member of the police force suddenly give a Spanish embrace to a shoeshiner on the street. They were evidently old friends, for, as an act of courtesy, the shoeshiner offered the policeman a shoeshine. Unfortunately the policeman was only wearing sandals, so the offer had to be turned down. In fact the police nearly all wore sandals and dusty blue overalls. Their only distinguishing mark was their rifle or revolver and a small badge showing they belonged to the police guards. The situation had become so normal that the newspapers devoted their headlines two days ago to the British coronation. One local paper got muddled up and announced that Edward was now King, while George had run off with Mrs. Simpson!

Air Raids, Valencia
• • • (END OF MAY 1937)

There were frequent air raids and shelling during my time in Spain. Earlier I have attempted to describe those I experienced during my brief, but eventful, visit to Madrid. The later bombing of Barcelona was the heaviest sustained attack of the war on a civilian target.

It seemed to me that in Madrid, and after Madrid, the enemy had finally got my number. For, in the early hours of the morning following my return from the capital, when I was still recovering from the exhaustion of many sleepless nights, I was rudely awakened by a naval bombardment of the harbour area of Valencia, followed by an air raid. The latter caused no damage as the bombs fell harmlessly in the sea, but one of the shells struck a water main, so most of the city was without water for 24 hours.

Some weeks later there was a sneak hit-and-run evening raid on the centre of Valencia. Again, little damage was done, but one of the bombs fell near the British Embassy, which had been evacuated there from Madrid. While surveying the damage, the butler discovered the ambassador's goldfish bowl lying shattered on the floor with the goldfish gasping their last. With great presence of mind the butler hurriedly scooped them up, headed for the bathroom and emptied them into the toilet bowl, which contained the only water available. The fish revived, but history does not relate whether the butler, or anyone else, absent-mindedly pulled the plug on them!

During this period, the spring of 1937, the BMU had its headquarters in the seaside suburb of La Malvarrosa, on a sandy beach three kilometres along the seashore from the Valencian harbour of El Grao. Air raids were fairly frequent, but most

of the bombs fell harmlessly in the sand. I made friends with the crew of an anti-aircraft battery stationed on the beach a few hundred metres to the south of us.

Rosita Davson, in her usual efficient way, was in charge of the day-to-day running of the villa, ably supported, as far as food was concerned, by Inocencia our plump, good-natured elderly cook, who had been affectionately re-christened Intendencia (army supply department) by the members of the BMU to whom she served her delicious food. Inocencia taught me some expressions in the Valencian dialect, which is a modified form of Catalan.

It was not often, even at the front, that one had the opportunity of watching an air raid in progress. On one occasion, however, we had just stopped for a meal at the coastal resort of Benicàssim, on our way from Barcelona to Valencia, when we heard the rattle of machine-gun fire coming from the direction of the sea. Almost immediately afterwards a ship hove in sight heading north, about a kilometre from the shore. She was pursued by two aircraft, which then proceeded to bomb her. My grandstand view was unimpeded and I could count the individual bombs as they fell. Most landed in the water, but finally one scored a direct hit and smoke immediately started to rise from the vessel amidships. Some of the crew began abandoning her in lifeboats.

This was my lucky day as far as news reporting was concerned, for I had my Leica ready and even found time to screw on my telephoto lens before taking the pictures. Having dropped their entire load, the aircraft flew off in the direction of Majorca. When the lifeboats reached the shore we were surprised to be addressed by the crew in cockney English. The ship turned out to be a British freighter — I have long forgotten its name, if I ever knew it — which ironically had been hugging the coast for safety's sake on her way to Marseille. Those members of the crew who had stayed aboard steered the vessel into shore where she was beached and the fire extinguished. Never again was I to witness a bombing attack at such close quarters, not even during the saturation air raids on Barcelona in the spring of 1938.

• • •

Because of Alec's failing health in 1981, his personal memoirs break off here unfinished. The balance of his story, however, continues and is narrated by Serge Alternês, who also composed the captions that accompany each of Alec's photos.

CHAPTER 7

Exiles: Citizens and Volunteers

• • • (AUGUST 1938 TO LATE 1939)

Alec's last participation with volunteers of the BMU was at the Ebro Front field hospital. On August 8, 1938, he returned to England, ill with hepatitis. After recuperating from his illness, Alec was without work prospects. As a Spanish volunteer veteran, he would have to wait several years before he could join the British Second World War effort. This was the result of the stigmatization attributed to those who had supported the Spanish Republic.

During this time, along with support from his mother Christine, he devoted himself to the Spanish Republican refugee cause. The tragic exodus of half a million refugees from Spain to France in the winter of 1938–39 moved Alec into action. As the Second World War loomed on the horizon, he knew that he was battling against time in his ef-

forts to help these exiles of Republican Spain transfer out of the French refugee camps and come to England. At this point, historians such as Antony Beevor indicate that only a few hundred of these refugees were allowed into Britain.

In January 1939, both Alec and Christine managed to secure Saint Michael's House, an empty building owned by the Anglican Church in Shipton-under-Whychwood, to accommodate about thirty resettled Basque refugee boys. The boys had come to England following the bombing of Guernica nineteen months earlier on an overcrowded ship, the *Habana*. These refugee children were completely dependent on aid from private donors as there was no support from the government.

The Shipton resettlement camp (originally it had been informally termed the "colony") was run

by twenty-seven-year-old Walter Leonard, known as "Leon" (born Walter Levy), a German-Jewish refugee. Leon and the Basque boys were frequent visitors in the Wainman family home, nearby in Shipton. The Wainman residence became their special retreat, complete with tents and all.

In 1939, before the outbreak of the Second World War, Alec travelled to Spanish refugee camps in France to assist in arranging passage for a group of Spanish youth and intellectuals. Some unsanitary camps had up to 100 deaths per day. One of these refugees included twenty-three-year-old theatre director José (Pepe) Estruch. Before the Civil War, Pepe was part of the university theatre troop of Federico García Lorca, an icon of the Spanish Republic whose assassination by Nationalist forces is currently being investigated. After his arrival in England, following eight months in a French internment camp, Pepe would produce numerous theatre performances around London with the Basque refugee children.

In the spring of 1939, Alec was also able to help relocate Marcelino Sánchez, an older Spanish Republican journalist whom he had met previously while he was in Spain with the BMU, from a French refugee camp to England. The exiled journalist then stayed on at the Wainman residence and helped look after the gardens. Sánchez loved to tell stories as they all sat around the campfire. They would gather around the bonfires on a little island on the Evenlode, a tributary to the Thames, which they nicknamed "California." They would sing, tell stories, and plan the safe passage of Spanish refugees and their well being.

Alec also visited the Spanish Basque country in

Pepe Estruch, Alec Wainman and Marcelino Sánchez at the Wainman residence, Shipton-under-Whychwood, 1939.

Nationalist Spain to offer his assistance to families of refugees who were in Britain. The adult refugees were unable to return to Spain for political reasons and were reassured to have Alec as their emissary. The majority of the Basque refugee boys from Shipton were able to return to their families in Spain after the end of the civil war in 1939. The last photographs in Alec's collection on Civil War Spain show his host families in the Spanish Basque country. Soon after, he returned to Britain and later joined the Intelligence Corps of the British Army during WWII — a war which he believed might have been averted if the Allies had taken up the fight against fascism in Spain.

ALEC'S
PHOTOGRAPHS

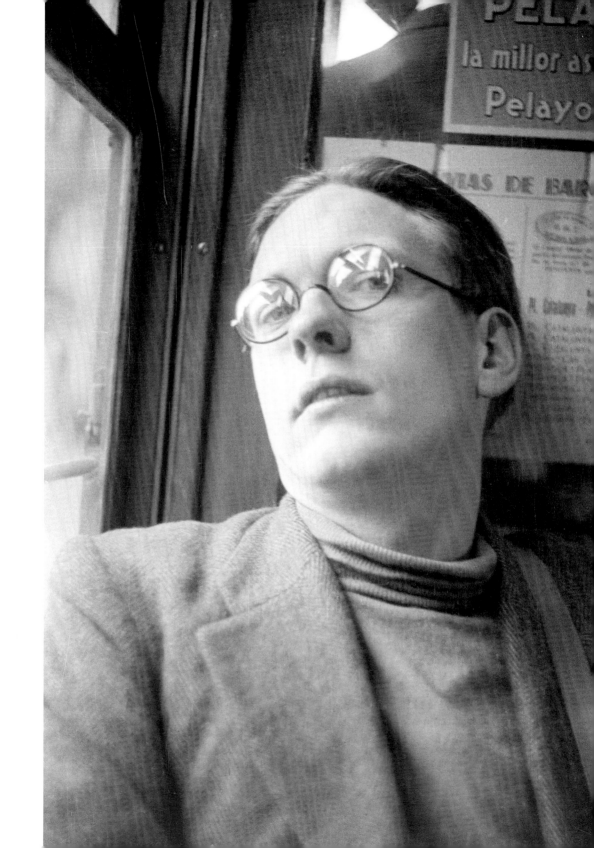

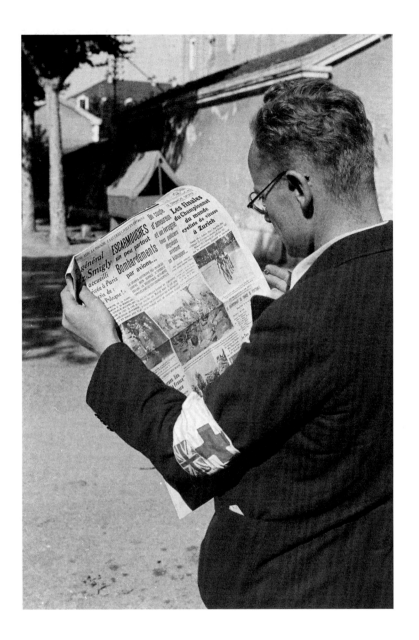

AUGUST 30, 1936, BRIVE-LA-GAILLARDE, FRANCE

British Medical Unit (BMU) volunteer en route to aid loyalist Spain
reading a French newspaper about the aerial bombardment by
Franco's Nationalists in the Spanish Civil War.

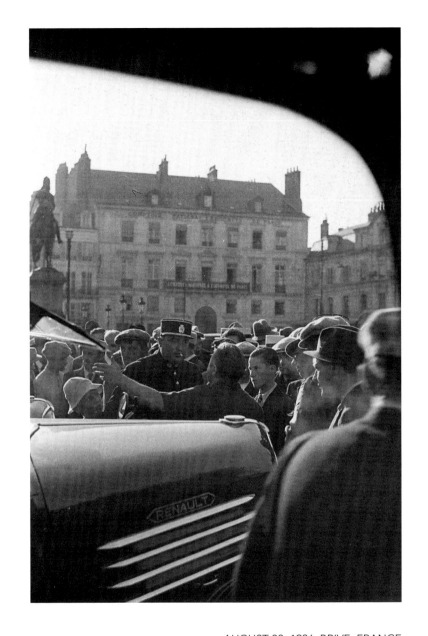

AUGUST 30, 1936, BRIVE, FRANCE

An altercation between a French policeman and sympathizers.
The public sided with the BMU's support of the Spanish Republic,
but the French and British authorities remained neutral.

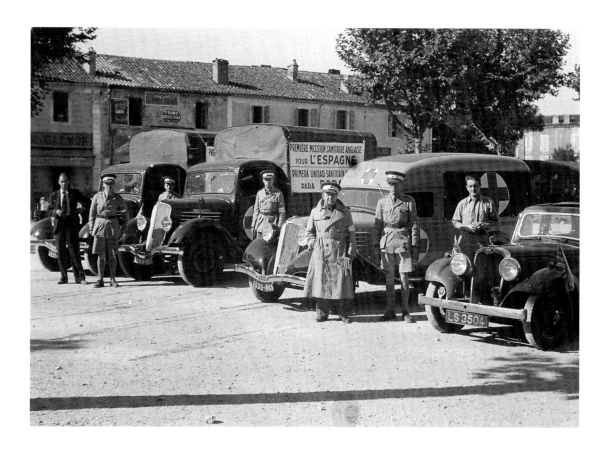

AUGUST 30, 1936, BRIVE, FRANCE

The first English healthcare mission volunteers with the BMU. The truck
signage is in French as the staging ground for international humanitarian
and military aid to the Spanish Republic was Paris.

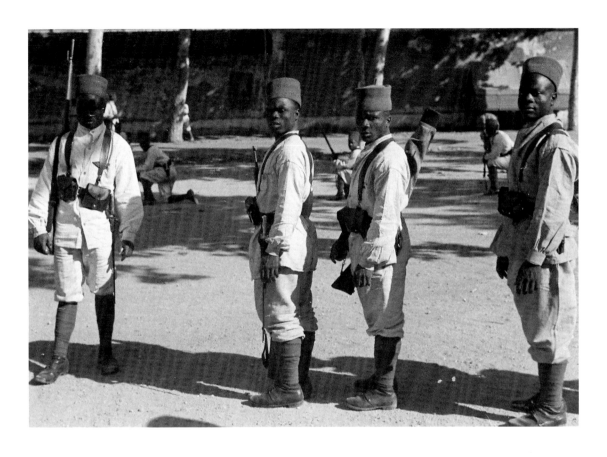

AUGUST 31, 1936, CAHORS, FRANCE

The French African Troops on an exercise. After the Nationalist army rebellion against the Republic, the forces of General Franco were initially composed mainly of the Moroccan Africa Corps and the Spanish Foreign Legion.

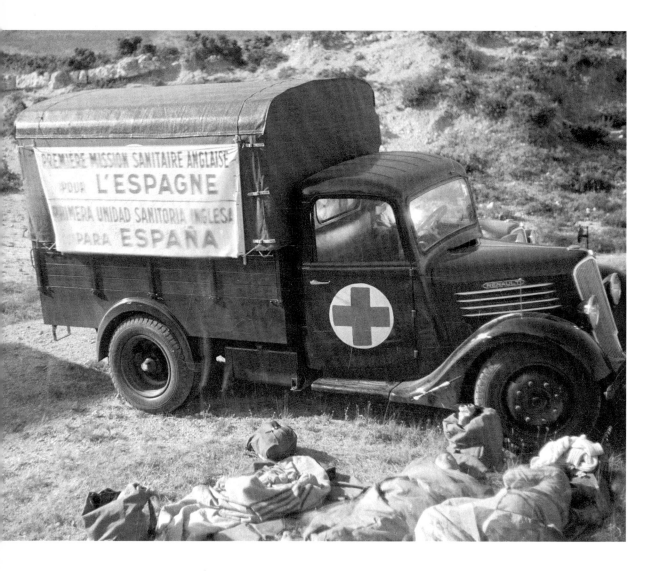

AUGUST 31, 1936, NEAR NARBONNE, FRANCE

A BMU truck with its banner "First English Medical Mission for Spain," with members of the mission camped overnight before arriving in Republican Spain the next day.

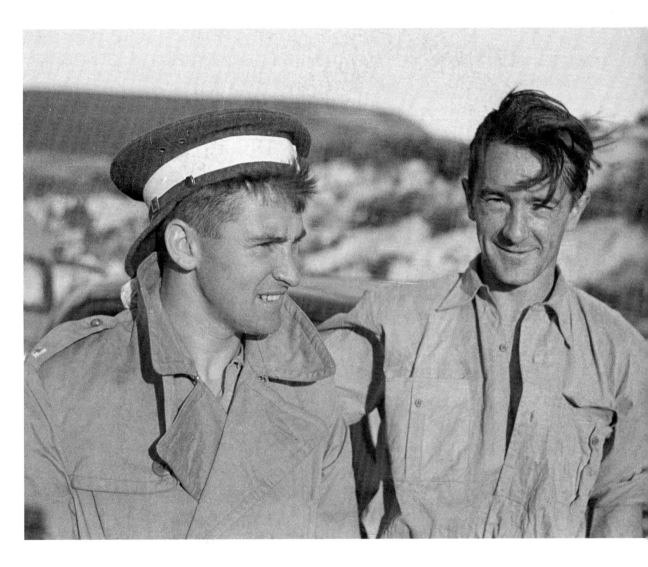

AUGUST 31, 1936, NEAR NARBONNE, FRANCE

Two members of the BMU stopped in the French
countryside on their way to Spain.

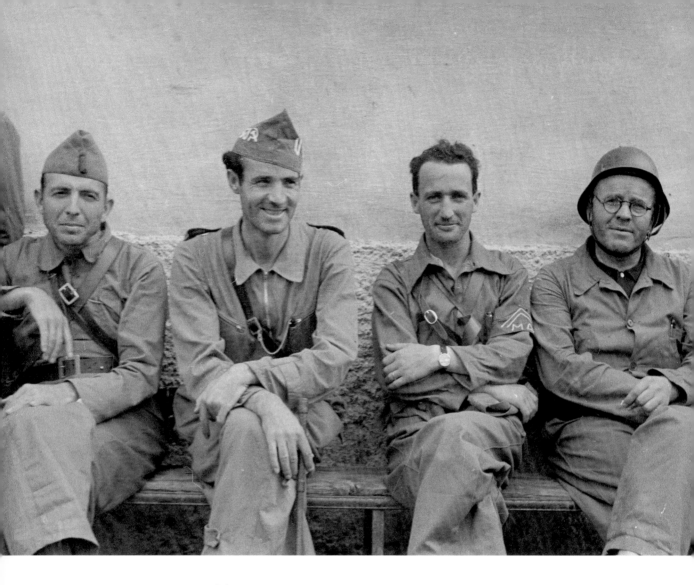

SEPTEMBER 12, 1936, GRAÑÉN, ARAGON FRONT IN REPUBLICAN-HELD SPAIN

Militia officers of the Spanish Republic, including a commander with the UGT
(Unión General de Trabajadores — General Union of Workers) insignia on his cap, and
a second commander with an MA armband, possibly standing for Antifascist Militia.

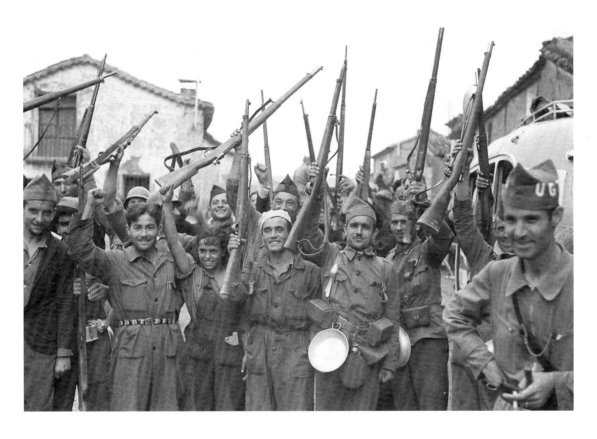

SEPTEMBER 12, 1936, GRAÑÉN, ARAGON FRONT

A jubilant Spanish Republican militia. These companies included
women and foreign volunteers already present on Spanish soil.
The commander has the UGT insignia on his cap.

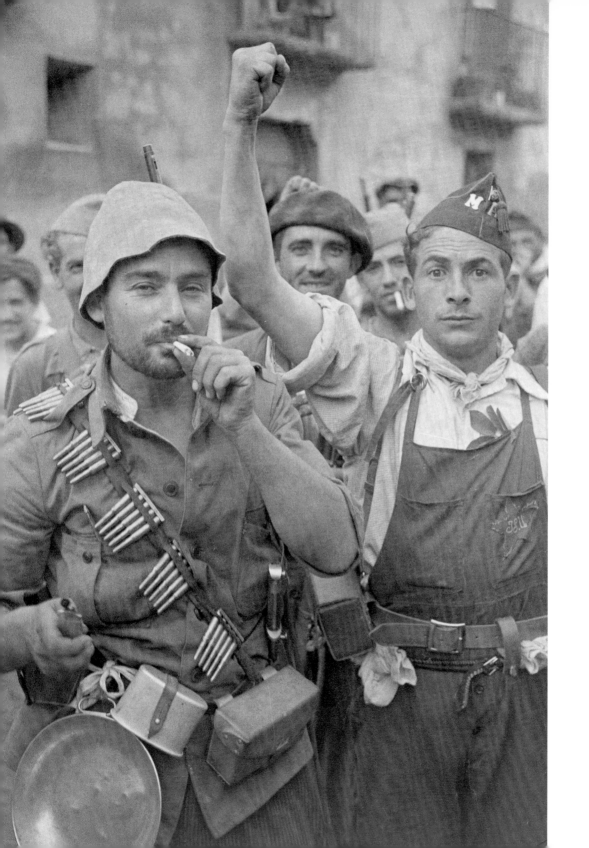

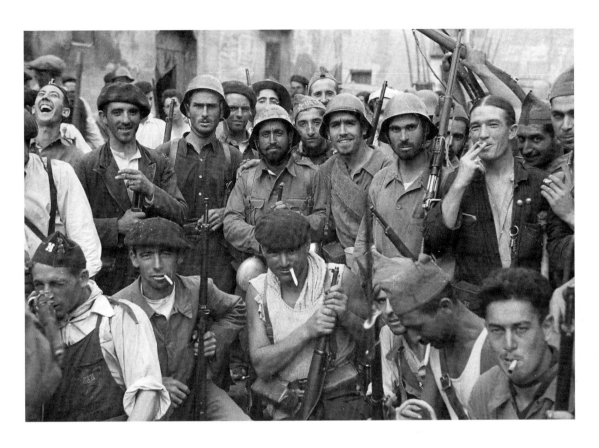

[ABOVE] SEPTEMBER 12, 1936, GRAÑÉN, ARAGON FRONT

The Republican militias had no formal uniform and chose their own attire, which explains the enormous disparity in dress. There were few helmets to go around.

[LEFT] SEPTEMBER 12, 1936, GRAÑÉN, ARAGON FRONT

Republican militiamen. The one on the left has much-coveted ammunition; the man on the right fervently clenching his fist is wearing his work overalls with a flower tucked in. His cap bears the MA insignia.

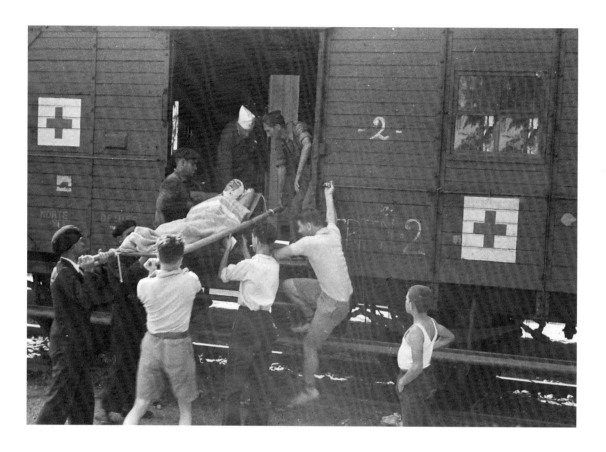

SEPTEMBER 13, 1936, GRAÑÉN

A wounded Republican soldier is loaded onto a train. Trains were
often used to transport the wounded to the nearest hospital.

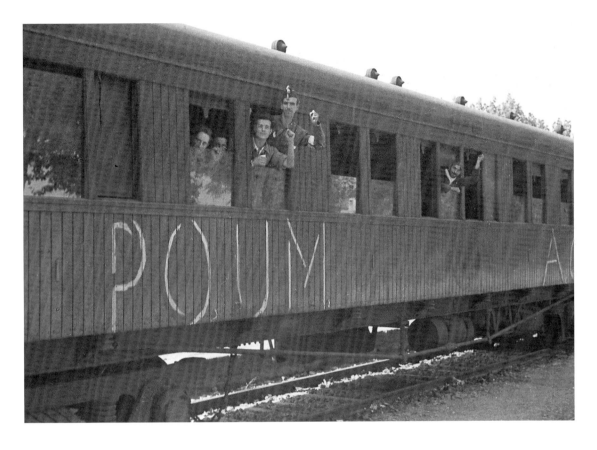

SEPTEMBER 14, 1936, GRAÑÉN

The POUM (Partido Obrero de Unificación Marxista — Workers Party of
Marxist Unification) militia train passes Grañén. George Orwell describes the
POUM fighting on the Aragon front later that year in *Homage to Catalonia*.

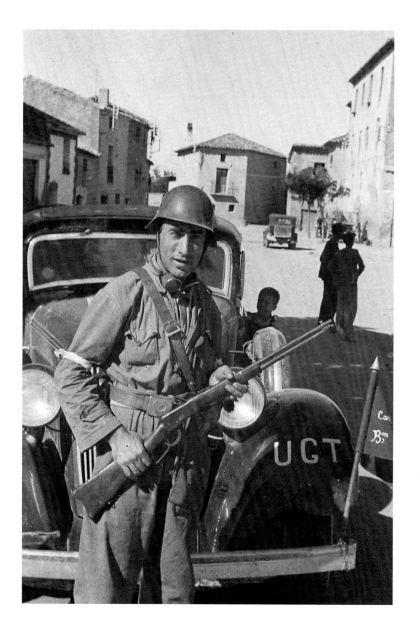

SEPTEMBER 14, 1936, GRAÑÉN

A member of the Unión General de Trabajadores passes through
Grañén. The UGT markings are also shown on the car.

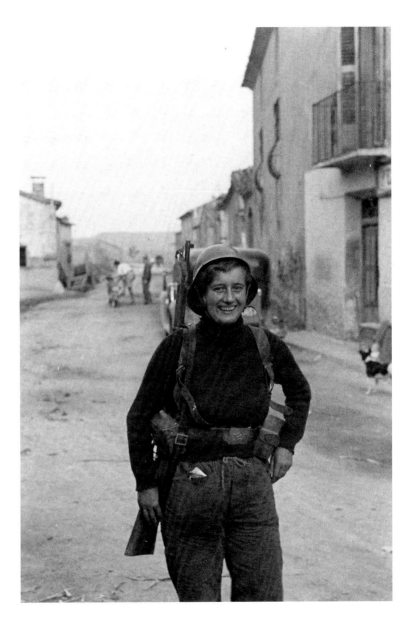

SEPTEMBER 14, 1936, GRAÑÉN

Militia volunteer Lisl Carritt was the German daughter-in-law
of an Oxford Oriel don. Her brother-in-law was badly wounded
while driving an ambulance at Brunete and later died.

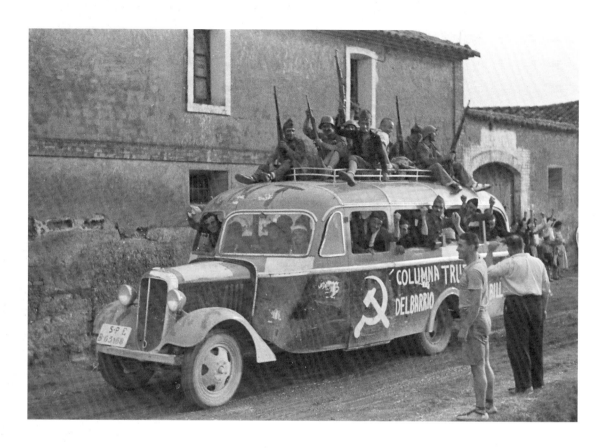

[ABOVE] SEPTEMBER 14, 1936, GRAÑÉN

The Republican militia often requisitioned vehicles for their
own use. These were often crowded with volunteers.

[RIGHT] SEPTEMBER 14, 1936, GRAÑÉN

Militia resting on the back of a truck while they pass through Grañén.

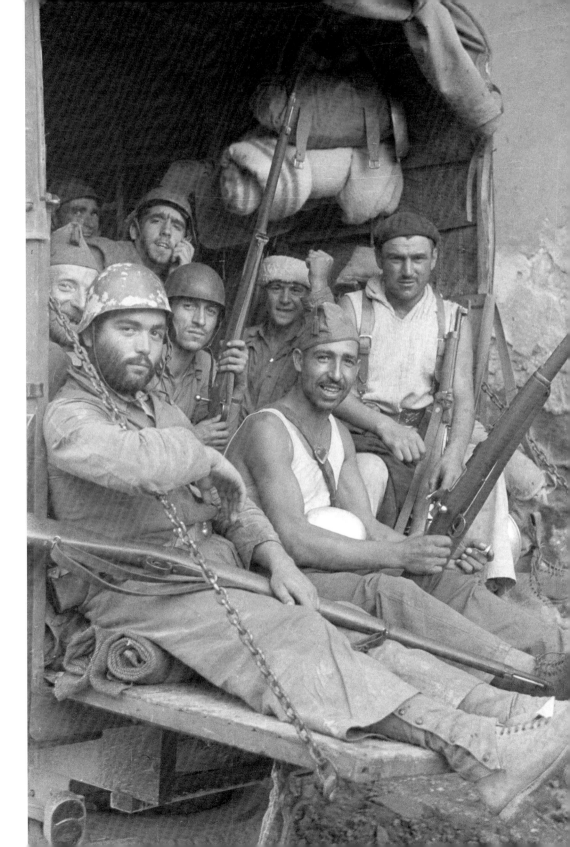

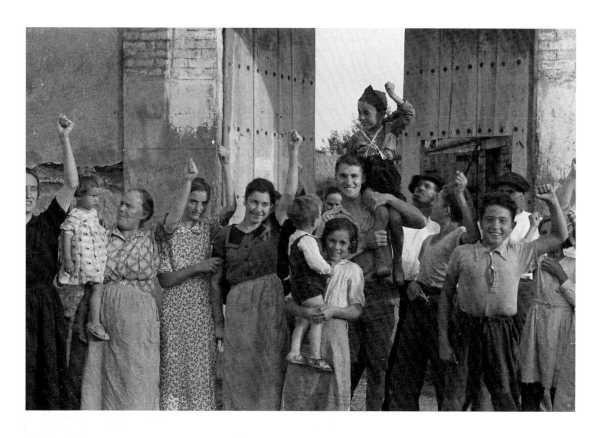

SEPTEMBER 14, 1936, GRAÑÉN

The civilian population cheers as the militia pass through Grañén,
while a BMU volunteer holds a local child on his shoulder.

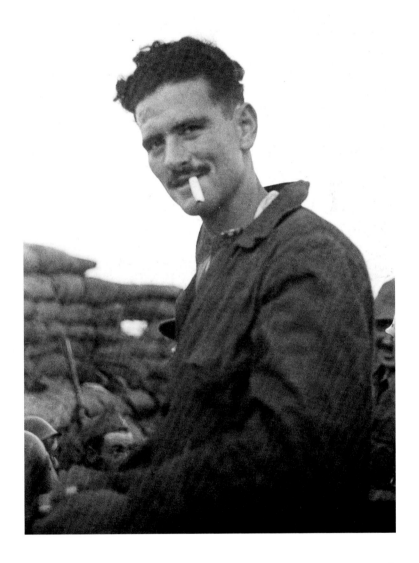

SEPTEMBER 21, 1936, TRENCHES BESIDE POMPENILLO

Militia volunteer in the trenches. Over the period of the Spanish Civil War, warfare was transformed from the trench battles of WWI into air war with the systematic bombing by Franco's Nationalists of Guernica, Madrid and Barcelona.

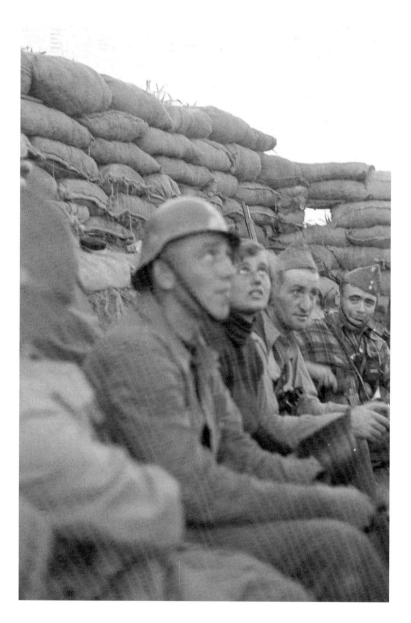

SEPTEMBER 21, 1936, UGT TRENCHES NEAR NATIONALIST LINES

German volunteers Hermann (left) and Lisl beside him, along with a Scot on
the right. Before the formation of the International Brigades, foreign volunteers
were fighting alongside Spanish trade unions such as the UGT, CNT and POUM.

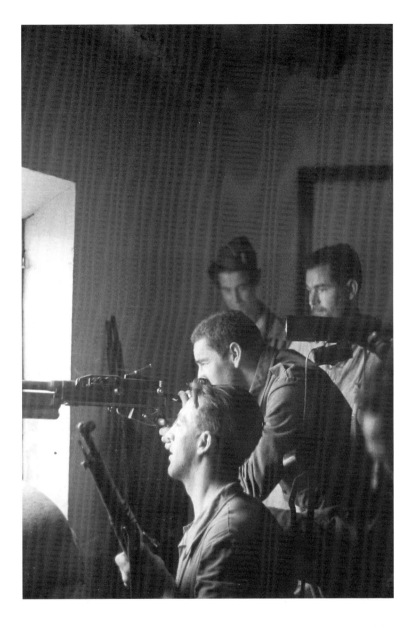

SEPTEMBER 22, 1936, HUESCA

Militia snipers in a Republican outpost. Throughout the Civil War,
Republican Spain struggled to obtain proper weaponry and ammunition.

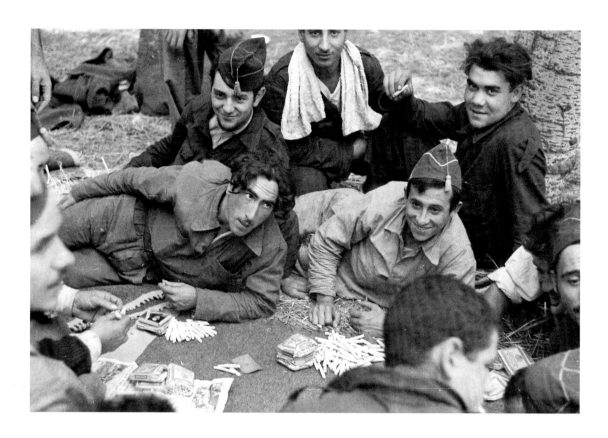

[ABOVE] SEPTEMBER 22, 1936, HUESCA

Young Republican militiamen sharing cigarettes. Many of the militia
members were not yet adults.

[RIGHT] SEPTEMBER 22, 1936, HUESCA

Hermann seen here with a hammer and sickle on his helmet. Typically volunteers
from dictatorships such as Germany or Italy would use *noms de guerre* or
underground pseudonyms.

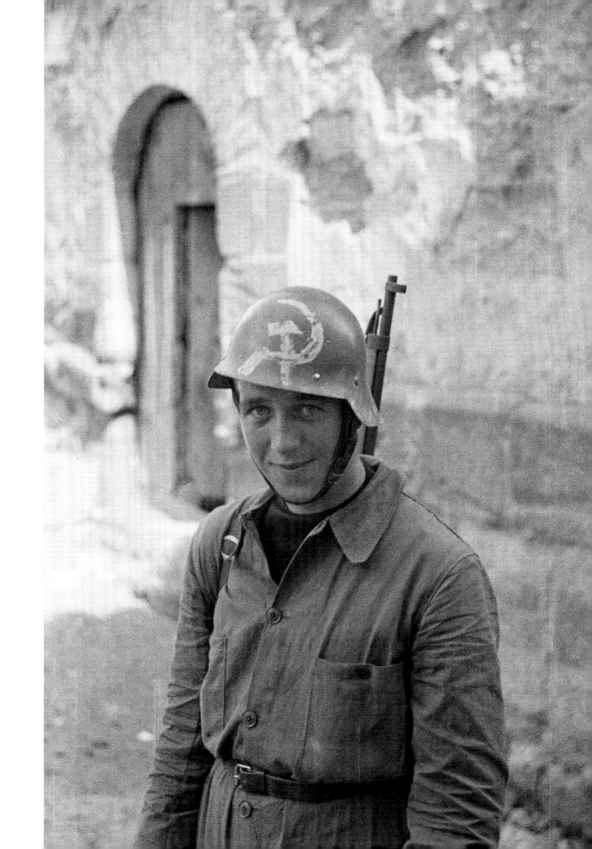

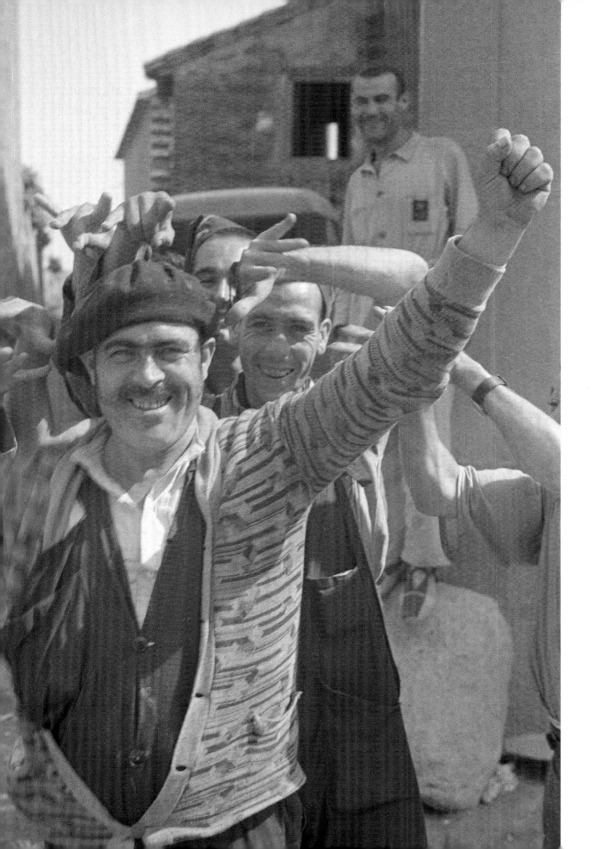

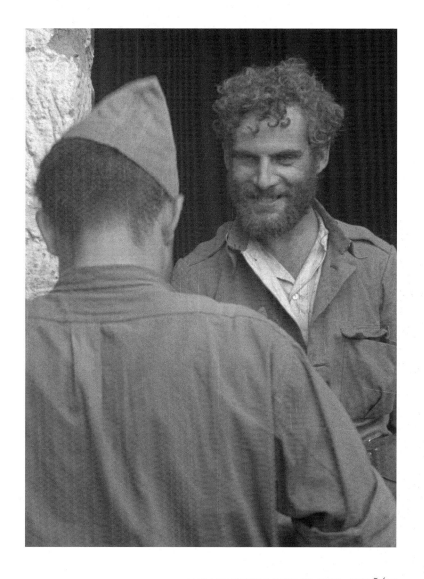

[ABOVE] SEPTEMBER 23, 1936, GRAÑÉN

This appears to be Beato Martín Martínez Pascual. The twenty-five-year-old priest had been forced to go underground. He was later one of the thousands of priests assassinated by the anti-clerical Republican militia.

[LEFT] SEPTEMBER 22, 1936, HUESCA

Sympathizers in Huesca cheering on the Republican fighters.

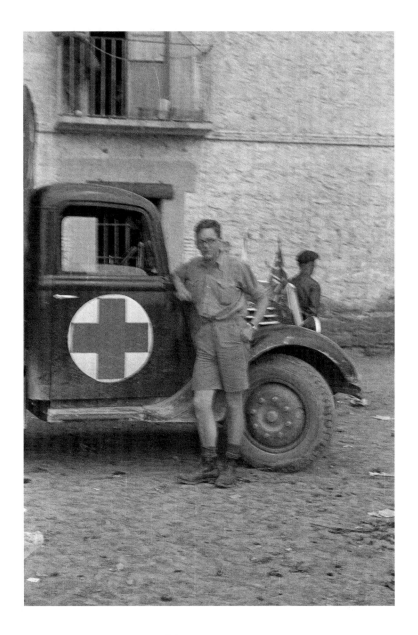

SEPTEMBER 23, 1936, GRAÑÉN

Alec Wainman, the photographer and author at age twenty-three, with
the BMU ambulance he drove. As a Quaker sympathizer, he volunteered
for ambulance duty in Republican Spain. Photo by a colleague.

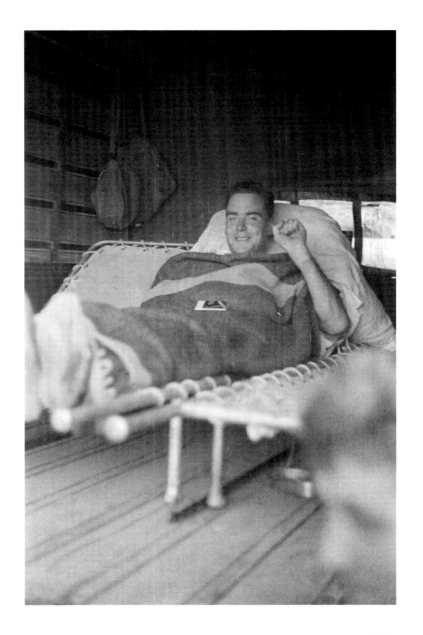

SEPTEMBER 23, 1936, GRAÑÉN

British poet John Cornford of the POUM militia composed "Heart of the Heartless World" on his arrival in Huesca. He defended Madrid with the Commune de Paris Battalion. He was later killed at age twenty-one.

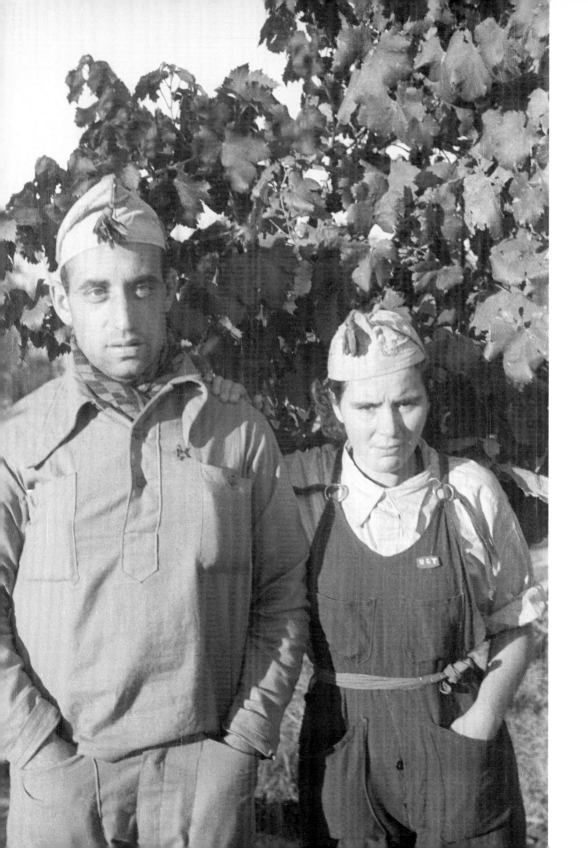

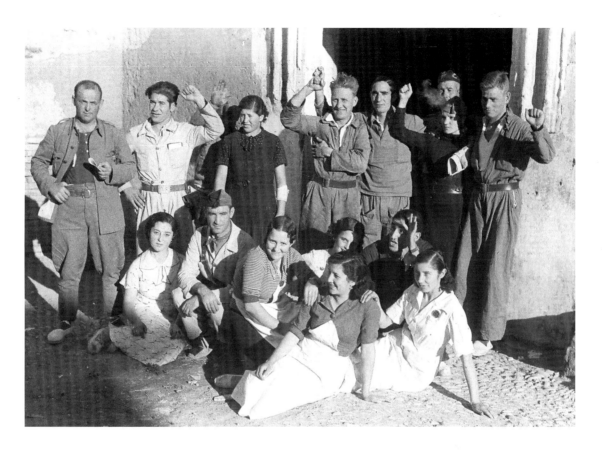

[ABOVE] OCTOBER 3, 1936, GRAÑÉN

Citizens and volunteers of Grañén, which was run by an anarchist mayor who went
by the nickname "Pancho Villa" in reference to the Mexican freedom fighter.

[LEFT] OCTOBER 1, 1936, GRAÑÉN

The first local civilian patient of the BMU hospital had pneumonia. He is
seen here with his wife. Both have political and trade union lapel pins.

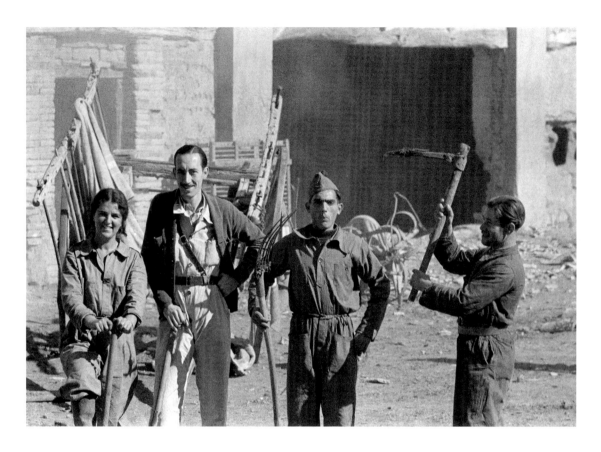

OCTOBER 8, 1936, GRAÑÉN

Members of the BMU and the anarchist militia working side by side to clean up the grounds of a country estate which was later used as the first BMU hospital.

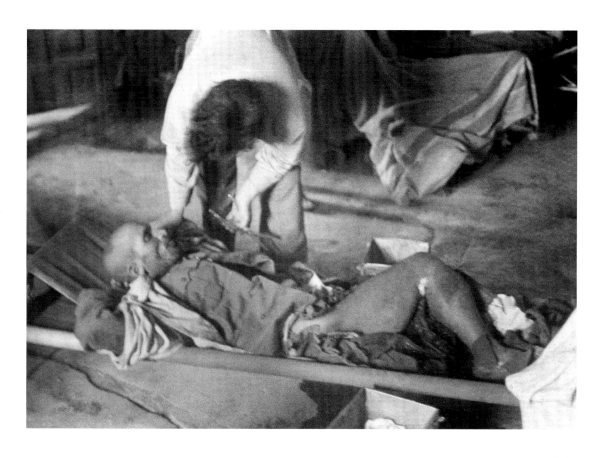

OCTOBER 24, 1936, GRAÑÉN

A wounded Nationalist Moroccan cavalryman, receiving emergency attention at the BMU Grañén Hospital. The anarchist militia wanted him executed but the doctors and medical staff objected. Even with good care, he did not survive the amputation.

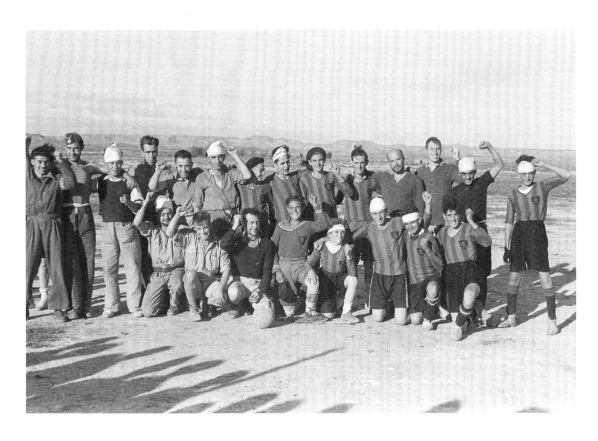

OCTOBER 25, 1936, GRAÑÉN

The village and hospital soccer teams included convalescent
Republican soldiers.

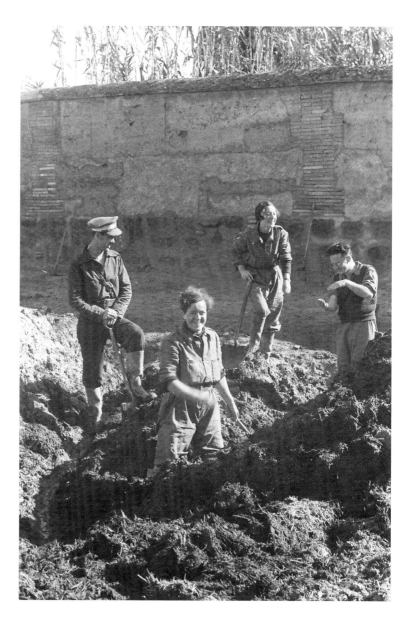

NOVEMBER 4, 1936, GRAÑÉN

BMU volunteers engaged in clearing manure from the hospital yard.

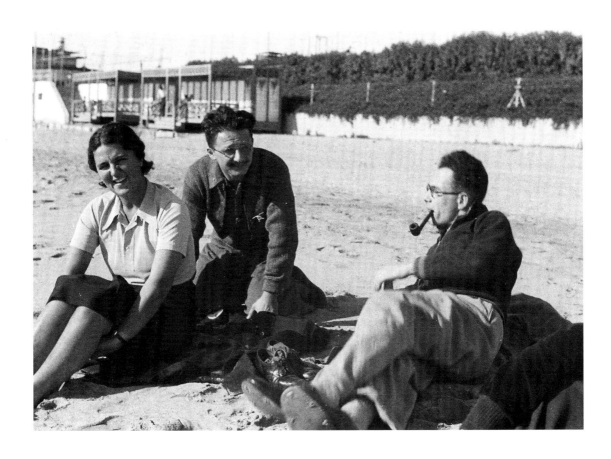

NOVEMBER 15, 1936, SITGES

BMU volunteers on a relaxing break at the beach.

DECEMBER 6, 1936, BARCELONA

Catalan Pioneer Republican Youth Group at Hans Beimler's funeral procession.
Beimler was a German politician and Dachau camp escapee. The leader of
one of the International Brigades, he was killed defending Madrid.

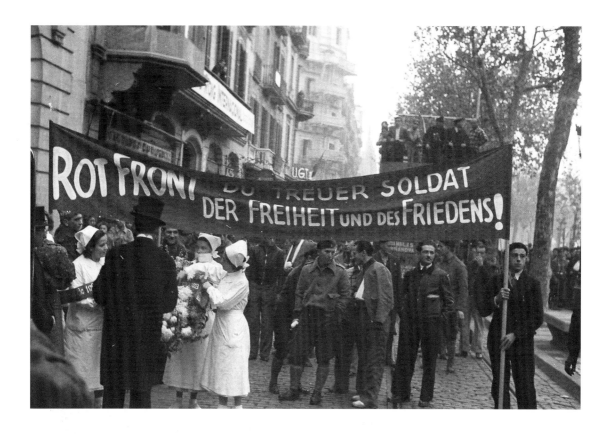

DECEMBER 6, 1936, BARCELONA

Hans Beimler's funeral procession. The propaganda banner in German reads
"Red Front: You're a True Soldier of Freedom and Peace!"

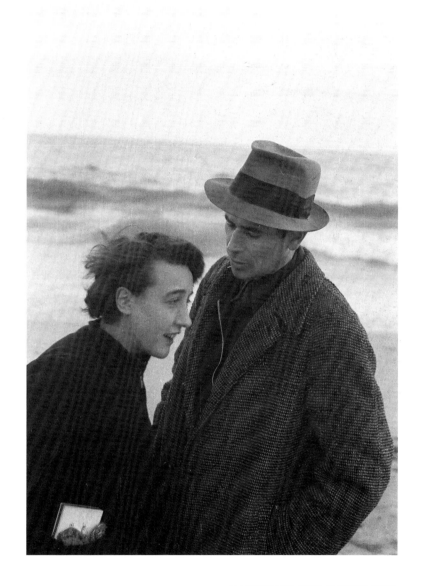

JANUARY 17, 1937, BARCELONA

Al and Rose Edwards at Masnou Beach. Al was an engineer from
New York in charge of the repair of Republican airplane engines and
later an organizer of the American Brigade.

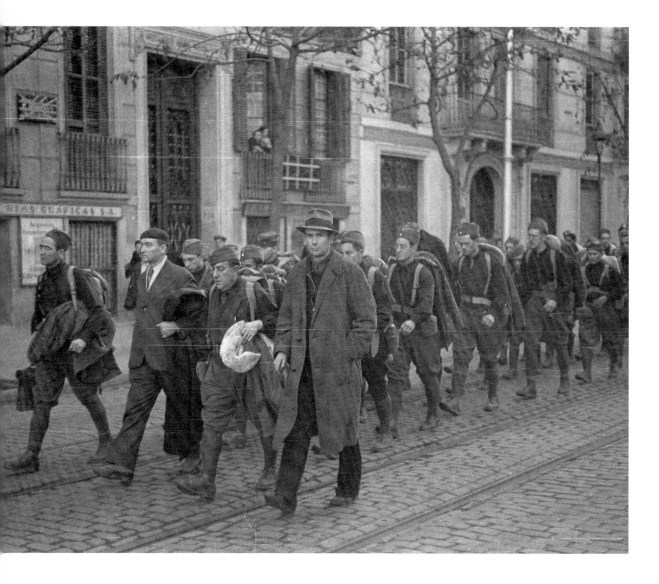

JANUARY 17, 1937, BARCELONA

Arrival of the Abraham Lincoln contingent of the International Brigade in Barcelona, escorted by Al Edwards. This was the first North American unit to fight in the conflict.

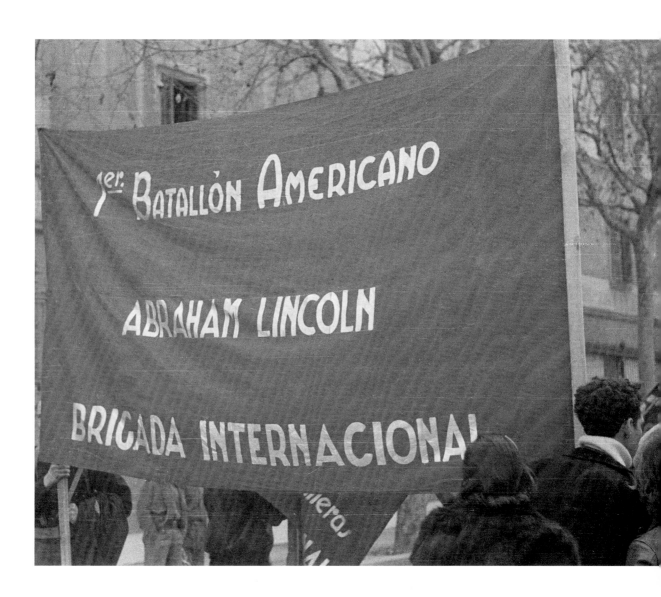

JANUARY 17, 1937, BARCELONA

Banner of the Abraham Lincoln contingent of the International Brigade.

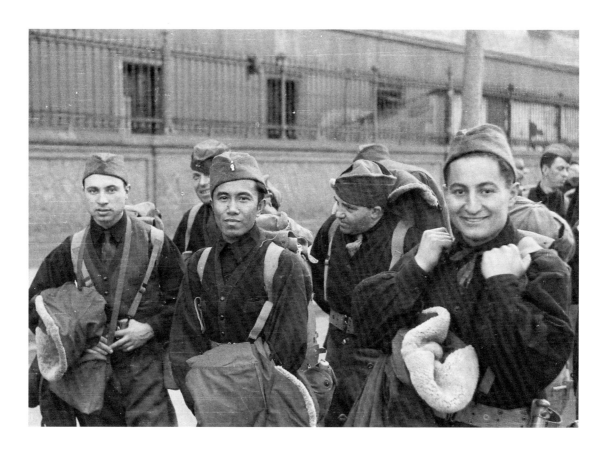

JANUARY 17, 1937, BARCELONA

The Lincoln Battalion was one of the brigades with the youngest volunteers.

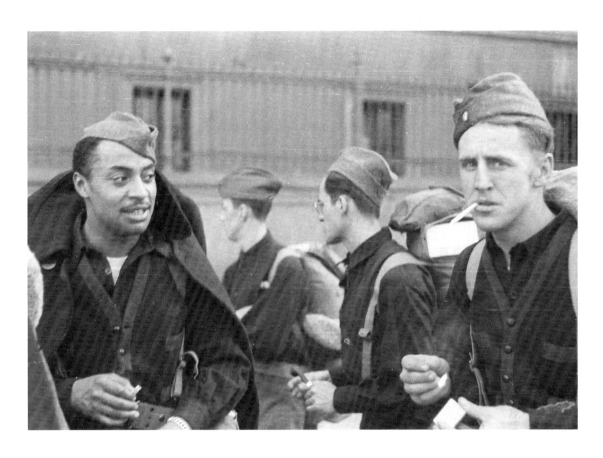

JANUARY 17, 1937, BARCELONA

Lincoln Battalion volunteers on a break. Losses were heavy in the fighting.
About a third of the 2,800 volunteers from America did not return.

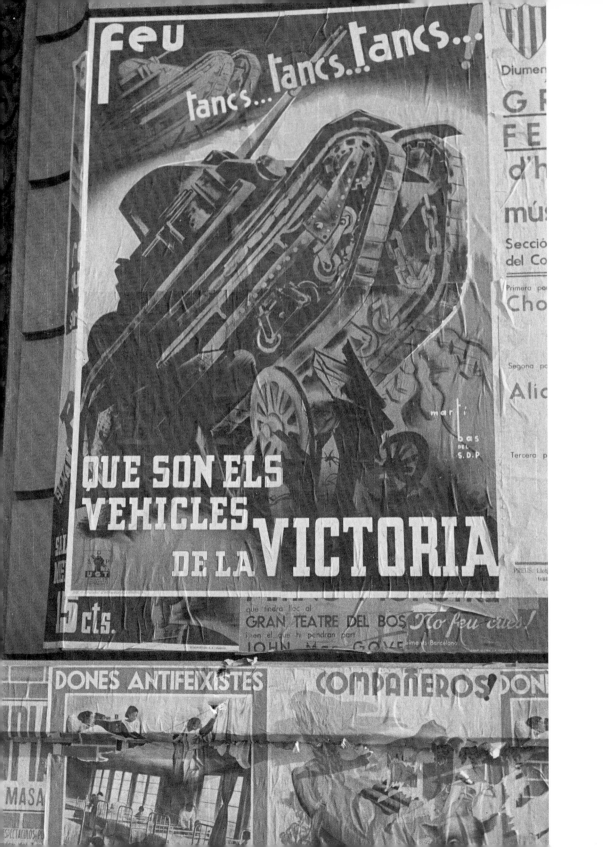

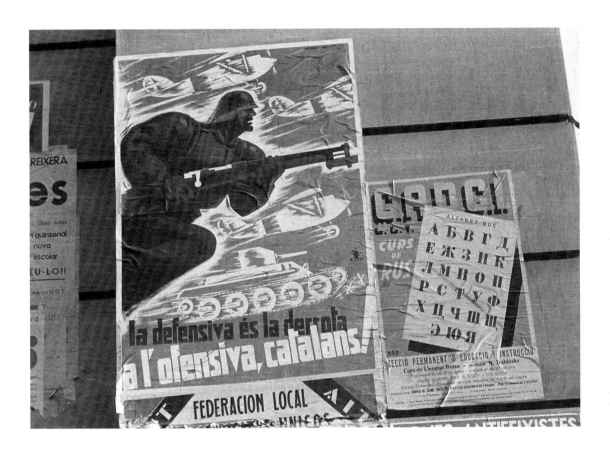

[ABOVE] JANUARY 17, 1937, BARCELONA

Republican propaganda posters inciting Catalans to the war effort.

[LEFT] JANUARY 17, 1937, BARCELONA

Republican propaganda poster reading "Tanks are the vehicles of victory."
These posters were often created by well-known artists.

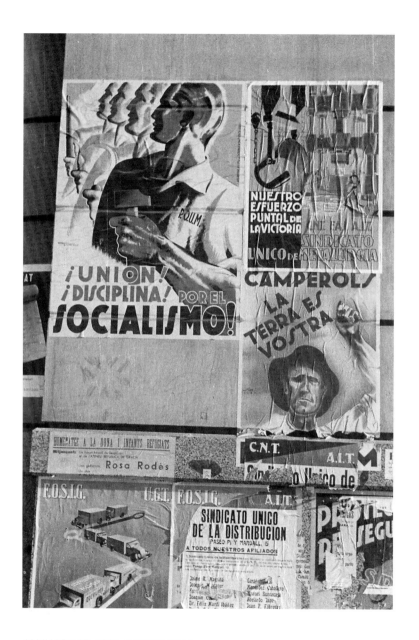

JANUARY 17, 1937, BARCELONA

Propaganda posters of the various trade unions.

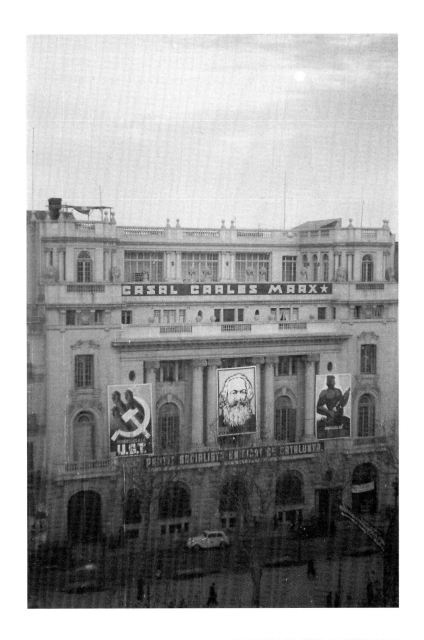

JANUARY 17, 1937, BARCELONA

The Karl Marx building in Barcelona. During the first months the atmosphere was revolutionary. The Soviet Union was the Republic's only staunch ally, Stalin later abandoning interest to prepare for WWII.

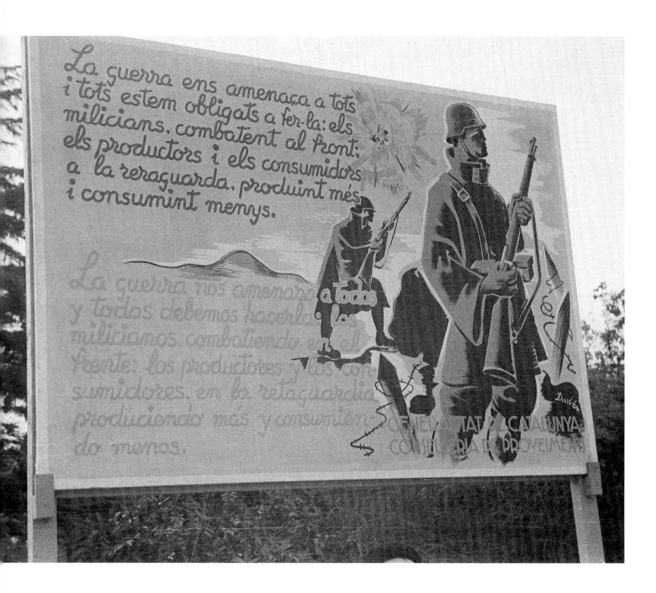

JANUARY 17, 1937, BARCELONA

In the Spanish Republic, posters were often also in the regional
language (here in Catalan on the top).

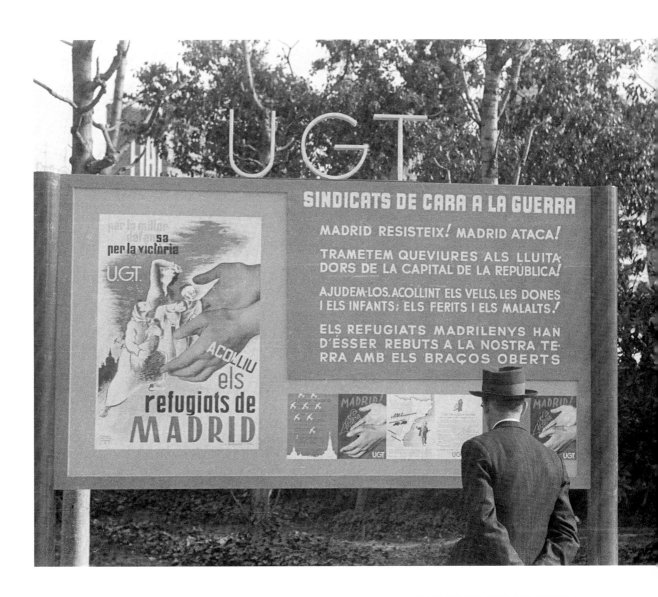

JANUARY 17, 1937, BARCELONA

A UGT trade union poster appealing for help for the refugees
from the siege of Madrid.

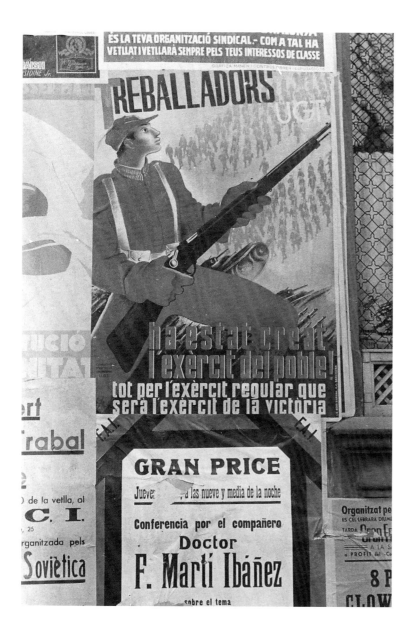

FEBRUARY 5, 1937, BARCELONA

Propaganda poster for the UGT in the Catalan
language: Unió General de Treballadors.

FEBRUARY 5, 1937, BARCELONA

Poster advertising the film *Kronstadt Sailors*, a revisionist history portraying the supposed integration of the anarchists into the Red Army.

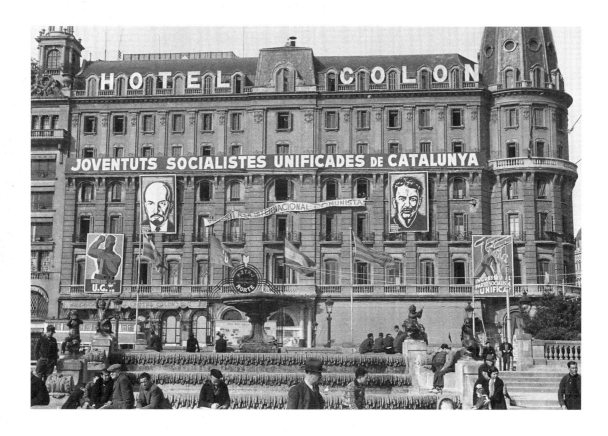

[ABOVE] FEBRUARY 5, 1937, BARCELONA

Hotel Colon was the headquarters of the Partido Socialista Unificado de Cataluña.
Foreign volunteers were vetted here by foreign Communist party officials. The PSUC
headquarters would be central to the May 1937 uprising in Barcelona.

[RIGHT] FEBRUARY 28, 1937, BARCELONA

A Barcelona woman is wearing a political lapel pin of a clenched fist with ¡No pasarán! —
the slogan of the defence of Madrid. Women were heavily involved in the Republican cause.

FEBRUARY 28, 1937, BARCELONA

The newly formed People's Army of the Spanish Republic in a cavalry parade.

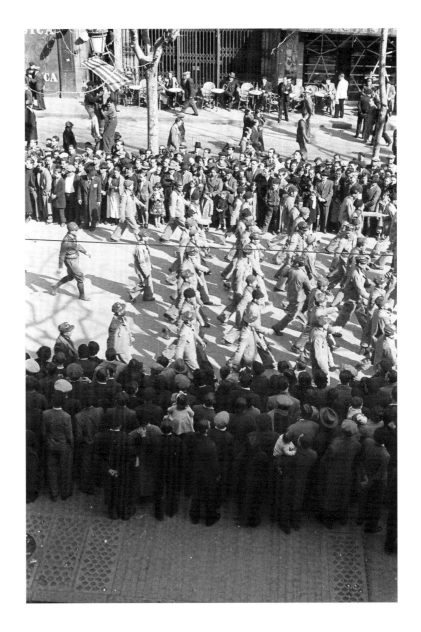

FEBRUARY 28, 1937, BARCELONA

People's Army infantry on parade.

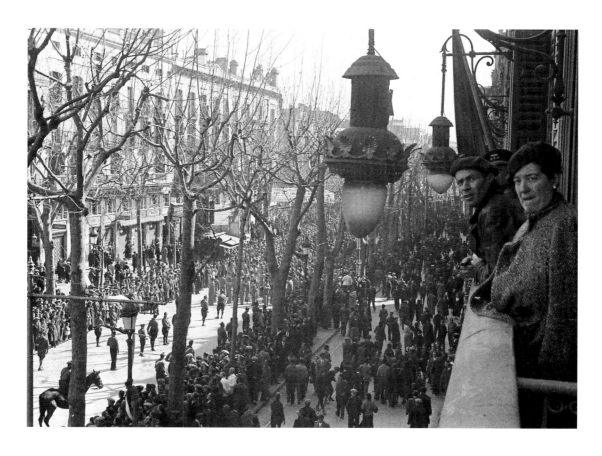

FEBRUARY 28, 1937, BARCELONA

Barcelona citizens looking on at the People's Army parade passing below.

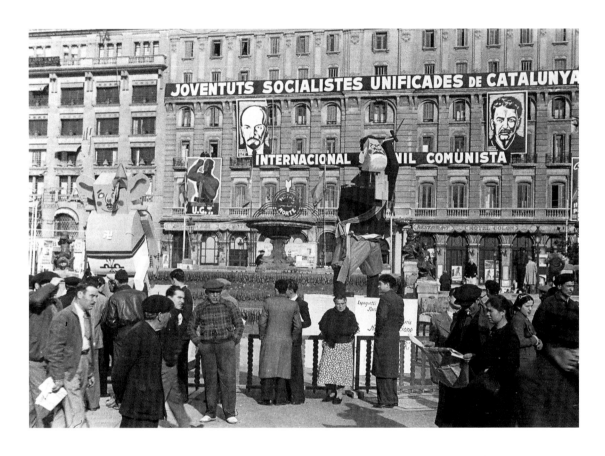

FEBRUARY 28, 1937, BARCELONA

Hotel Colon with pro-Soviet images of Lenin and Stalin and satirical effigies
of Hitler (left) and Mussolini (right). The Spanish Civil war pitted anti-fascist
Germans and Italians fighting their own countrymen sent by Hitler and
Mussolini to underpin Franco's Nationalist Army rebellion.

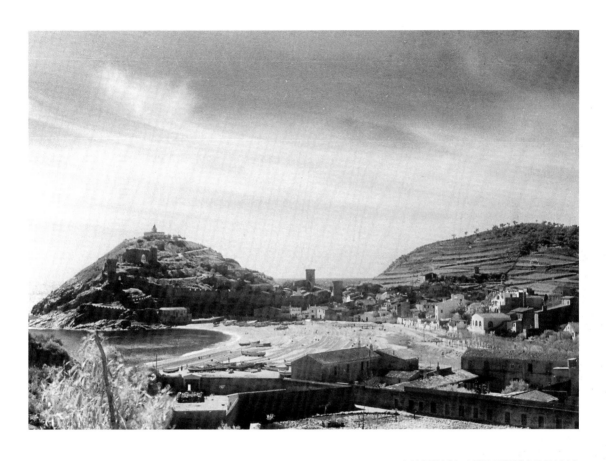

[ABOVE] MARCH 21, 1937, TOSSA DE MAR

Tossa, north of Barcelona, a fishing and agricultural town,
seen here relatively untouched by the war.

[LEFT] MARCH 14, 1937, BARCELONA

Statue of a People's Army Soldier promoting anarchist
and union militia integration.

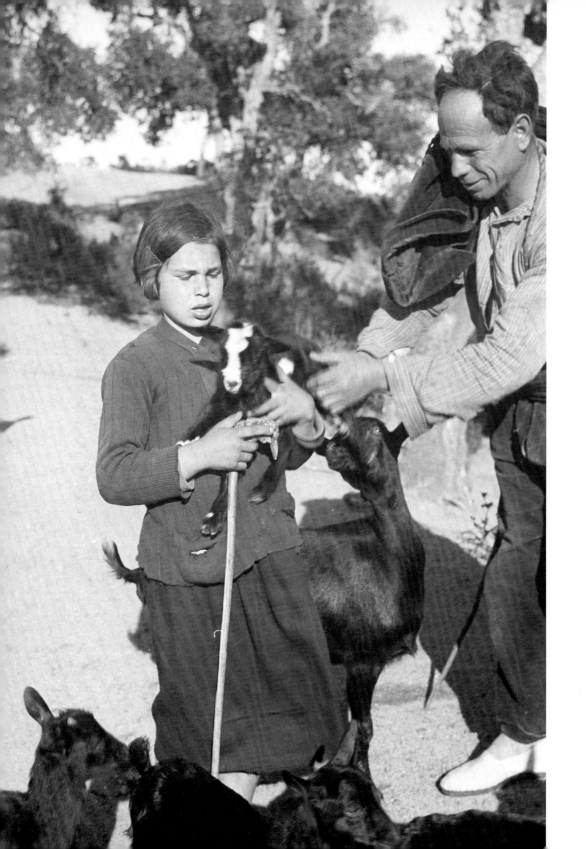

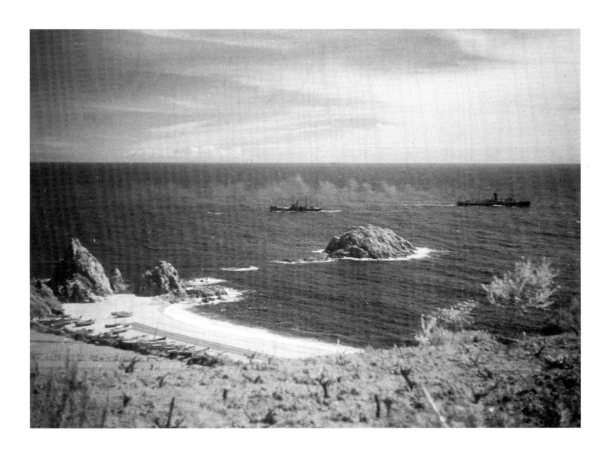

[ABOVE] MARCH 21, 1937, TOSSA DE MAR

The Republican side initially had a naval advantage with more ships.
Later, the Italian and German navies supported Franco's Nationalist side.

[LEFT] MARCH 22, 1937, TOSSA DE MAR

Local girl, with a newborn goat, helping to tend livestock.

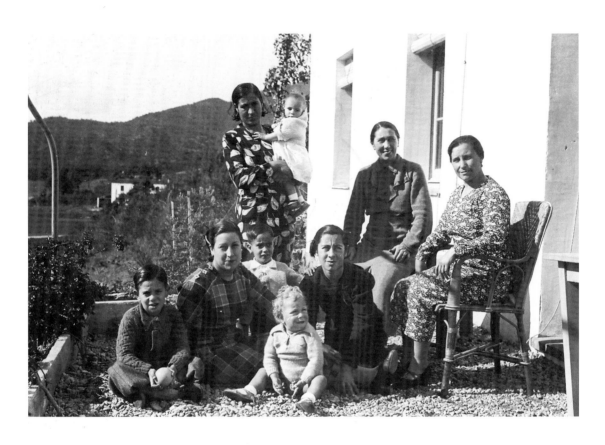

MARCH 22, 1937, TOSSA DE MAR

Portrait of a local family.

MARCH 22, 1937, TOSSA DE MAR

Francisco Robles, a Republican government press officer.

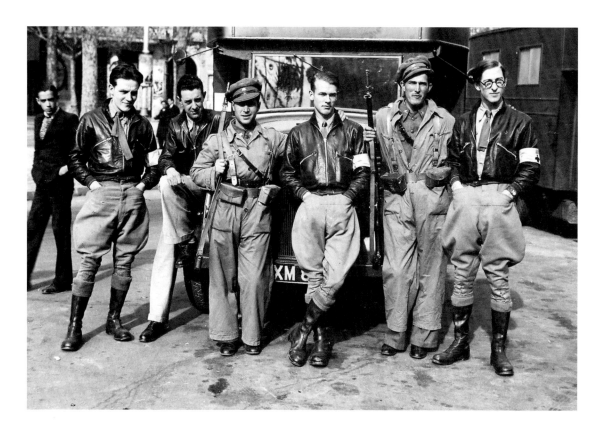

APRIL 2, 1937, BARCELONA

The arrival of BMU ambulances and a new team.

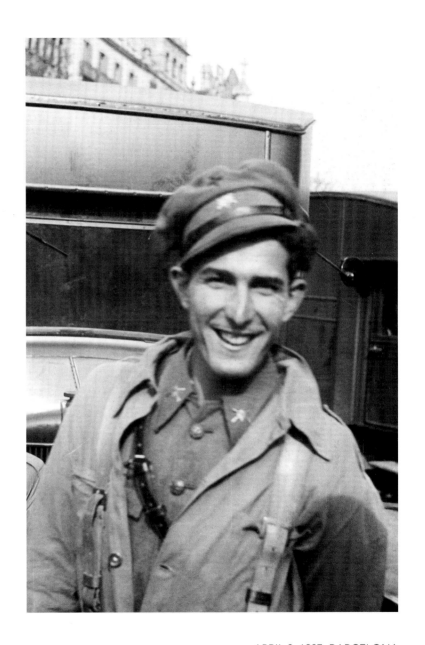

APRIL 2, 1937, BARCELONA

BMU new arrival, Peter Harrison.

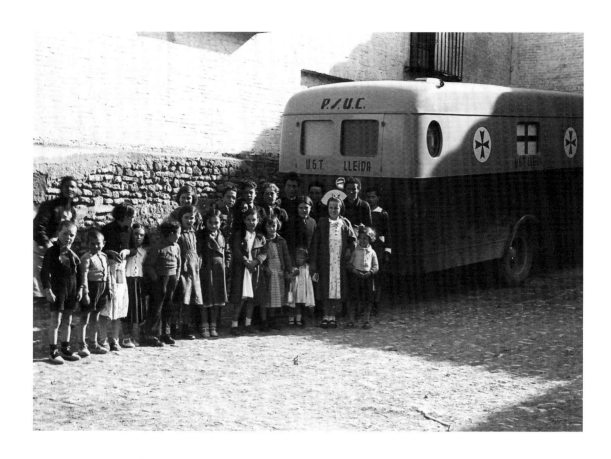

APRIL 3, 1937, POLEÑINO

Local children gathered in front of the BMU hospital on the Aragon front.

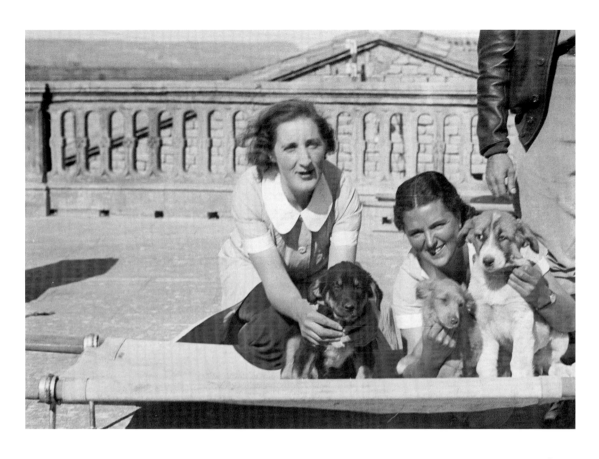

APRIL 3, 1937, POLEÑINO

Nurse Ann Murray and Rosita Davson with their
pets from the BMU hospital.

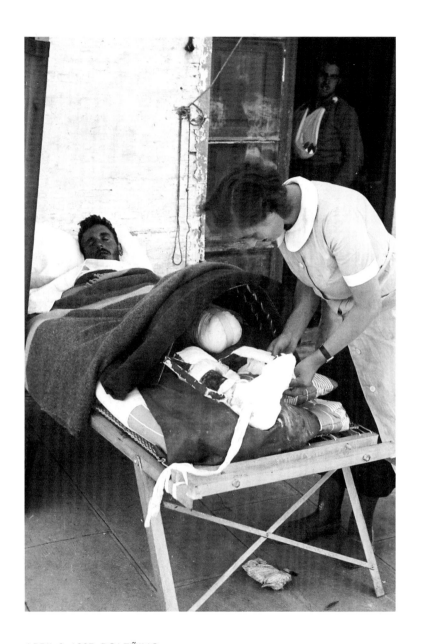

APRIL 3, 1937, POLEÑINO

Nurse tending to a wounded man at the BMU hospital.

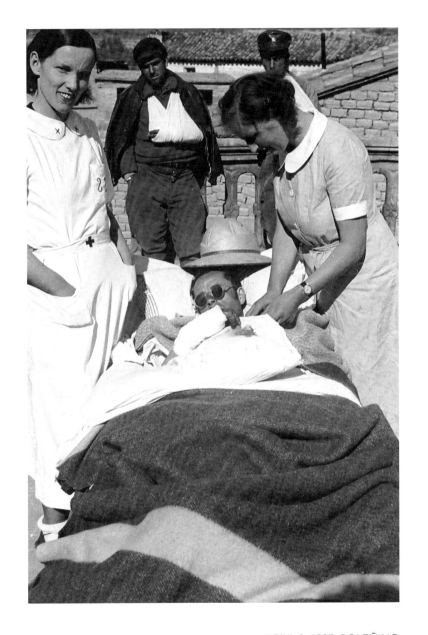

APRIL 3, 1937, POLEÑINO

A convalescing patient outside in the bright sun with
blankets to keep warm on a cool spring day.

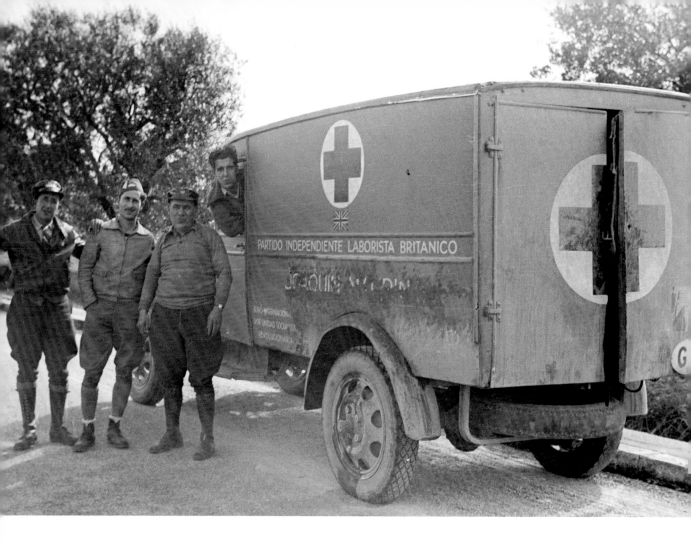

APRIL 4, 1937, POLEÑINO

Volunteers of the British Independent Labour Party (ILP).
George Orwell came to Spain with this group.

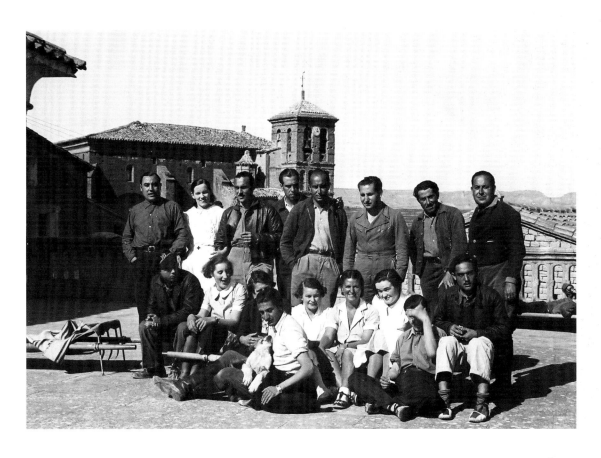

APRIL 3, 1937, POLEÑINO

BMU hospital team.

APRIL 17–19, 1937, MADRID

Every mode of transportation was used in
the war effort, including donkeys.

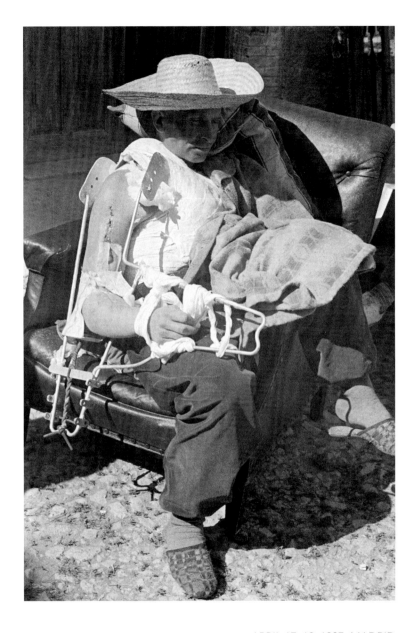

APRIL 17–19, 1937, MADRID

A victim of the first carpet bombing of modern warfare —

with his injured right arm in an elaborate brace.

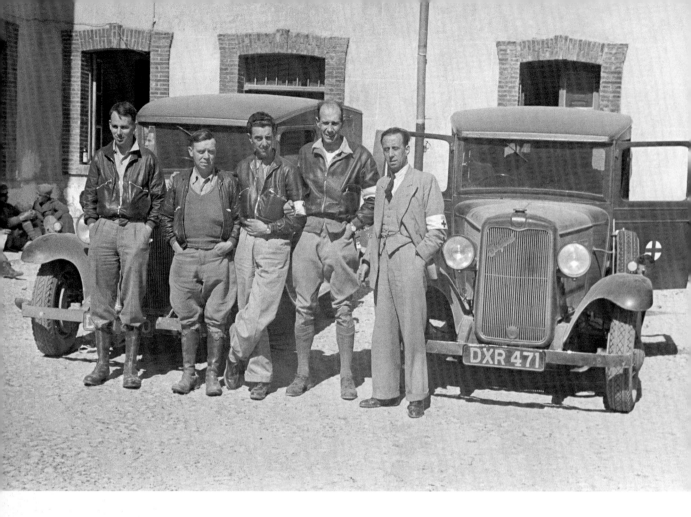

[ABOVE] APRIL 17–19, 1937, MADRID

BMU volunteers in front of their ambulances.

[RIGHT] APRIL 17–19, 1937, MADRID

A BMU team on a tram in besieged Madrid.

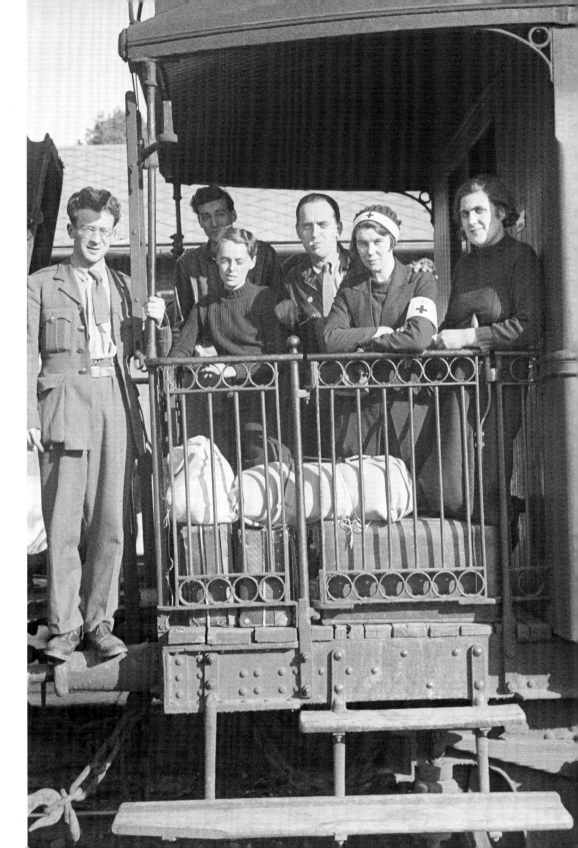

APRIL 20, 1937, TORRELODONES, NEAR MADRID

BMU nurse on a break, relaxing on the steps.

APRIL 20, 1937, TORRELODONES, NEAR MADRID

BMU nurse with convalescing international volunteer.

APRIL 20, 1937, TORRELODONES, NEAR MADRID

BMU hospital staff and recuperating international volunteers.

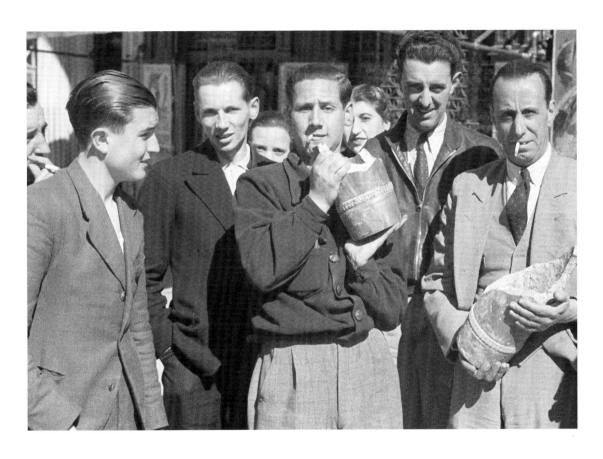

APRIL 21, 1937, MADRID

Civilians holding an exploded shell from the heavy bombardment of the
capital. Suffering huge losses, the population resisted the Nationalist army for
eighteen months, with the help of the international volunteers.

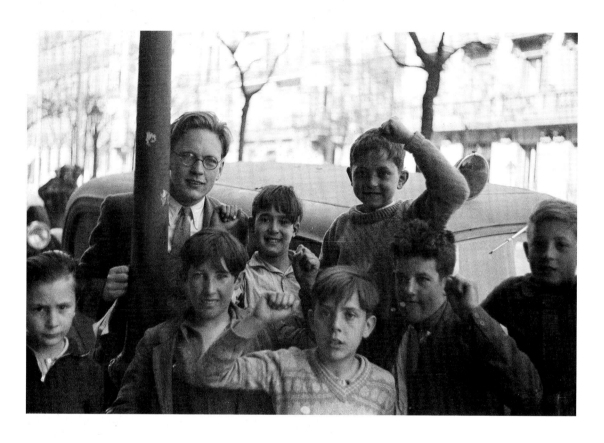

APRIL 21, 1937, MADRID

Alec Wainman, photographer and author, with local
children during the visit of an American journalist.

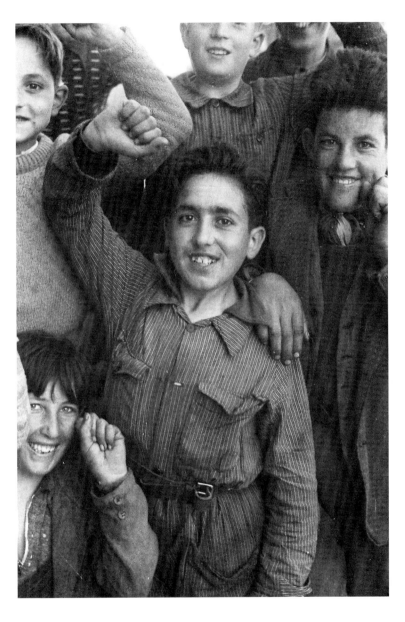

APRIL 21, 1937, MADRID

Happy and defiant children in the besieged capital.

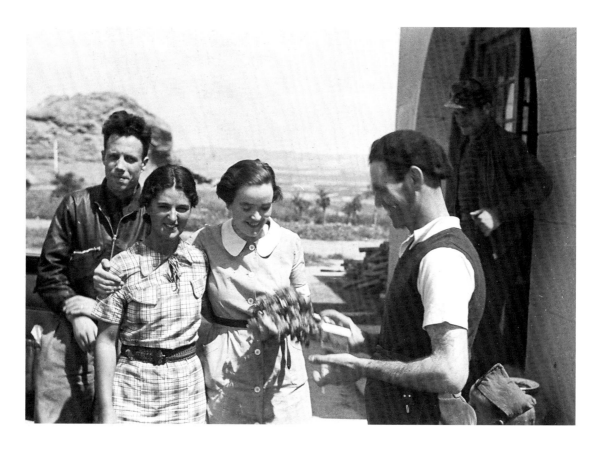

APRIL 28, 1937, POLEÑINO

BMU volunteer Rosita Davson (left) and nurse Margaret Powell (centre).
Margaret was interned in the Argelès-sur-Mer refugee camp in France after
the Civil War, where she was rescued by a Quaker aid group.

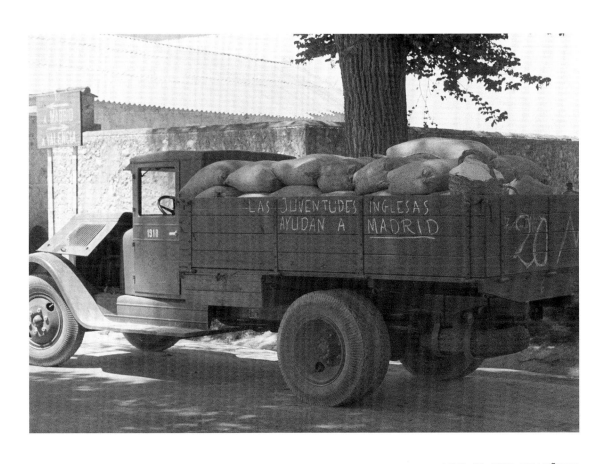

APRIL 28, 1937, POLEÑINO

This truck on the Aragon front bears the slogan
"British youth helps Madrid."

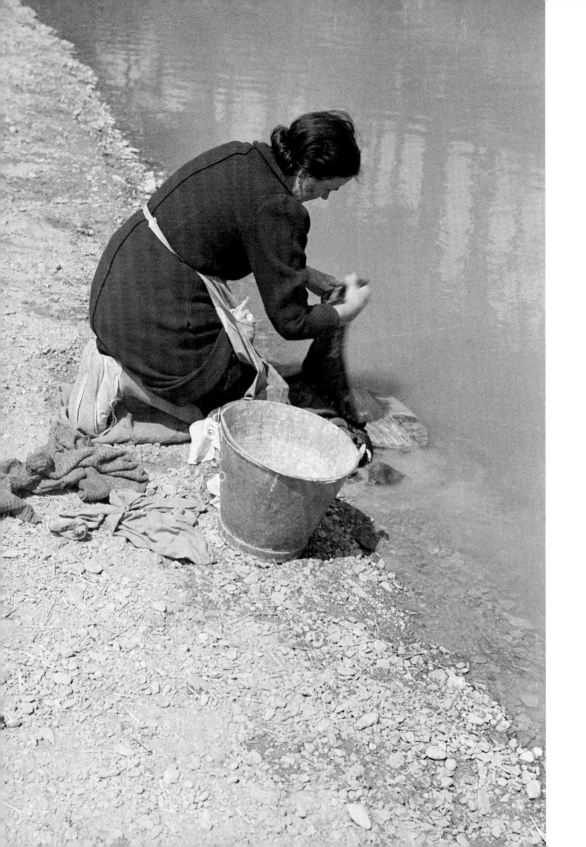

[ABOVE] APRIL 28, 1937, POLEÑINO

A laundry truck was later improvised with whatever machinery was at hand.

[LEFT] APRIL 28, 1937, POLEÑINO

The BMU hospital laundry was initially washed by hand at a nearby river.

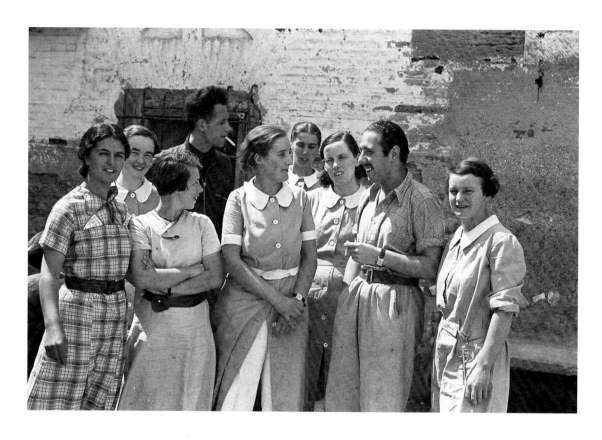

APRIL 28, 1937, POLEÑINO

Catalan surgeon Dr. González Aguiló (front row) ably ran the hospital with the
BMU nurses. (Front row: Rosita Davson, Mary Slater, Ann Murray, Agnes Hodgson;
Back row: Margaret Powell, Ray Poole, Patience Darton and Susan Sutor, who
later married the doctor).

MAY 14, 1937, BARCELONA

American journalist Dick Bennett and his wife Margot on the balcony
outside the apartment where, days before, Alec Wainman had
sought refuge during the May uprising.

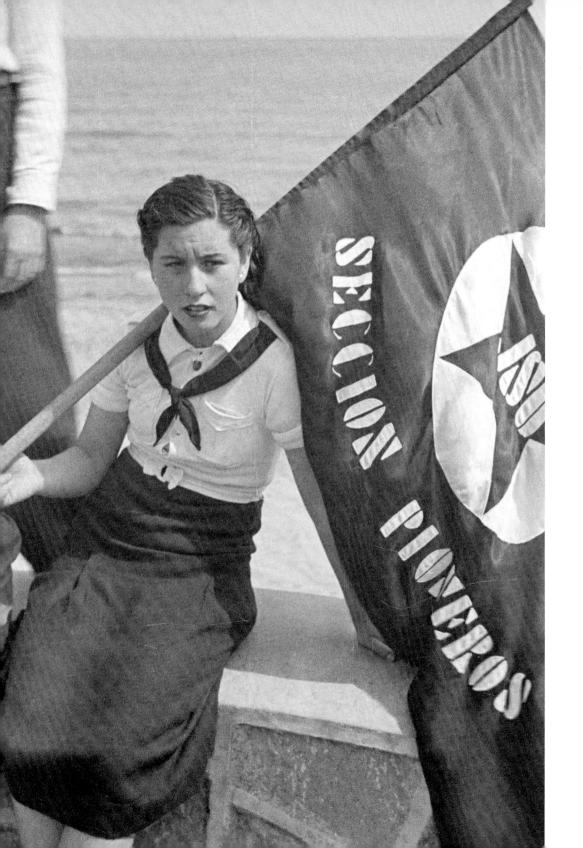

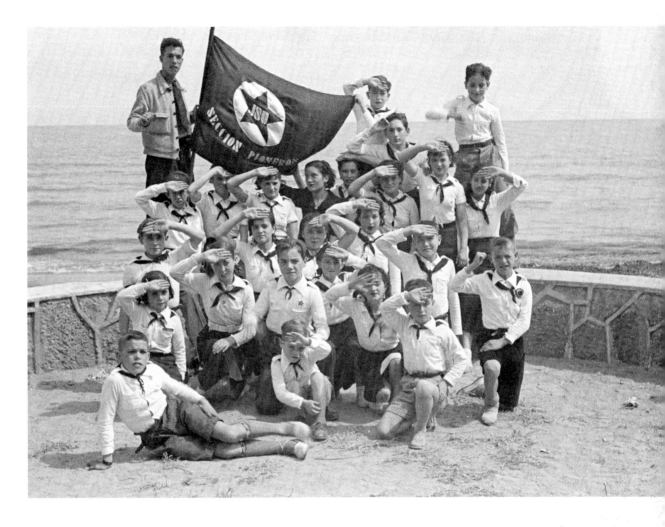

[ABOVE] MAY 18, 1937, BENICÀSSIM

A Sección Pioneros youth group giving their salute on the
Mediterranean, with their flag bearing the JSU star.

[LEFT] MAY 18, 1937, BENICÀSSIM

A young woman with the flag of Sección Pioneros,
a Republican youth organization.

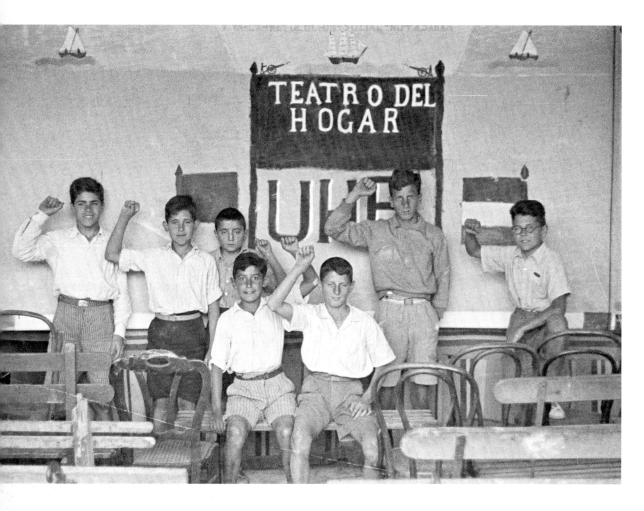

[ABOVE] MAY 18, 1937, BENICÀSSIM

A youth theatre group in Benicàssim giving the Republican salute. Amateur and youth theatre played an important role in the Spanish Republic.

[RIGHT] MAY 18, 1937, BENICÀSSIM

A young boy in the Republican school literacy program. At the beginning of the Second Republic half the Spanish population was illiterate.

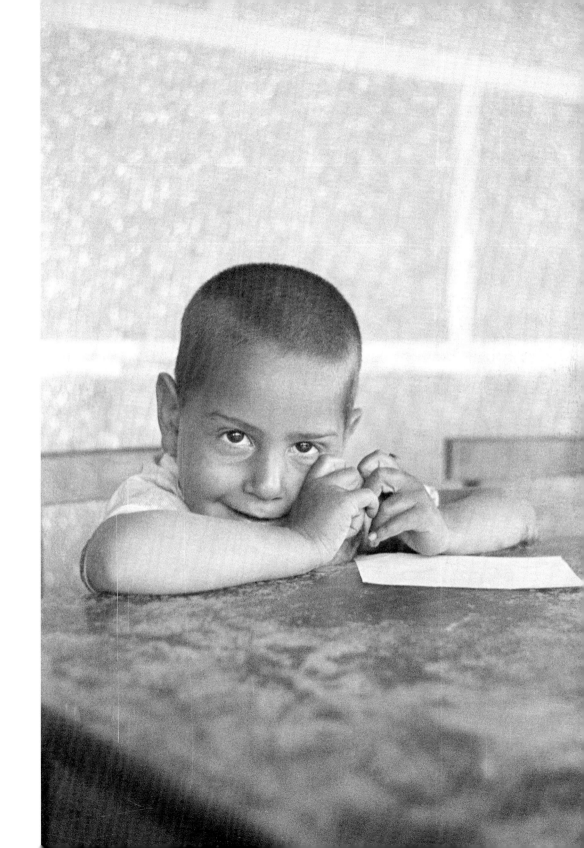

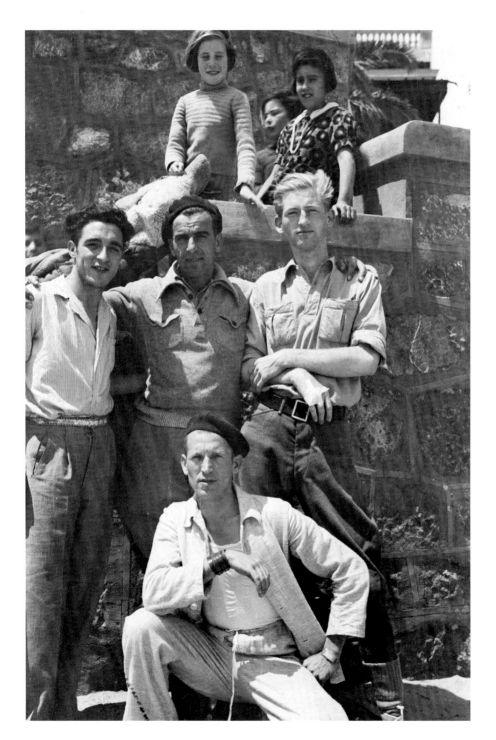

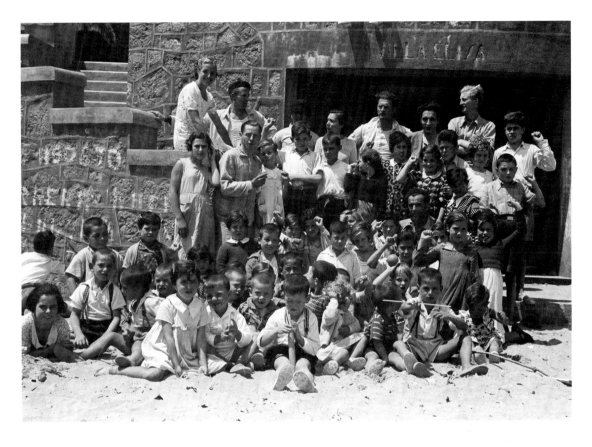

[ABOVE] MAY 18, 1937, BENICÀSSIM

Young children with volunteers at the
International Brigade Hospital.

[LEFT] MAY 18, 1937, BENICÀSSIM

International volunteers from different parts of Europe
with local children on the steps behind.

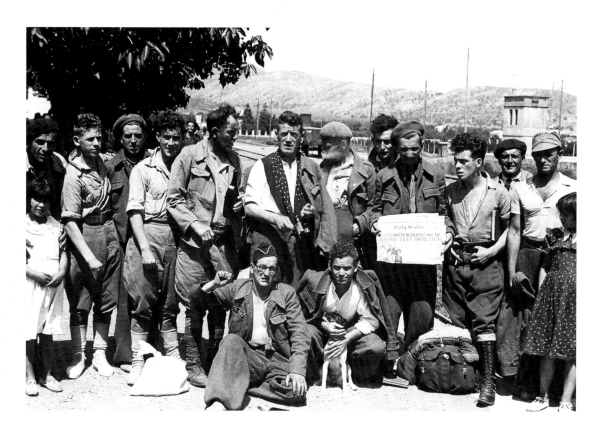

[ABOVE] MAY 18, 1937, BENICÀSSIM

After convalescing at the hospital, the British Battalion
International Brigade members assemble at the train station.

[RIGHT] MAY 18, 1937, BENICÀSSIM

British Battalion members with the Jack Russell hospital mascot,
as they board a train before the Battle of Brunete, fought in July 1937.

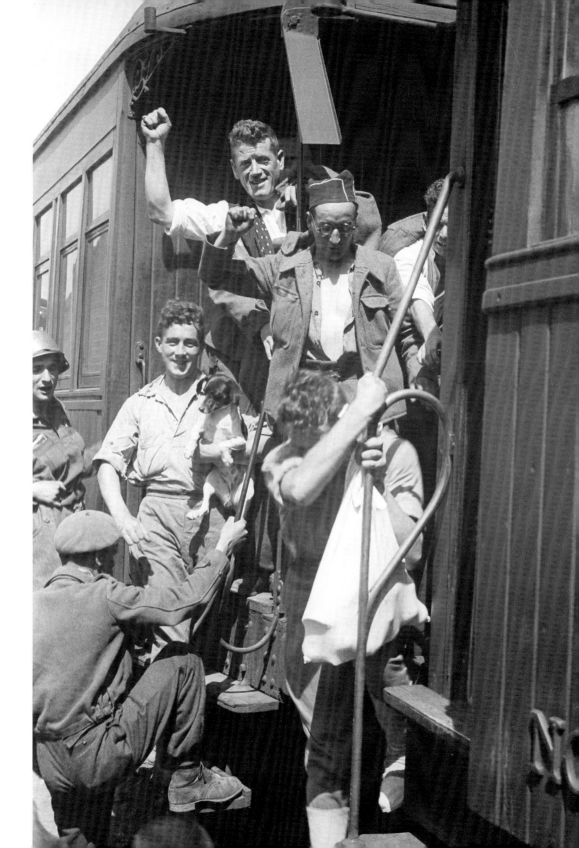

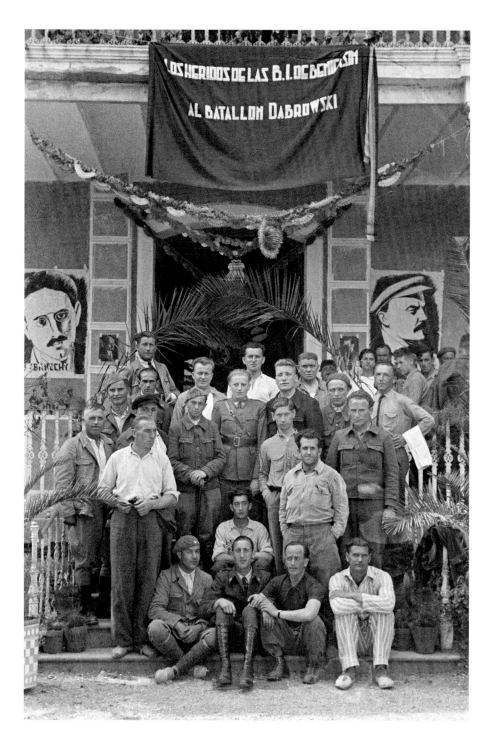

142

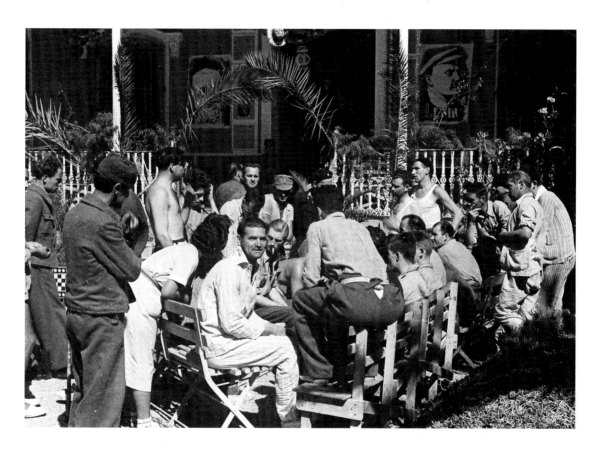

[ABOVE] MAY 18, 1937, BENICÀSSIM

Volunteers convalescing at the International Brigade hospital. A camaraderie
developed among the many volunteers from over fifty countries.

[LEFT] MAY 18, 1937, BENICÀSSIM

The Dabrowski International Brigade Battalion was composed mainly of
Polish members who had been working in France. It also included
some Canadian Croats and Serbs.

MAY 18, 1937, BENICÀSSIM

A moment of recuperation in front of
the International Brigade hospital.

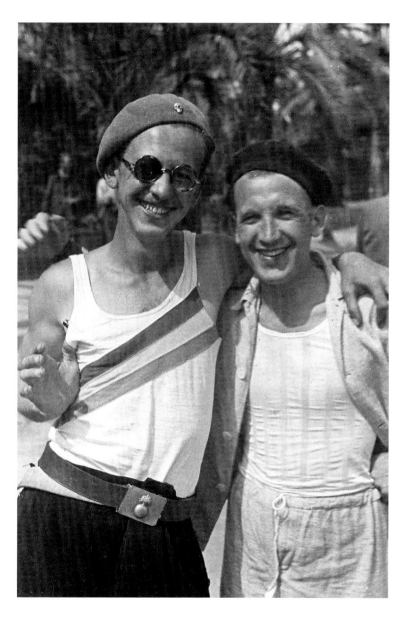

MAY 18, 1937, BENICÀSSIM

Volunteers enjoying some rest and relaxation
on the Costa del Azahar.

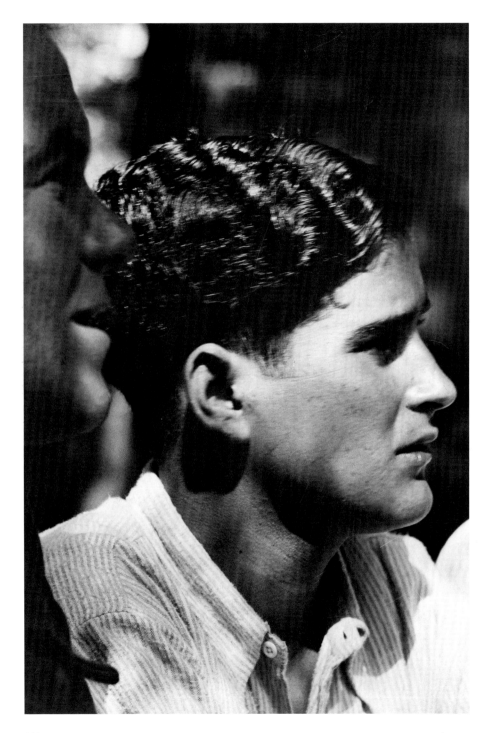

[ABOVE] MAY 18, 1937, BENICÀSSIM

The sizes of the respective posters would
have provoked Stalin's paranoia.

[LEFT] MAY 18, 1937, BENICÀSSIM

An apprehensive volunteer before mobilization.

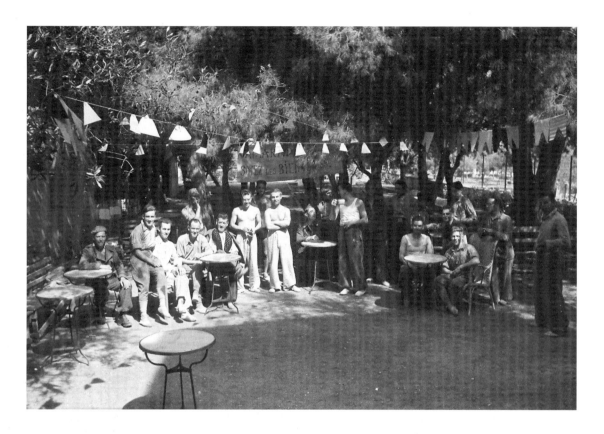

[ABOVE] MAY 18, 1937, BENICÀSSIM

A happy moment during the anarchist and trade union phase of the war,
when there was not yet the pressure of conventional military campaigns.

[RIGHT] MAY 18, 1937, BENICÀSSIM

British author Stephen Spender, a Republican sympathizer,
reading at the International Brigade Hospital.

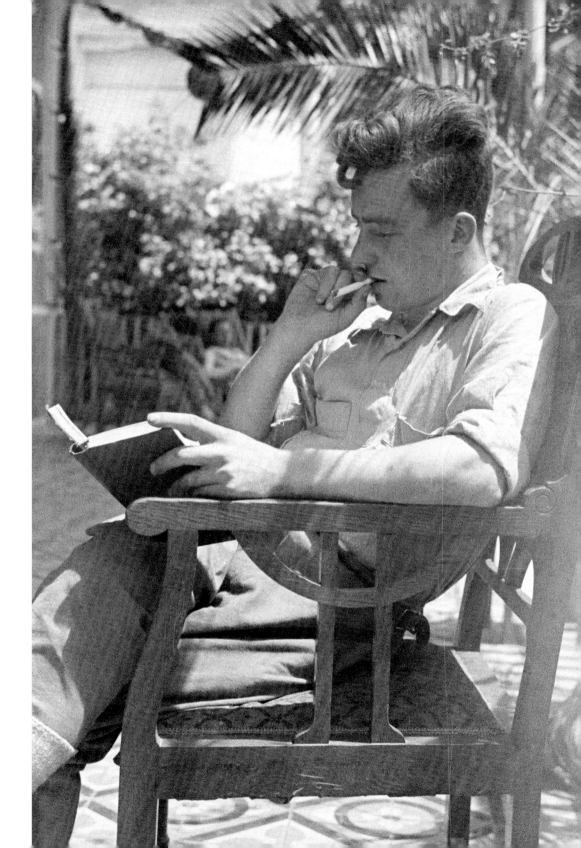

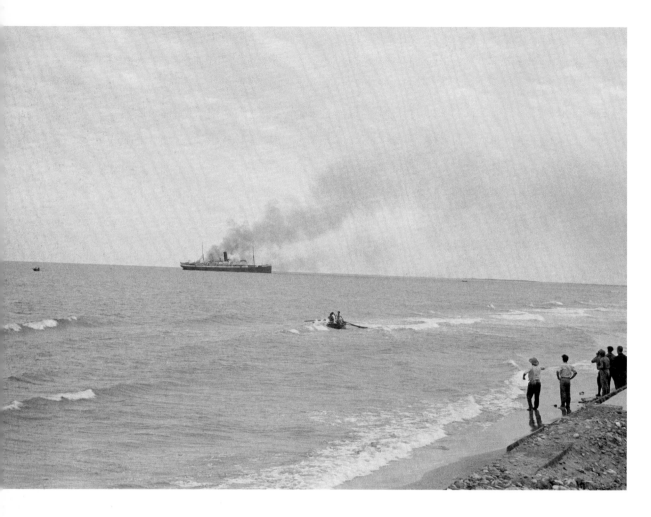

MAY 19, 1937, BENICÀSSIM

The vessel SS *Legazpi* shortly after being bombed by Franco's Nationalist planes coming from the Italian air base on Majorca.

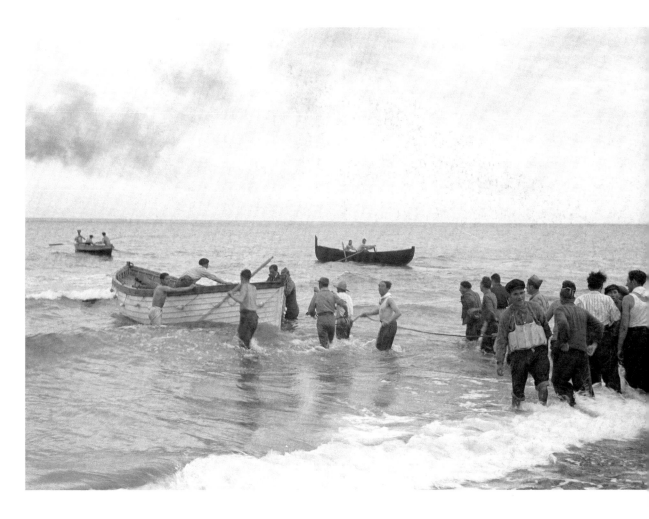

MAY 19, 1937, BENICÀSSIM

Lifeboats from the bombed SS *Legazpi* arriving
on shore with local people helping in the rescue.

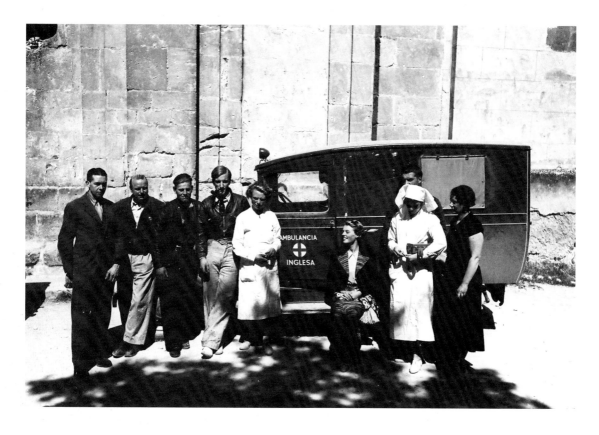

[ABOVE] MAY 23, 1937, HUETE

BMU hospital team with their newly arrived ambulance
with the insignia "Ambulancia Inglesa."

[RIGHT] MAY 23. 1937, HUETE

A lone nurse in her full uniform in the BMU hospital.

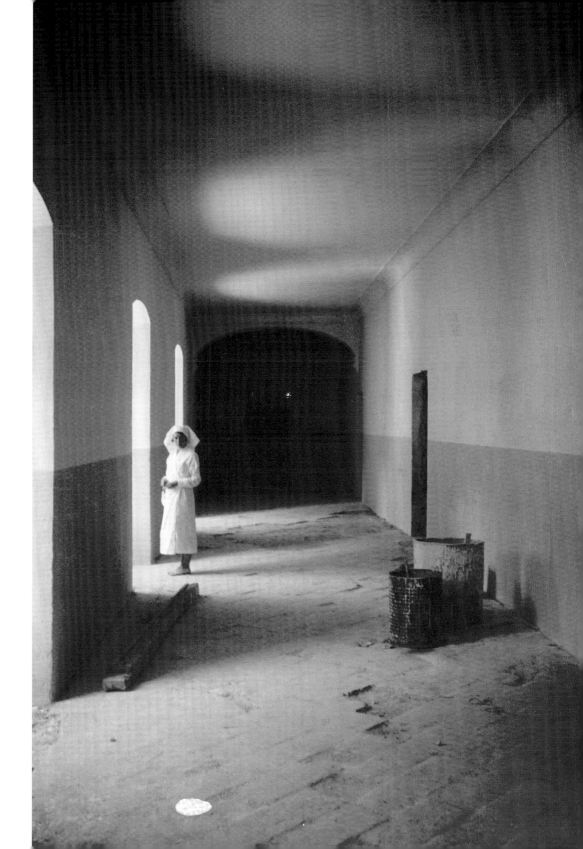

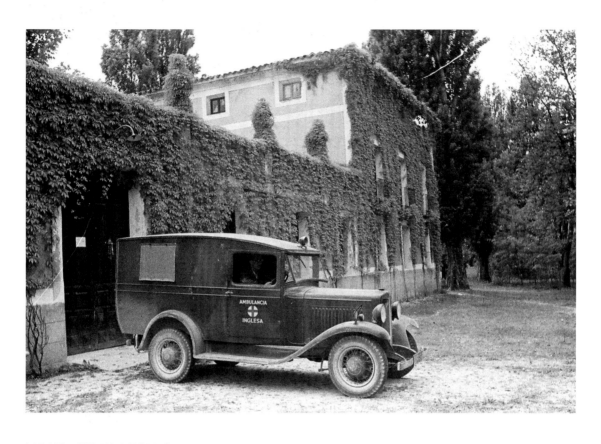

MAY 25, 1937, VALDEGANGA

Ambulance leaving the BMU hospital building.

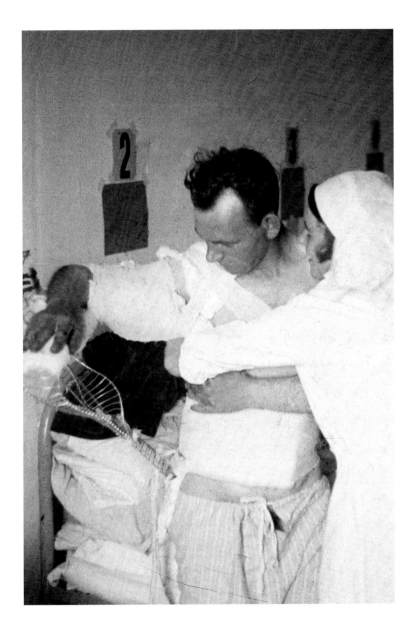

MAY 25, 1937, VALDEGANGA

Nurse bandaging a patient's injuries
at the BMU hospital.

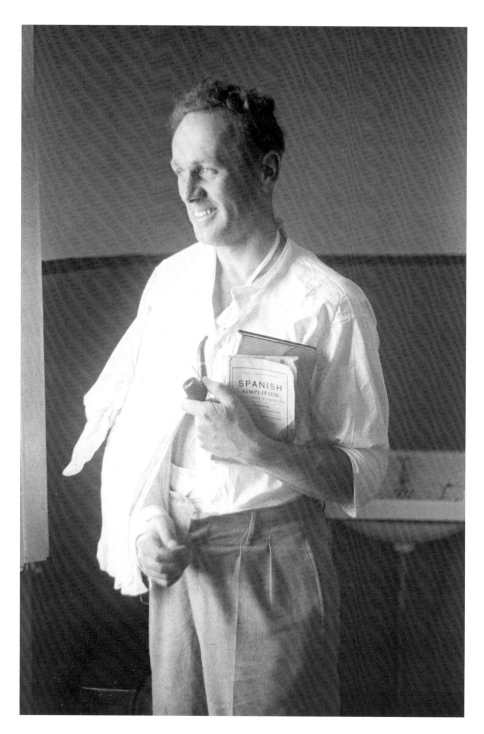

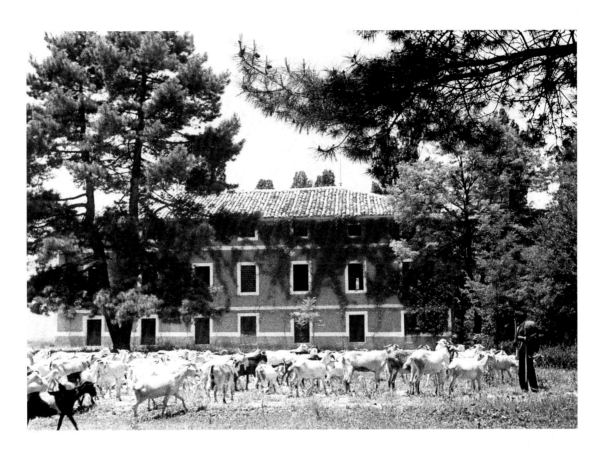

[ABOVE] JUNE 15, 1937, HUETE

A large rural building, seen here with a herd of goats,
which was soon to become a BMU hospital.

[LEFT] JUNE 6, 1937, VALDEGANGA

Wogan Philipps, Second Baron Milford, with his *Spanish
Simplified* guide, recuperating at the BMU hospital.

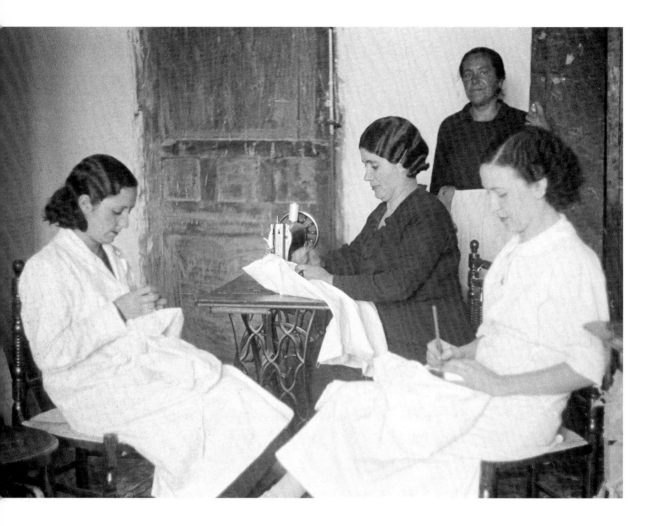

JUNE 15, 1937, HUETE

More chores after a full day of nursing.

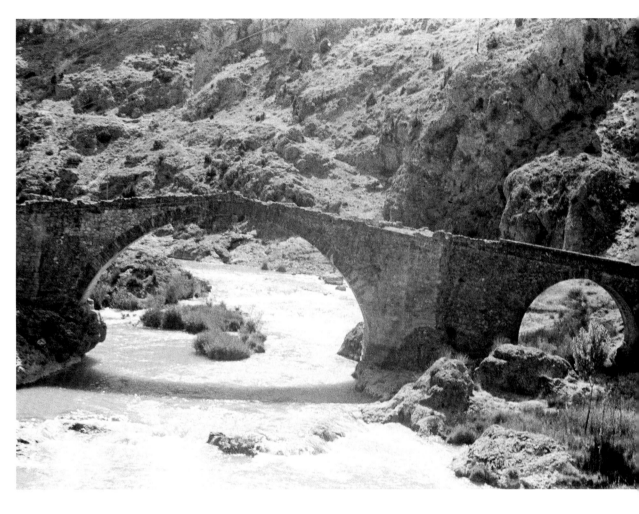

JUNE 28–JULY 11, 1937, VALDEGANGA

Stark landscape with a stone bridge near Valdeganga.

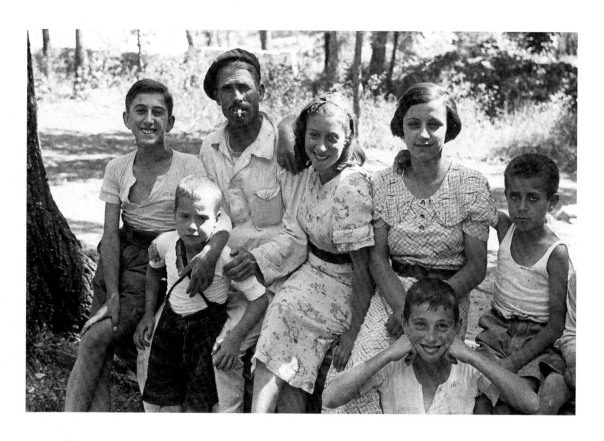

[ABOVE] JUNE 28–JULY 11, 1937, VALDEGANGA

A contented local family in the countryside.

[RIGHT] JUNE 28–JULY 11, 1937, VALDEGANGA

A local boy seemingly untouched by the war.

[ABOVE] JUNE 28–JULY 11, 1937, VALDEGANGA

Two women collecting firewood, of which there
was a continual shortage.

[RIGHT] JUNE 28–JULY 11, 1937, VALDEGANGA

A donkey was a prized possession in the local villages.

[ABOVE] JULY 16–31, 1937, VALDEGANGA

Children of Valdeganga with smiles even in wartime.

[LEFT] JULY 16–31, 1937, VALDEGANGA

A smiling local girl.

[ABOVE] JULY 16–31, 1937, VALDEGANGA

Local children from different backgrounds.

[RIGHT] JULY 16–31, 1937, VALDEGANGA

A farm worker takes a break from hard
work on the land.

JULY 16–31, 1937, VALDEGANGA

A local farmer with his two oxen pulling
a cartload of hay.

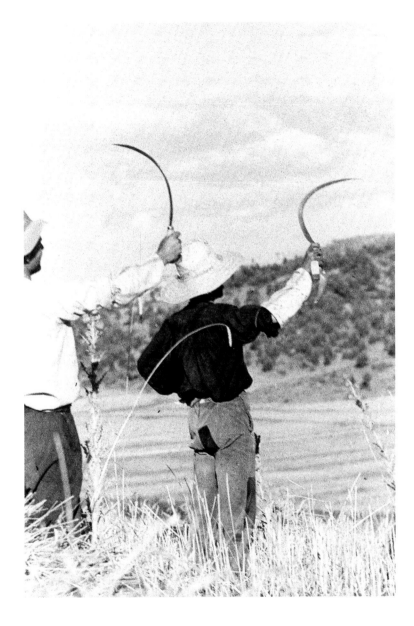

JULY 16–31, 1937, VALDEGANGA

Farm workers with their sickles
raised in salute.

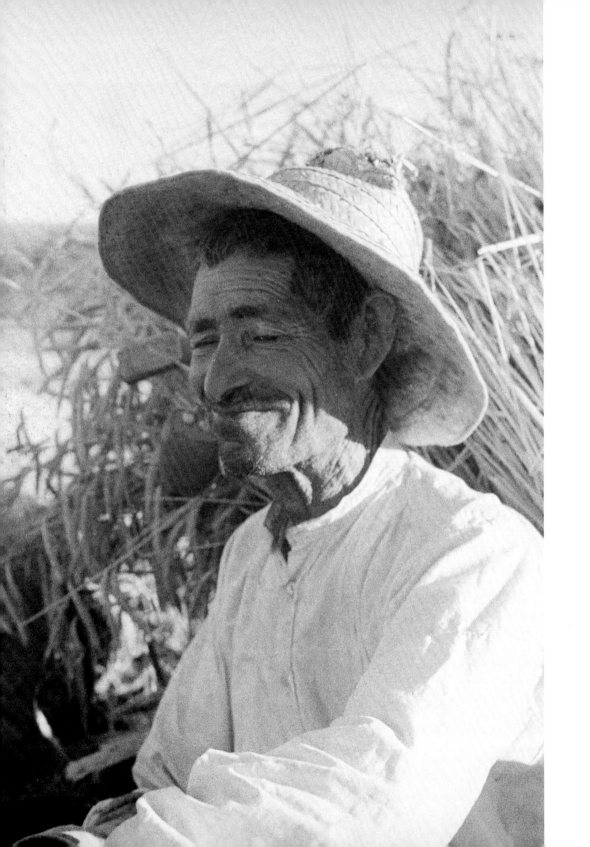

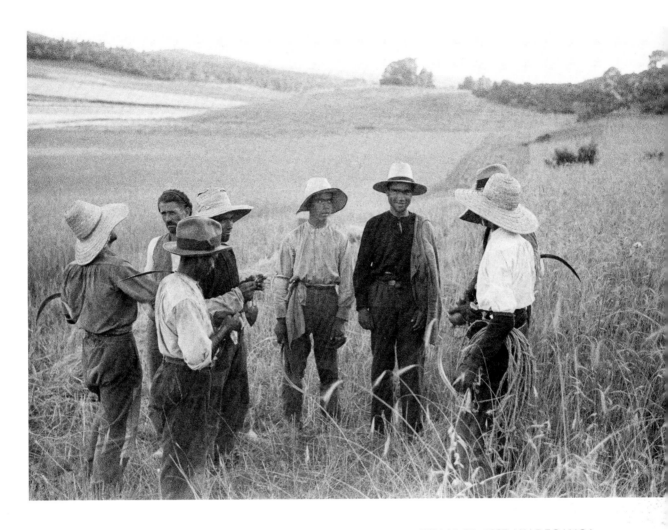

[ABOVE] JULY 16–31, 1937, VALDEGANGA

Farmers chatting in the fields.

[LEFT] JULY 16–31, 1937, VALDEGANGA

A worker takes a break in the sunshine.

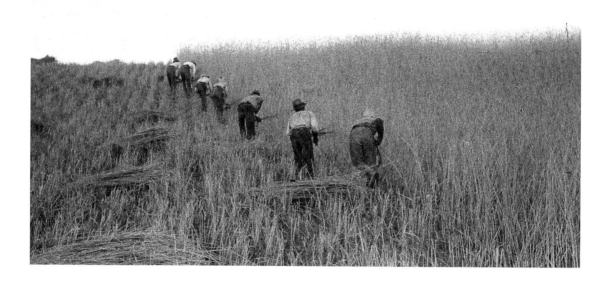

[ABOVE] JULY 16–31, 1937, VALDEGANGA

Harvest time, with the work done often by hand.

[RIGHT] JULY 16–31, 1937, VALDEGANGA

Threshing in the fields.

[ABOVE] JULY 16–31, 1937, VALDEGANGA

Valdeganga looking peaceful.

[LEFT] JULY 16–31, 1937, VALDEGANGA

A local man pausing in his work on the land.

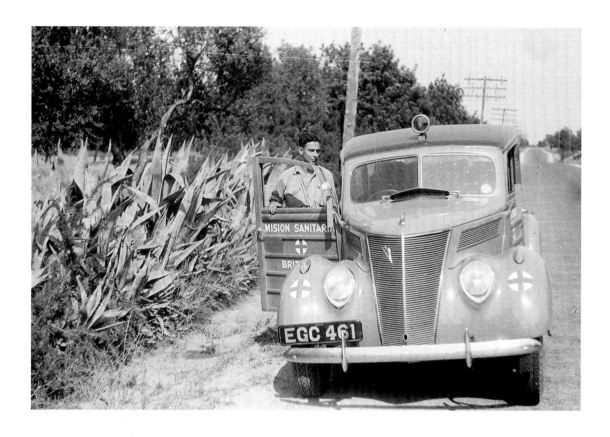

[ABOVE] SEPTEMBER 5, 1937, CROSSING FRANCE

A new BMU "Misión Sanitaria" in France en route to Spain.

[RIGHT] SEPTEMBER 15, 1937, UCLÉS

This BMU hospital was in a former Jesuit monastery run
by Catalan doctors with British support staff. The Jesuits
were expelled from Republican Spain in 1932.

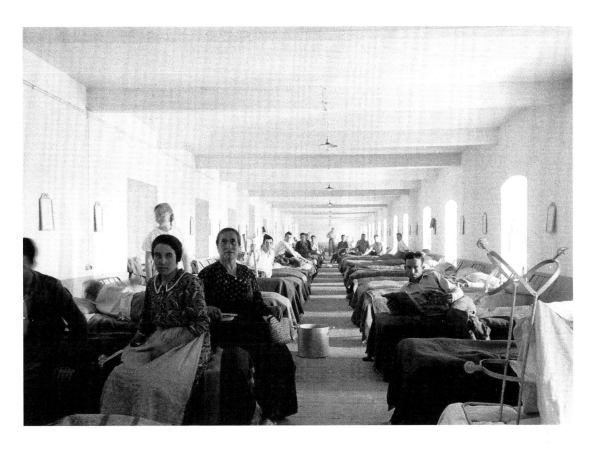

[ABOVE] SEPTEMBER 15, 1937, UCLÉS

A large, well-functioning hospital ward.

[LEFT] SEPTEMBER 15, 1937, UCLÉS

Patient standing on the grand staircase
in Uclés Hospital.

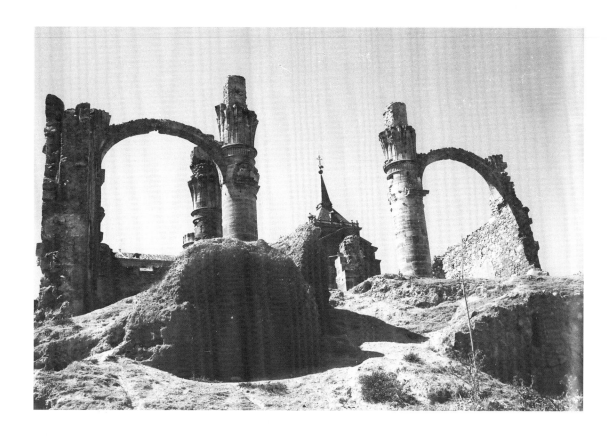

[ABOVE] SEPTEMBER 15, 1937, UCLÉS

View of the hospital spire with partial ruins
of the monastery in front.

[RIGHT] SEPTEMBER 15, 1937, UCLÉS

Stephen Spender looking down at the view
from the hospital tower.

[ABOVE] SEPTEMBER 28, 1937, ALACUAS

Visiting delegation to the women's prison. Alec Wainman, behind the camera, is now in his new position of press officer with the Ministry of State in the Spanish Republic.

[LEFT] SEPTEMBER 28, 1937, ALACUAS

Warden working at the women's prison near Valencia.

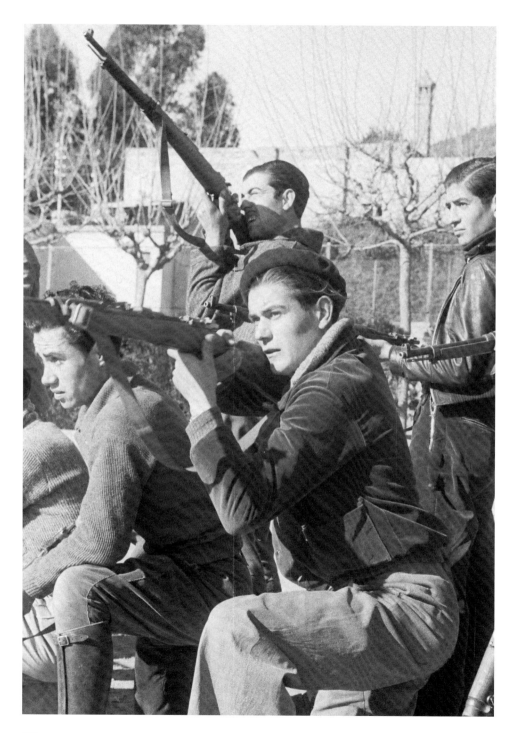

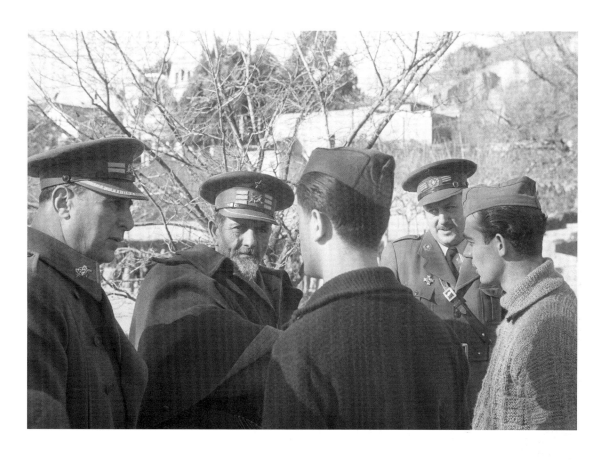

[ABOVE] JANUARY 14, 1938, BARCELONA

High-ranking Republican officers in discussion with trainees.

[LEFT] JANUARY 14, 1938, BARCELONA

A number of men and a woman engaged in arms-training exercises.

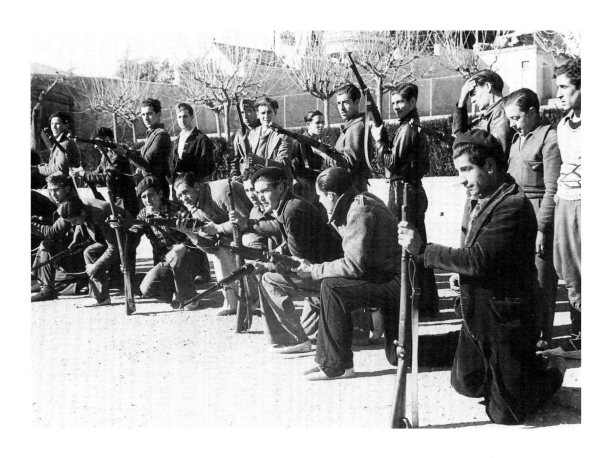

JANUARY 14, 1938, BARCELONA

Young recruits in military training.

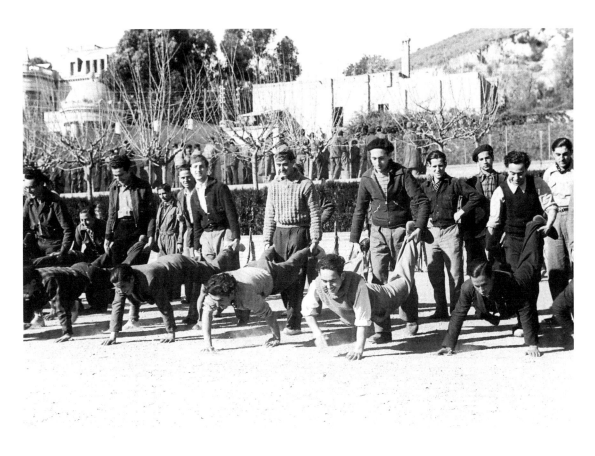

JANUARY 14, 1938, BARCELONA

Trainees enjoying their athletic exercises.

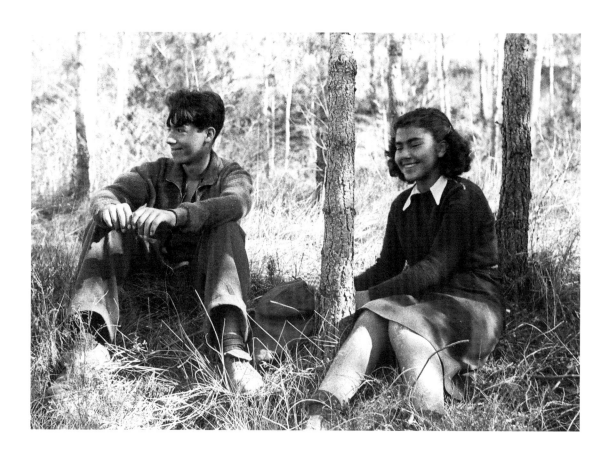

FEBRUARY 6, 1938, MONTSERRAT

A young couple enjoying some quiet
time in the countryside.

FEBRUARY 6, 1938, MONTSERRAT

Children playing on a creatively designed cart
built for them by volunteers.

[ABOVE] FEBRUARY 12, 1938, MONTSERRAT

Landscape around Montserrat.

[LEFT] FEBRUARY 11, 1938, ARAN VALLEY, PYRENEES

A war industry factory supporting the 43rd Division, who were operating mainly on skis used to access the alpine regions.

[ABOVE] FEBRUARY 12, 1938, MONTSERRAT

Even in a war-torn region one can find beauty.

[RIGHT] APRIL 10, 1938, BARCELONA

Young recruits undergoing basic training organized
by the Ministry of State.

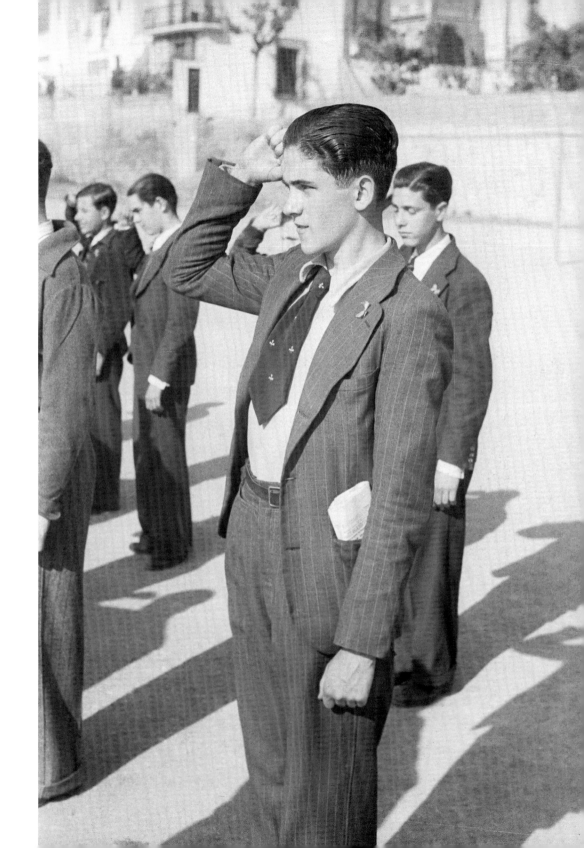

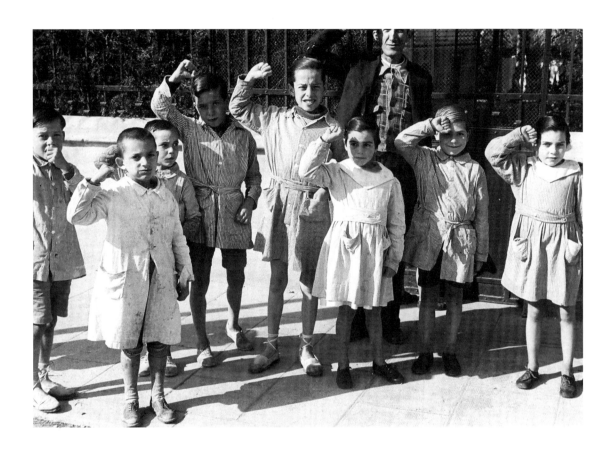

APRIL 10, 1938, BARCELONA

Children performing their own version
of basic training.

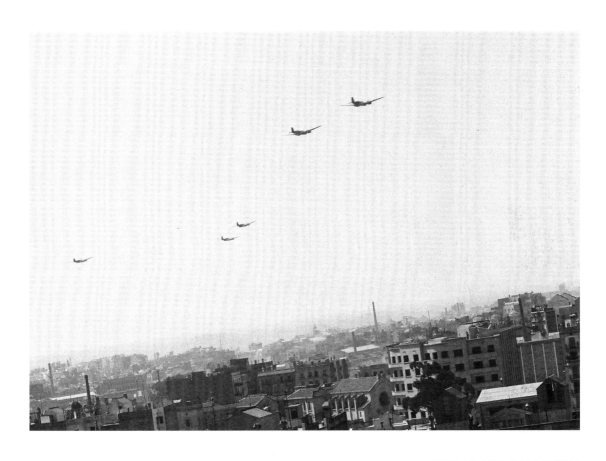

APRIL 10, 1938, BARCELONA

Republican planes over Barcelona. The Republican Air Force began
with obsolete French aircraft. Only later did they receive Soviet planes.
The Republican pilots came from the Soviet Union, the USA,
Yugoslavia and France, countries that were later allies in WWII.

MAY 8, 1938, SABINOSA, NEAR BARCELONA

A BMU mobile X-ray unit at Sabinosa.

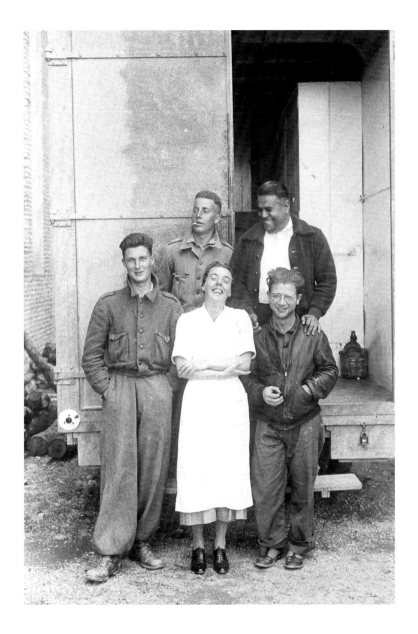

MAY 8, 1938, SABINOSA

BMU team behind the mobile X-ray truck.

MAY 8, 1938, SABINOSA

Propaganda poster calling for a national union. The poster depicts
soldiers and nurses. Prime Minister Juan Negrín is shown top-middle
with Catalonian leader Lluís Companys on the right.

MAY 8, 1938, SABINOSA

Propaganda poster of the JSU (Juventudes Socialistas Unificadas — Unified Socialist Youth), which was under Communist control.

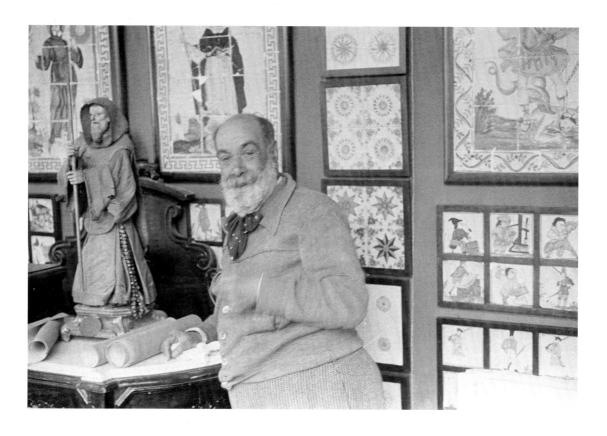

[ABOVE] MAY 8, 1938, BARCELONA

Catalan painter, Joaquim Mir, in his home.

[RIGHT] MAY 8, 1938, BARCELONA

Joaquim Mir in his garden, drinking
from a *porrón*.

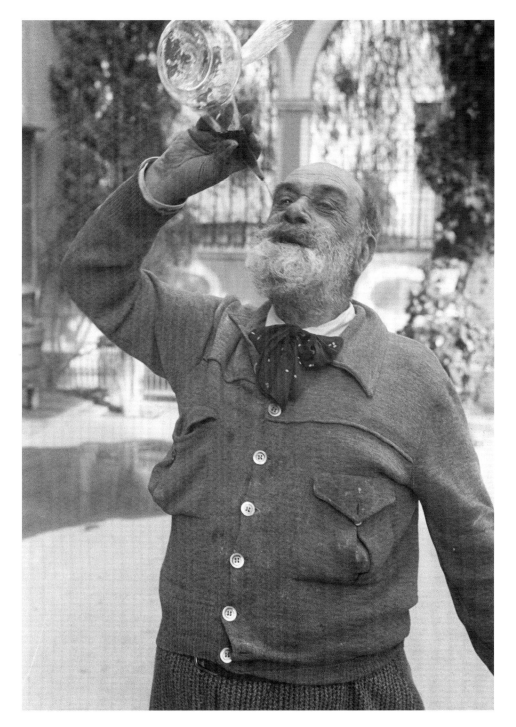

MAY 22, 1938, BARCELONA

Basque folklore performance honouring
women leaders of the war industry.

MAY 22, 1938, BARCELONA

Women executives of the war
industry receiving bouquets.

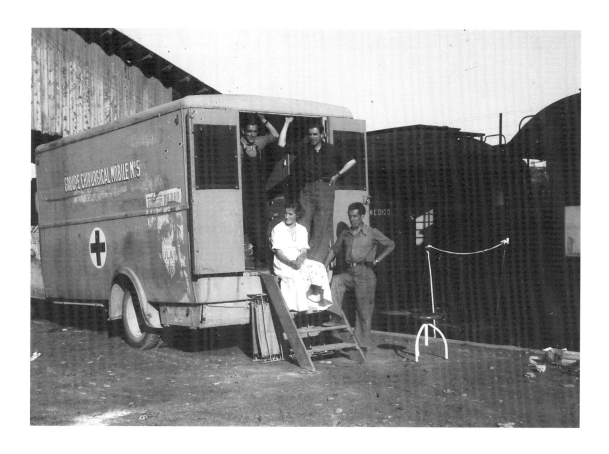

MAY 29, 1938, NEAR LLEIDA

Nurse Ann Murray from Scotland sitting on a mobile
surgical truck next to the train station. Her brother was
also a volunteer in the British Battalion.

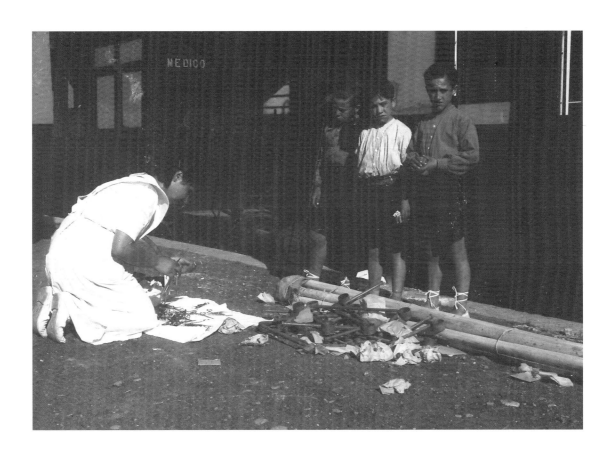

MAY 29, 1938, NEAR LLEIDA

Ann Murray sorting her medical implements
on the pavement in front of the hospital train.
Local children look on.

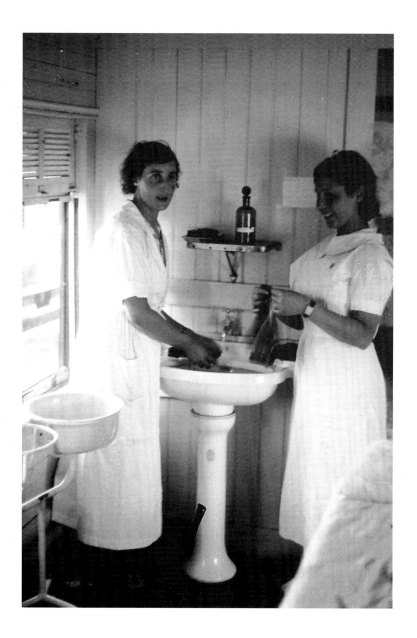

MAY 29, 1938, NEAR LLEIDA

Nurses washing up on the hospital train.

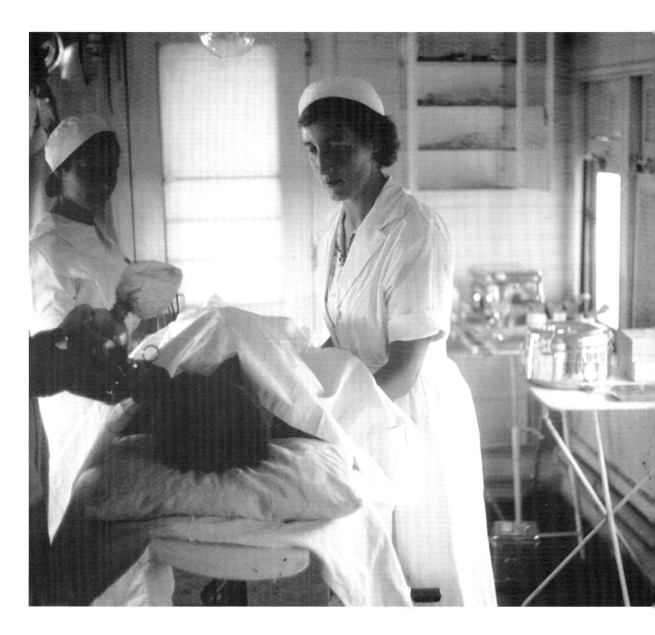

MAY 29, 1938, NEAR LLEIDA

Operating on the hospital train.

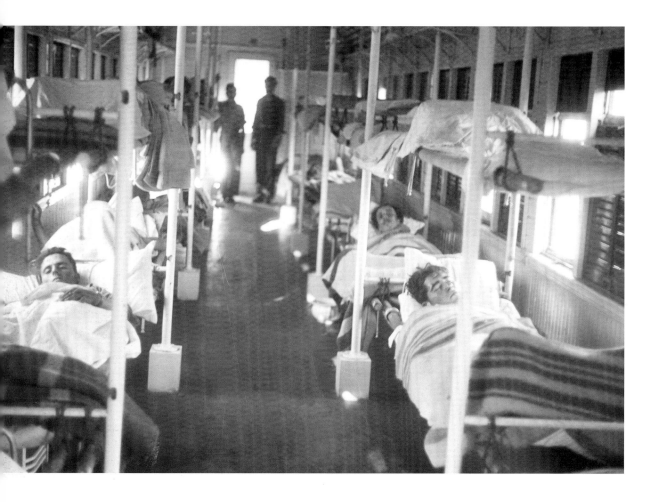

MAY 29, 1938, NEAR LLEIDA

Trains were used for evacuating the wounded from a field dressing
station in Pompenillo to the hospital in Grañén. From there a daily
train took those fit to travel to Lleida and Barcelona.

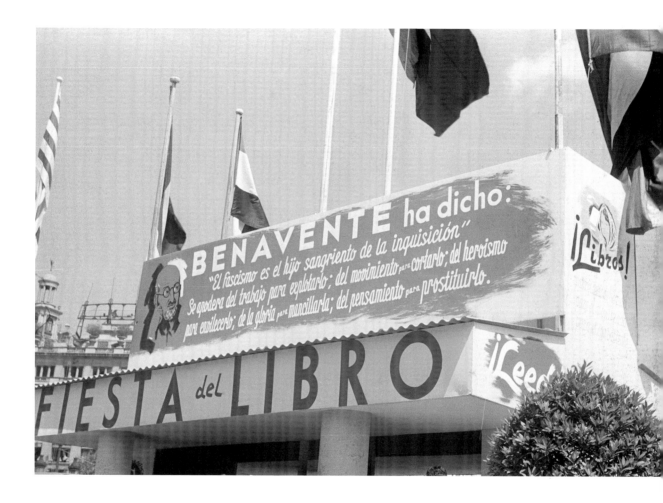

JUNE 15, 1938, BARCELONA

The Barcelona Book Fair was organized by the Republican
government. The slogan reads "Benavente said: 'Fascism
is the bloody son of the Inquisition.'"

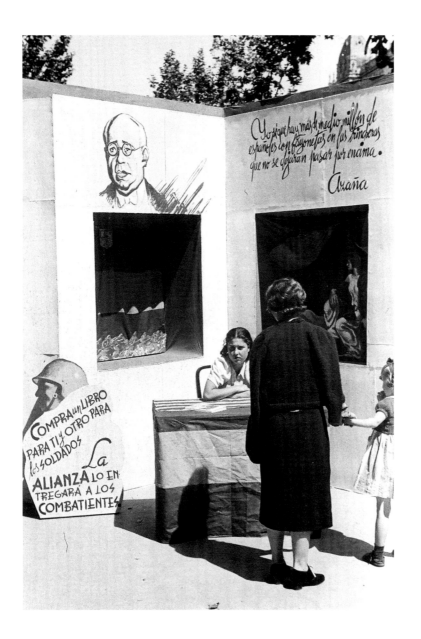

JUNE 15, 1938, BARCELONA BOOK FAIR

A message from President Azaña with a poster encouraging the
public "to buy a book for yourself and another for the soldiers."

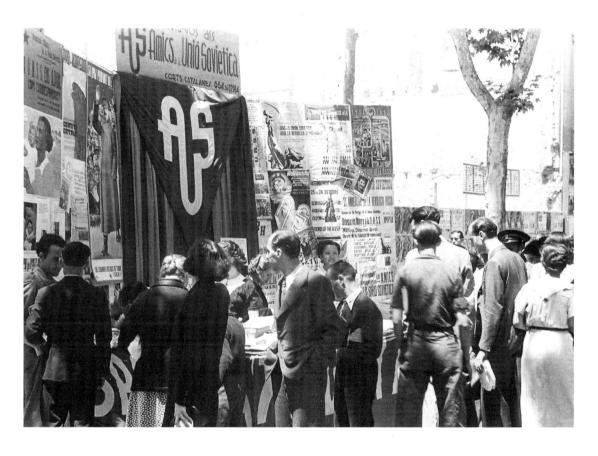

JUNE 15, 1938, BARCELONA BOOK FAIR

A group gathers before the Soviet Union booth.

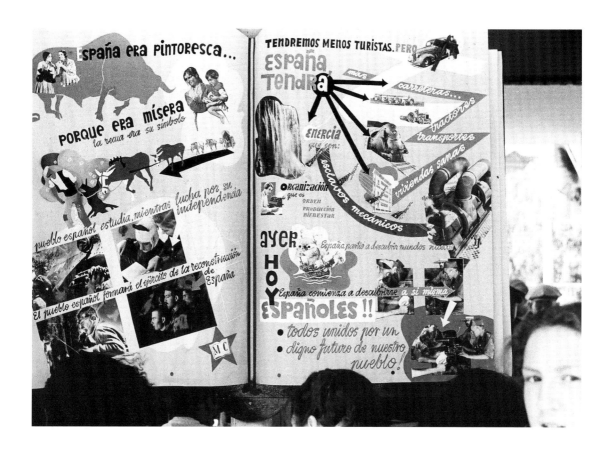

JUNE 15, 1938, BARCELONA BOOK FAIR

Posters with slogans: "Spain was picturesque because she was miserable.
The train of mules was its symbol" (left). "Yesterday Spain departed to
discover new worlds. Today Spain starts to know itself" (right).

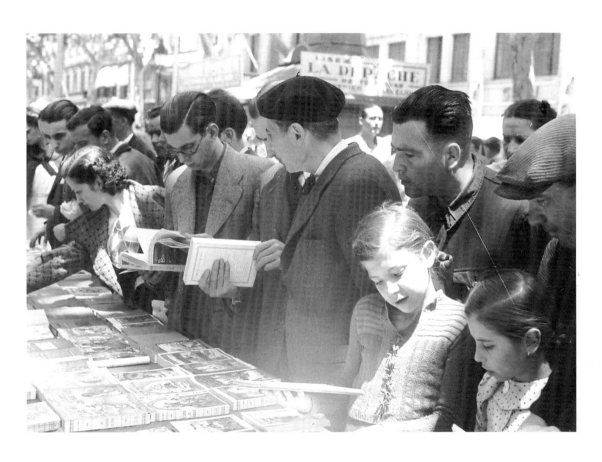

JUNE 15, 1938, BARCELONA BOOK FAIR

Avid readers of all ages.

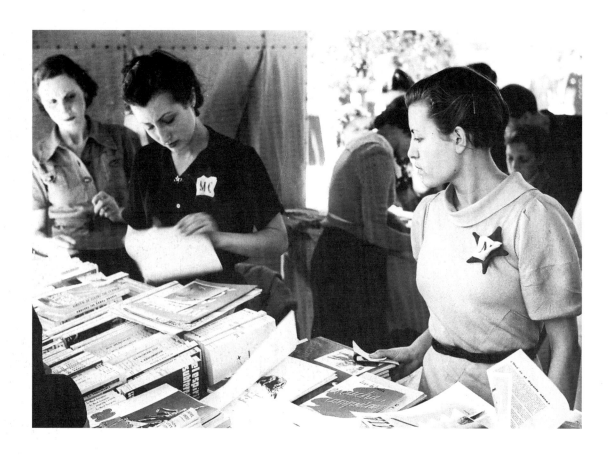

JUNE 15, 1938, BARCELONA BOOK FAIR

Women sorting books and pamphlets.

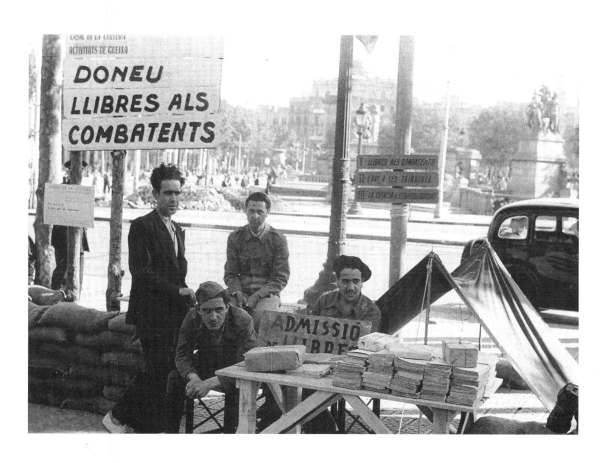

JUNE 15, 1938, BARCELONA BOOK FAIR

War veterans' stand with a Catalan sign reading,
"Donate books to the combatants."

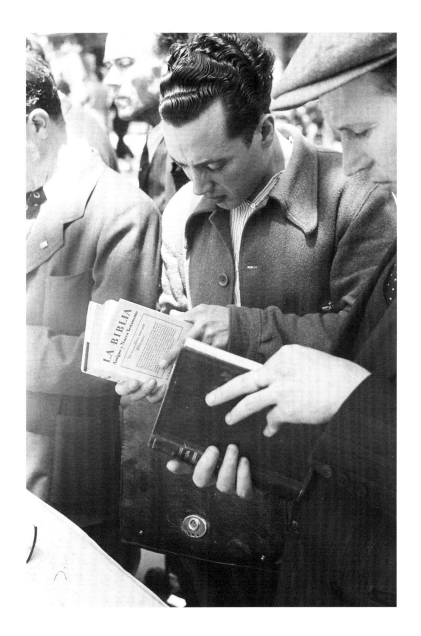

JUNE 15, 1938, BARCELONA BOOK FAIR

In an officially lay and anti-clerical Spanish Republic,
the Bible stand is very popular.

JUNE 15, 1938, BARCELONA BOOK FAIR

A well-dressed man browses the Bible at the fair.

JUNE 15, 1938, BARCELONA BOOK FAIR

A boy inspects a *Biblia* on display at the
busy Bible stand.

JUNE 15, 1938, BARCELONA BOOK FAIR

Solace found in the Bible during a terribly
violent conflict.

JUNE 27, 1938, BARCELONA

A privileged child belonging to a Ministry of State family.

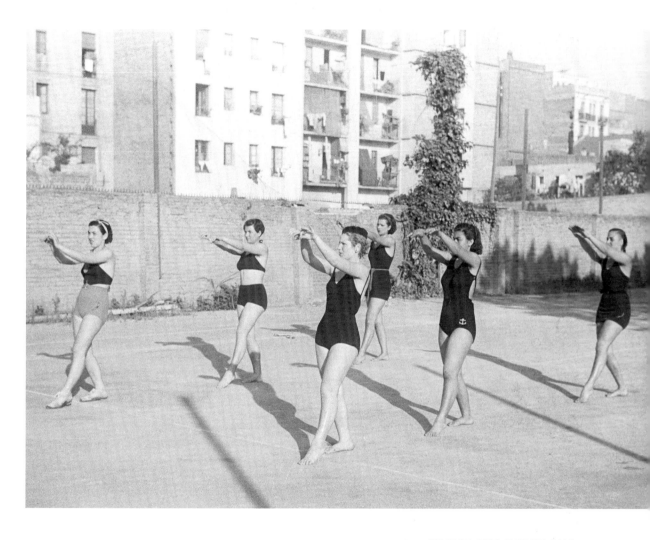

JUNE 27, 1938, BARCELONA

Ministry of State members in physical exercise classes.

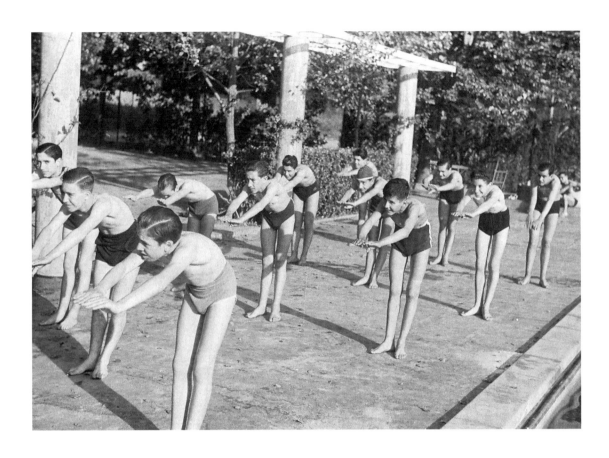

JUNE 27, 1938, BARCELONA

The "happy few" youths of the system.

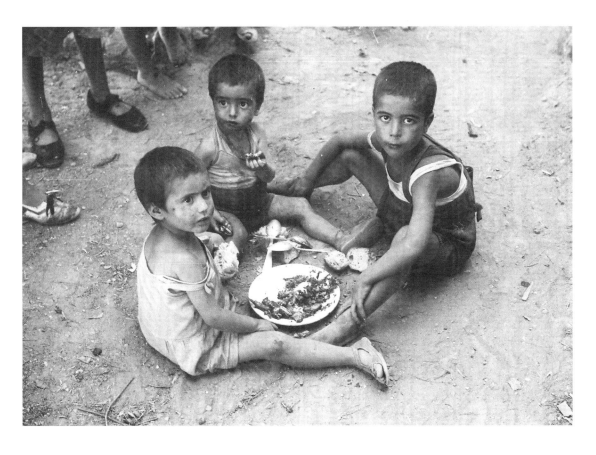

JULY 1938, SABINOSA, ON THE OUTSKIRTS OF BARCELONA

Hungry refugee children from the Aragon front area.

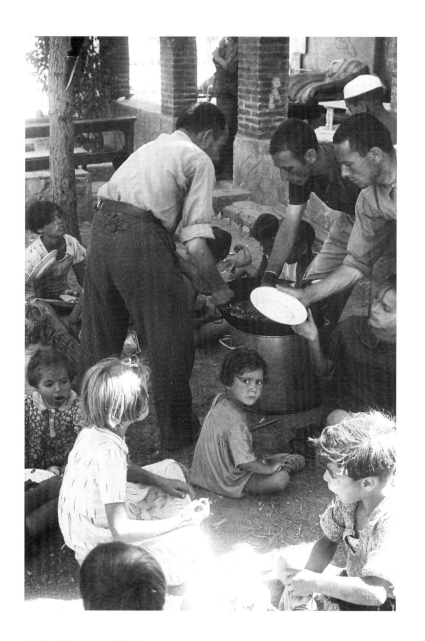

JULY 1938, SABINOSA

Volunteers feeding refugee children from
the Aragon front area.

JULY 1938, SABINOSA

Leah Manning (left), a BMU founder, and a manager
of the children's orphanage.

[ABOVE] JULY 28, 1938, NEAR THE EBRO FRONT

Locals work at the harvest while the volunteer
medical teams were preparing for the battle.

[LEFT] JULY 28, 1938, NEAR THE EBRO FRONT

A local man still seemingly unaware of the decisive battle of
the Spanish Civil War soon to take place at the Ebro River.

JULY 28, 1938, NEAR THE EBRO FRONT

Volunteer on the radio at the temporary field hospital. The Spanish Republic
lost the decisive battle on the Ebro and was effectively cut in two, severely
hampering communications between Valencia and Barcelona.

JULY 28, 1938, NEAR THE EBRO FRONT

Leah Manning (left) with Nan Green (standing), who would lose her husband George on the Ebro Front in September. The International Brigades were disbanded by the Spanish Republic soon thereafter.

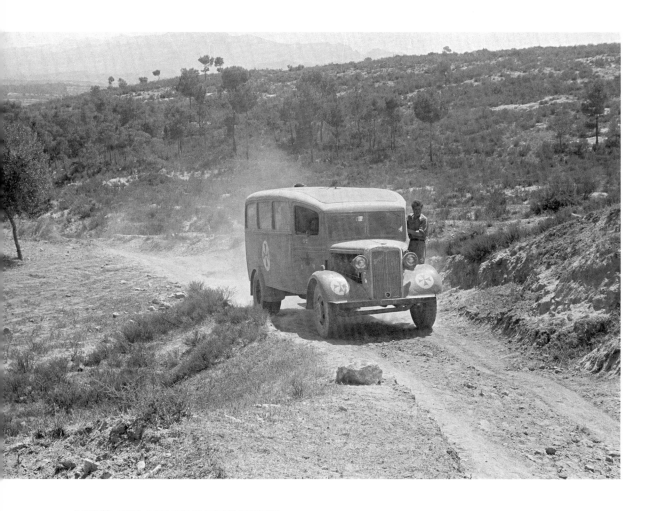

JULY 28, 1938, NEAR THE EBRO FRONT

Ambulance en route to a field hospital located
in caves near Bisbal de Falset.

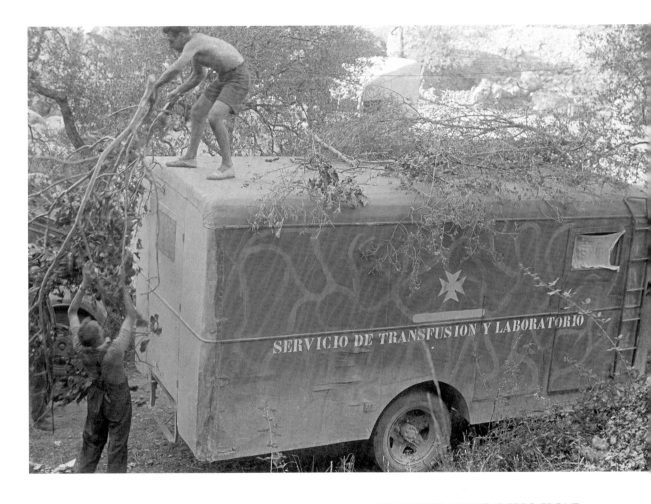

JULY 28, 1938, NEAR THE EBRO FRONT

Refrigerated blood transfusion truck en route to the Ebro Front field hospital with medical workers cutting down trees to allow passage. Thanks to Dr. Norman Bethune's earlier work, Dr. Reginald Saxton of the BMU was able to obtain this truck.

[ABOVE] AUGUST 1938, EBRO FRONT

The base camp with the cave hospital
in the background.

[RIGHT] AUGUST 1938, EBRO FRONT

A nurse being given her lunch at the field
hospital base camp.

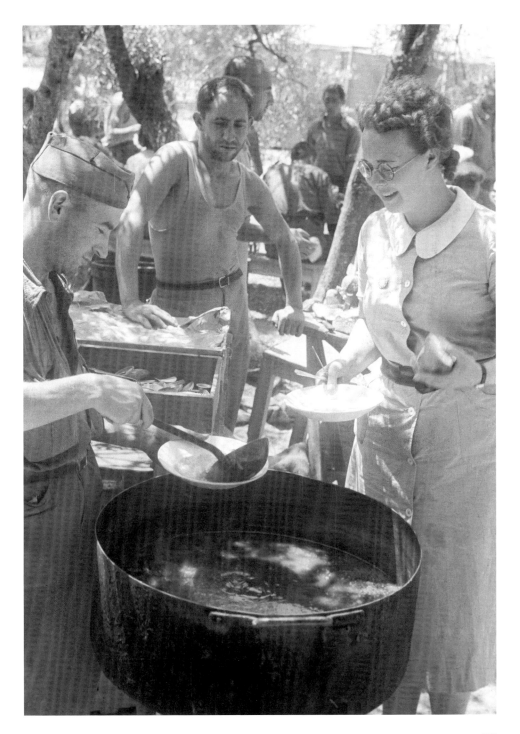

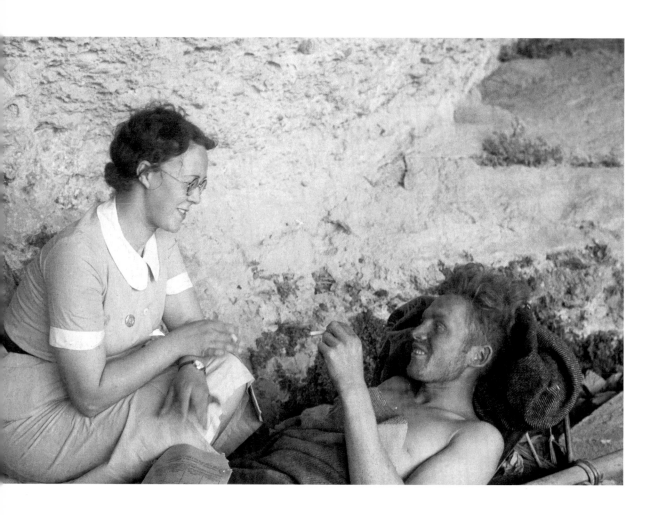

AUGUST 1938, EBRO FRONT CAVE FIELD HOSPITAL

A nurse comforts a patient in the cave.

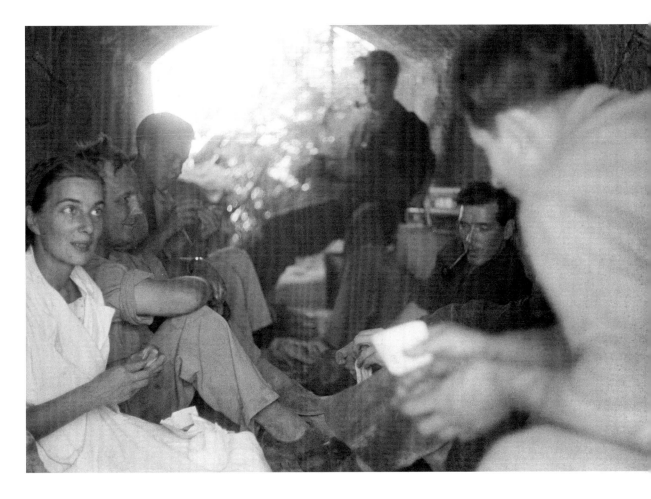

AUGUST 1938, EBRO FRONT CAVE FIELD HOSPITAL

Medical teams taking a break.

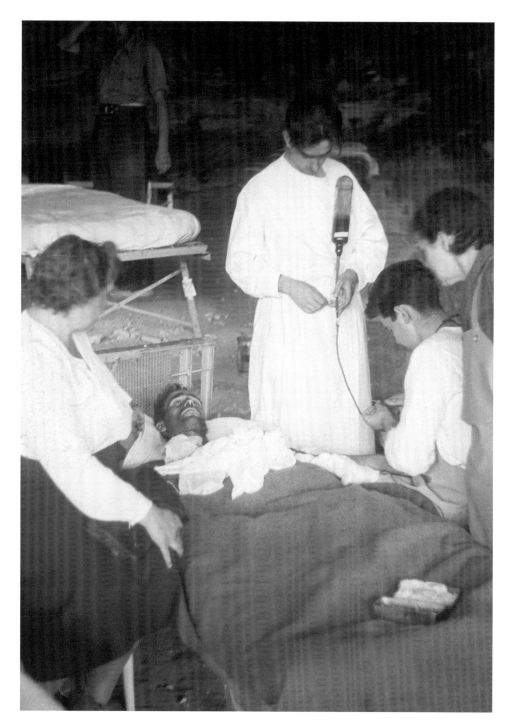

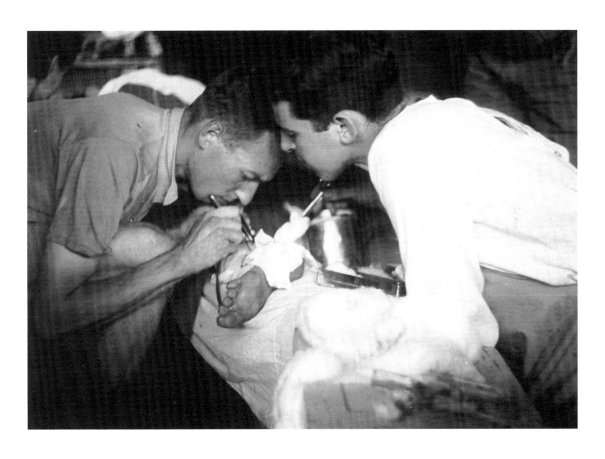

[ABOVE] AUGUST 1938, EBRO FRONT CAVE FIELD HOSPITAL

Operating on a patient's foot in the cave.

[LEFT] AUGUST 1938, EBRO FRONT CAVE FIELD HOSPITAL

Harry Dobson, Welsh miner and British Brigade member, receiving a blood
transfusion in the cave while being comforted by Leah Manning (left).

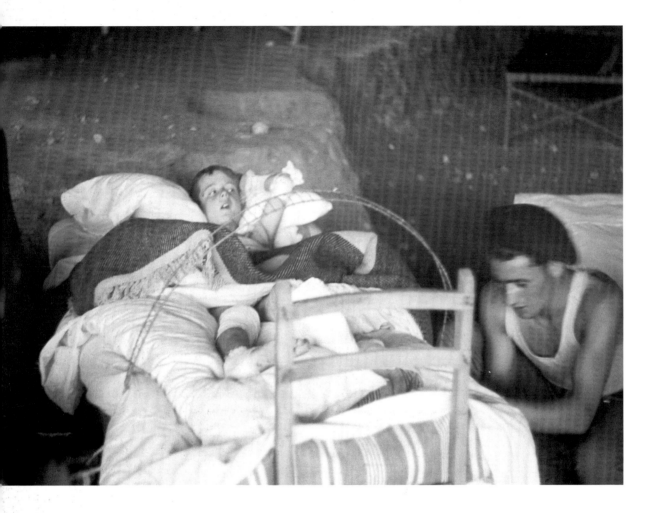

[ABOVE] AUGUST 1938, EBRO FRONT CAVE FIELD HOSPITAL

A child patient recuperating with a wounded leg.

[RIGHT] AUGUST 1938, EBRO FRONT CAVE FIELD HOSPITAL

Dr. Reginald Saxton (seated) developed highly novel blood transfusion
techniques during the war along with Canadian Dr. Norman Bethune.
The patient, Harry Dobson, did not survive.

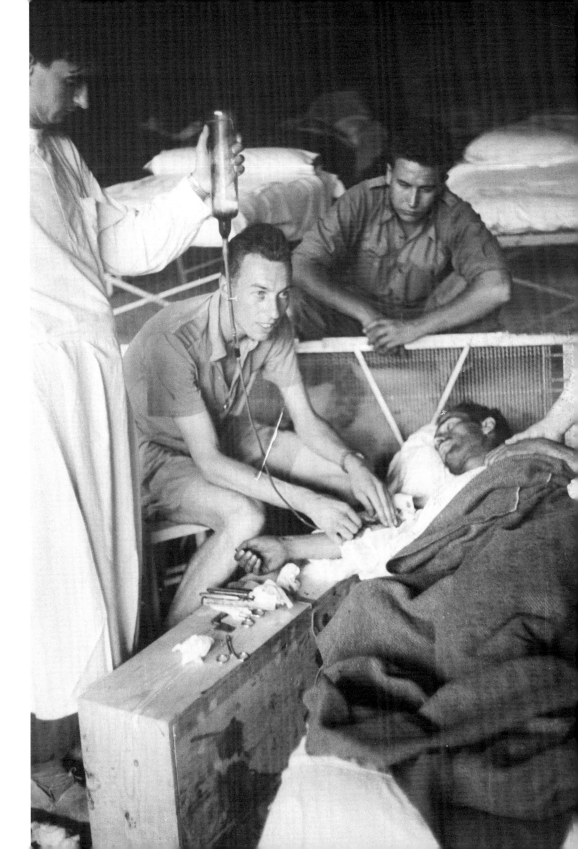

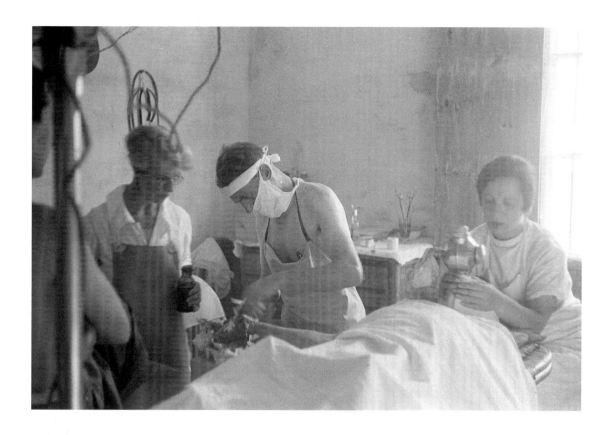

[ABOVE] AUGUST 1938, NEAR EBRO FRONT

Due to heavy casualties, operations were often performed
on site. Here the nurse administers an anaesthetic as the
surgeon begins the operation.

[RIGHT] AUGUST 1938, NEAR EBRO FRONT

A surgeon operates on the hand of a combatant in
makeshift quarters.

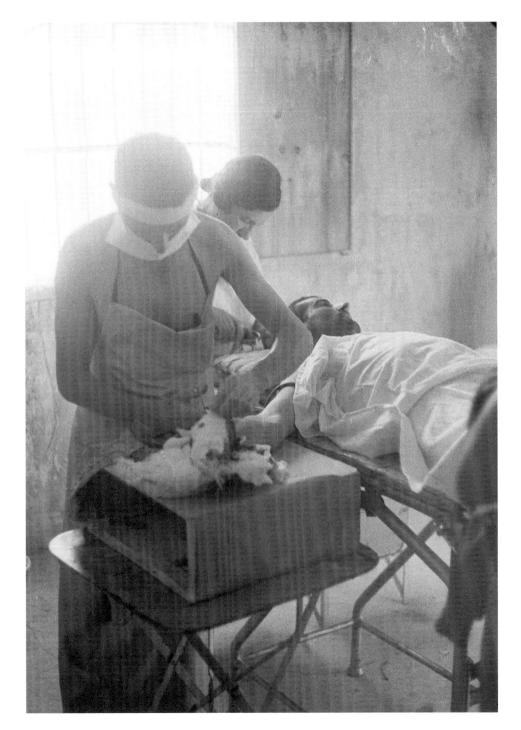

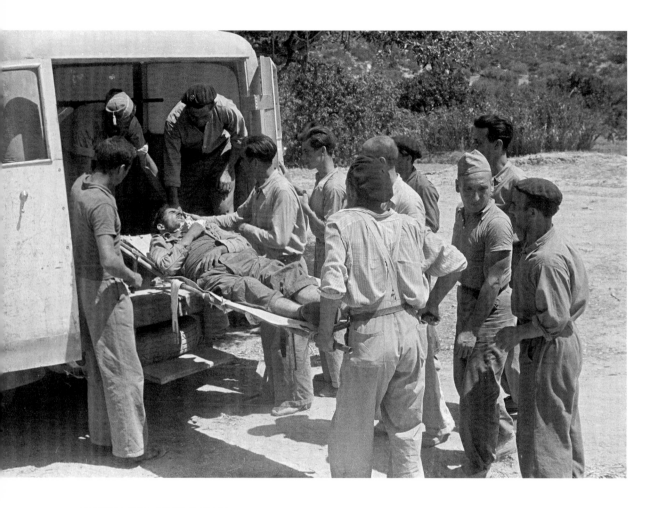

AUGUST 1938, EBRO FRONT

Evacuating wounded from the front lines.

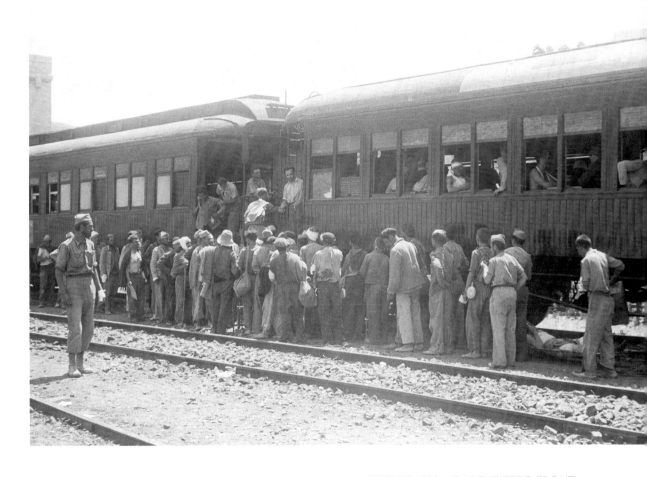

AUGUST 1938, NEAR THE EBRO FRONT

The wounded lining up outside the train for
transportation to the nearest hospital.

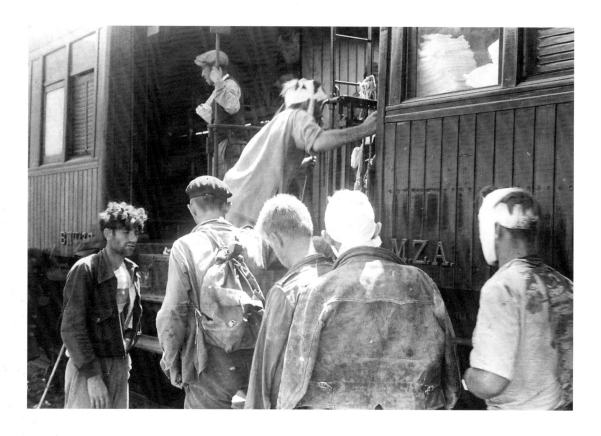

[ABOVE] AUGUST 1938, NEAR THE EBRO FRONT

Wounded boarding the hospital train.

[RIGHT] AUGUST 1938, NEAR THE EBRO FRONT

Three tiers of patients crowded inside the Ebro Front hospital train.

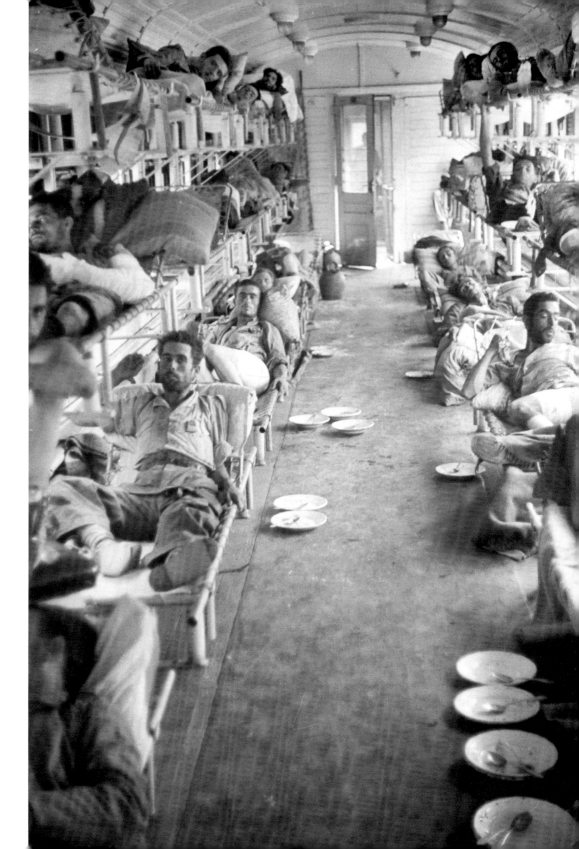

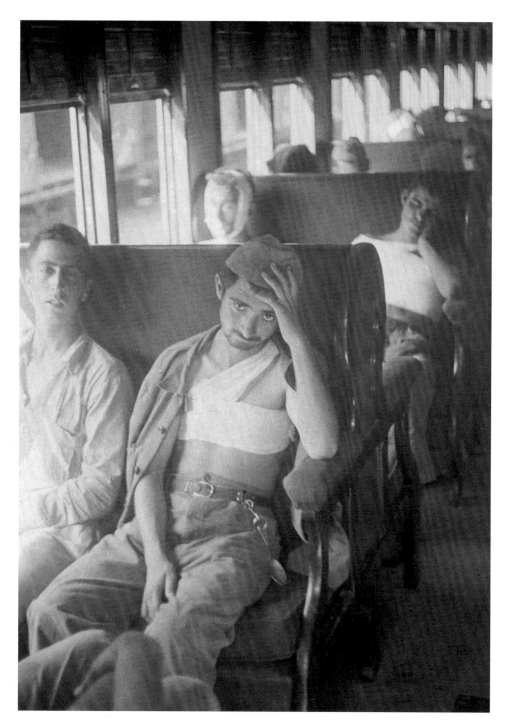

246

[ABOVE] AUGUST 1938, EBRO FRONT

Republicans found these Nationalist propaganda tracts
when they crossed the Ebro River. The poster proclaims
"Our destiny: save the world, serving God and Spain!"

[LEFT] AUGUST 1938, NEAR THE EBRO FRONT

Wounded Republicans being evacuated via train
to the nearest hospital.

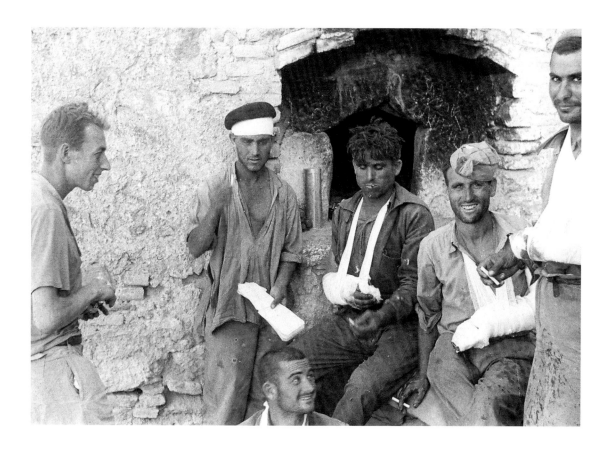

AUGUST 1938, EBRO FRONT

Republican wounded coming back from the Ebro Front.

AUGUST 1938, EBRO RIVER

View of the river running through the rugged landscape.

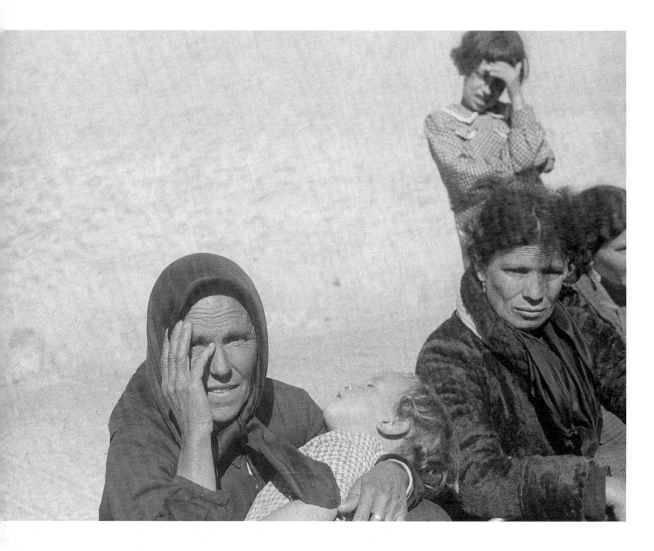

[ABOVE] AUGUST 1938, NEAR THE EBRO FRONT

Civilians with a young child in the summer heat.

[RIGHT] AUGUST 1938, ON THE EBRO FRONT

The last picture taken of Alec Wainman in Republican Spain
before his forced return to England with hepatitis.

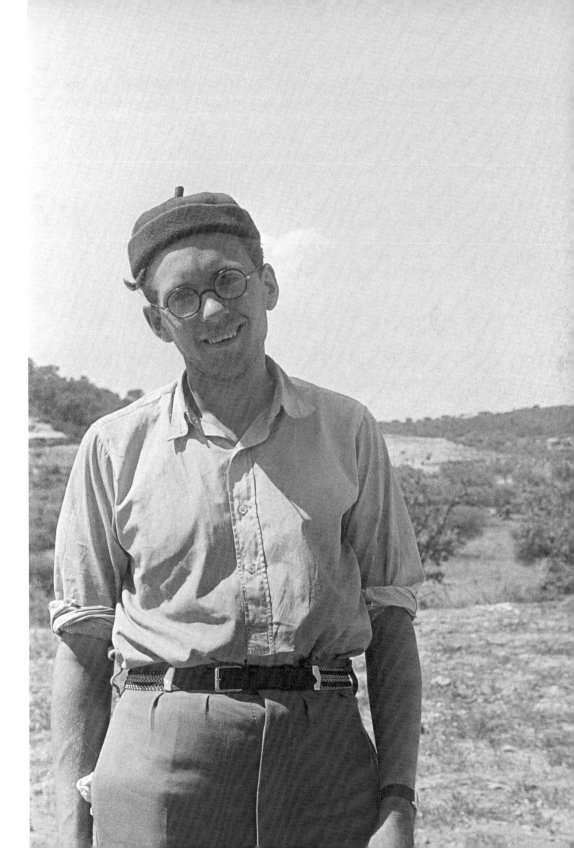

1939, SPANISH BASQUE COUNTRY

After Franco's victory, Alec returned to Spain where he was greeted by members of a host family. He visited with the families of refugees who had been evacuated earlier to the UK and were aided by Alec and his mother in Shipton.

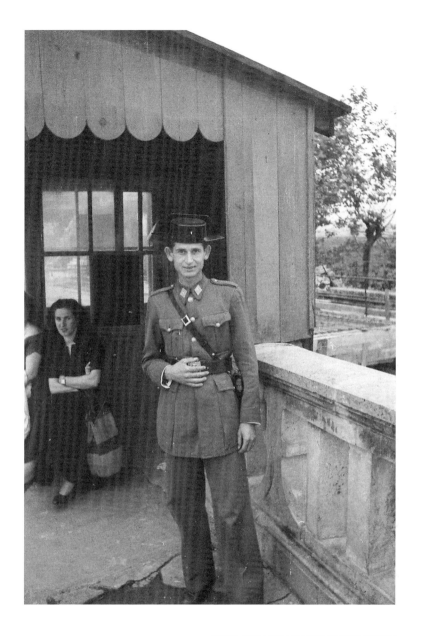

1939, SPANISH BASQUE COUNTRY

A friendly looking Guardia Civil border guard. The vast majority of his
corps had joined the Nationalist rebellion of Franco during the war.

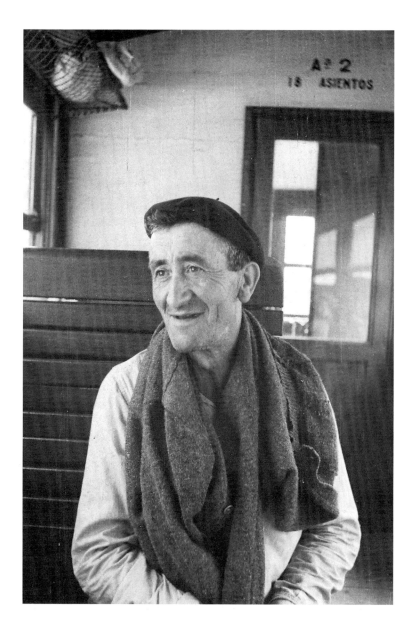

1939, SPANISH BASQUE COUNTRY

Alec's host on a train.

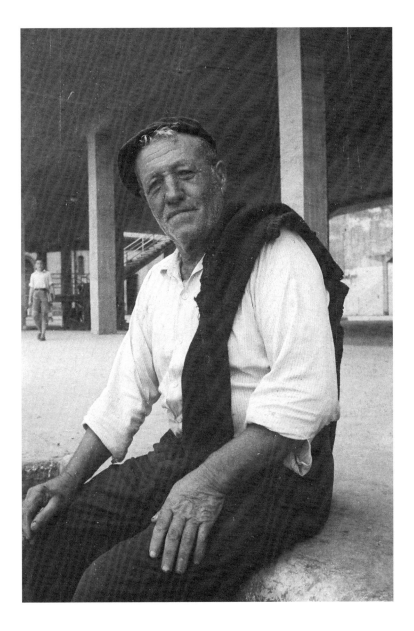

1939, SPANISH BASQUE COUNTRY

Another of Alec's hosts at the sea docks.

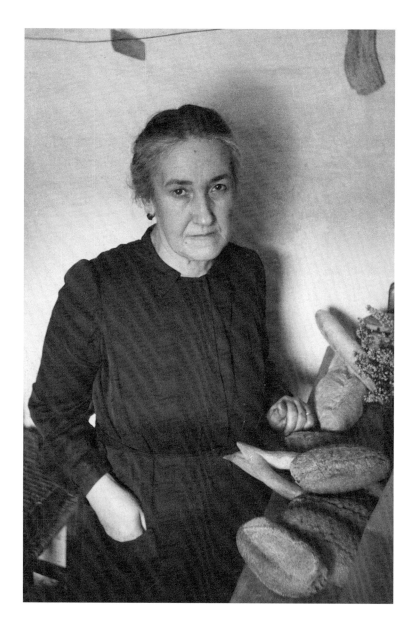

1939, SPANISH BASQUE COUNTRY

In the home of Alec's hosts where the wife is putting together a meal.

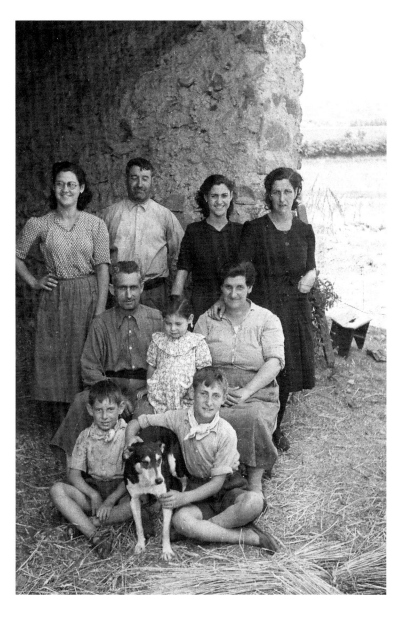

1939, SPANISH BASQUE COUNTRY

One of Alec's large host families on their farm with their dog.

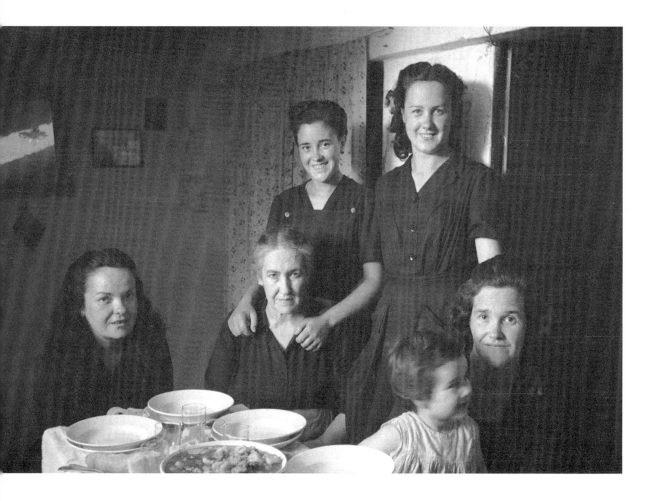

1939, SPANISH BASQUE COUNTRY

A host family gathers around the supper table.

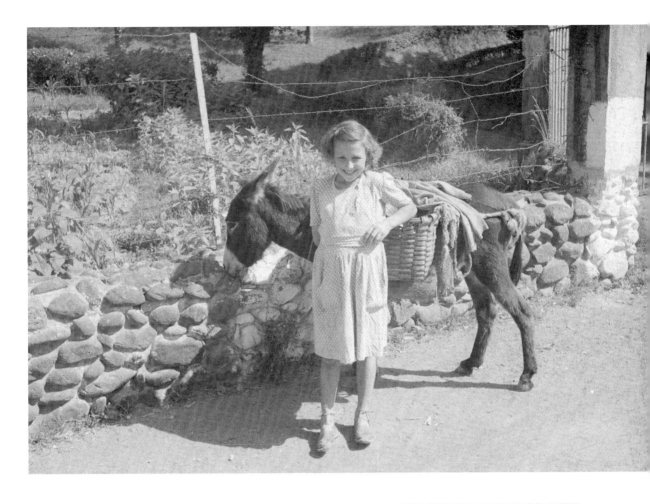

1939, SPANISH BASQUE COUNTRY

Local Basque child with a big smile and a well-laden donkey. Life remained
as before for those children who were not orphaned or evacuated.

Afterword

\cdots

The Spanish Civil War attracted over forty thousand volunteers from all walks of life. Alec Wainman was one of these. A humanitarian with Quaker ideals, he was deeply moved by what was happening in Spain. He understood that the Spanish Republic was at the forefront of the fight against fascism, in which the aggressors, the Nationalist forces, were openly supported by the fascist governments of Germany and Italy. He also recognized that this civil war would have a significant impact on the future. In the late 1970s, after the death of Franco, Alec decided to write about his experiences as a volunteer with the British Medical Unit (BMU). Alec was also an avid photographer and had a collection of over sixteen hundred photographs taken during his time in Spain, some of which he planned to share in his book.

While working on his manuscript, he remarked that up to this point, the numerous books about the civil war had focused primarily on the military experiences of British and American volunteers. Alec felt it was important to create a book with a more comprehensive perspective. Unfortunately, Alec became ill and the publication of his book with his photos did not materialize. Now, however, his experiences and remarkable photographs of his time as a volunteer during the Spanish Civil War have finally come to fruition in *Live Souls: Citizens and Volunteers of Civil War Spain*.

Alec's experience of the Spanish Civil War exerted a profound effect on the rest of his life. As a lifelong humanitarian, he continued to support refugee causes in the 1950s, '60s and '70s. He was deeply involved in aiding numerous refugees fleeing dictatorships from Hungary, Czechoslovakia and Tibet (see Appendix 1). He was particularly delighted in the early 1980s when he met a retired Yugoslav theatre director, and they were able to reminisce about their struggles against tyranny. His new-found friend had joined Tito's Second World War partisans at age sixteen to fight the

Axis aggressors, and he later founded an amateur theatre group, inspired by Federico García Lorca, an early iconic victim of the Spanish Civil War. Together they shared memories of their struggles against fascism in Spain and the Balkans.

Clearly, the Spanish citizens themselves suffered most from the Spanish Civil War and its aftermath. Many who had fought on the Republican side were later sent to re-education camps in Franco's Spain, often never to return. Exiles who went to Britain had a challenging cultural assimilation, as they were met with suspicion by the authorities. Alec kept in contact with many of his exiled friends. He followed some, such as Marcelino Sánchez, to half a dozen addresses in the UK. When Coco Robles (see Alec's photo of March 22, 1937, in Tossa de Mar) travelled from his new home in Mexico City to Vancouver, he had a jubilant reunion with Alec on August 31, 1984, which happened fortuitously to be the forty-eighth anniversary of Alec's arrival in Republican Spain. Another exile, and a friend of Alec's in Spain, was the young theatre director, Pepe Estruch, who, after a period in Britain, moved to Uruguay where he had the opportunity to direct theatre productions. He returned to Franco's Spain in 1967. In 1990, after Spain's return to democracy, he was awarded the National Theatre Prize.

The foreign volunteers and International Brigades were a significant source of support for the Spanish Republic during the civil war. These groups consisted of volunteers from many different countries and from all backgrounds: from the average citizen, to career humanitarians, as well as a number of notable personalities. Many saw the rise of fascism in Europe early on and understood that Spain was the epicentre of the struggle. Some international volunteers and Spanish citizens came from prominent families, such as Leah Manning, Constancia de la Mora, and Patience Darton. Well-known writers and journalists included George Orwell, Ernest Hemingway, Bob Capa, Gerda Taro, Willy Brandt, Franz Borkenau, Antoine de Saint-Exupéry, and André Malraux. The artists Pablo Picasso and Pepe Estruch were both mobilized by the consequences of the bombing of Guernica.

There were also prominent military advisors, such as Alexandr Ilych Rodimtsev and Koča Popović, who later became key Second World War commanders. The medical contingent included such notables as Dr. Norman Bethune, Dr. Reginald Saxton, Jakov Kranjčević Brado and Ann Murray, who were instrumental in creating innovative medical techniques that were the forerunners of today's medical practices. And, of course, there were the many thousands of international volunteers in all categories of service who unselfishly gave their time. What motivated such a diverse group of citizens and international volunteers to converge in such great numbers in defence of the Spanish Republic — and never since? Undoubtedly, each had his or her own reasons for making such a personal and vital decision. Sadly, many sacrificed their lives in support of the cause. For others, this experience was an inspiration and catalyst to important achievements in the future.

Almost eighty years have passed since the start

of the Spanish Civil War, the effects and consequences of which have been far reaching and have impacted many countries. Surprisingly, its multiple implications remain largely unstudied even though they offer insights into much subsequent history. It is important to look at the forces that set this conflict in motion and to point to some of the consequences.

Various factors led to the eruption of the Spanish Civil War. Spain in the early twentieth century had been in a long period of post-colonial decline and was lagging behind other European countries. In 1931, the Spanish monarch left Spain and was replaced with the Republican government, but the new government had difficulty implementing its reform policies and enforcing law and order. The ideological differences between the political Left and the Right increased, and the gap in living conditions between the cities and the countryside with its wealthy landowners also continued to widen. Catalonia and the Spanish Basque country yearned for more autonomy. The Church hierarchy, a bastion of power in the country, was opposed to social reform and vehemently disapproved of the Republican government. Army officers had a history of interfering in the country's politics.

When in the spring of 1936, the Popular Front of the Left won the election with a clear majority, emboldening the Second Spanish Republic, the Right reacted angrily, resulting in a reign of violence and insurrection in the streets. Dissatisfied with this state of affairs, military Nationalist leaders, including General Franco and General Mola, staged a military rebellion in the summer of 1936. They were aided by Germany and Italy, who provided equipment as well as troops throughout the conflict. Anarchist-trade unionists, on the Republican side, seized power in many different areas of Spain. The Republicans became entrenched in defensive positions, primarily in the areas around Madrid, Valencia, and Barcelona. Britain and France, fearful of becoming involved in another war so soon after the Great War, convinced one another to join in the Non-Intervention Agreement. Aside from the initial limited support from France, the Spanish Republic government received no official aid from other countries, except from the Soviet Union and Mexico. The Soviets provided tanks, aircraft and military advisors.

The lessons learned by Nazi Germany in their support of Franco's army rebellion gave them an excellent advantage in pre-planning for their military invasions in the Second World War. In particular, the German generals came to see the importance of the change from trench warfare and cavalry to modern combat with bombing and tanks. Alec witnessed first-hand how air warfare would change conflicts in the future. According to the Versailles Treaty of 1918, a German air force was not permitted. The Condor Legion fighting the air war in Spain was a subterfuge by which Germany could create a powerful Luftwaffe.

Alec's first photo in *Live Souls* is of a BMU volunteer reading a French newspaper about Franco's Nationalists' aerial bombardment (August 30, 1936). It has the additional headline: "The Welcome of Polish Commander-in-Chief Edward Rydz-Śmigły in Paris." Rydz-Śmigły had

come to Paris to receive the French *Légion d'honneur* and to discuss defence matters with his French counterpart, General Maurice Gamelin. Their concerns about the rising military power of Germany would prove accurate three years later with Nazi Germany's invasion of Poland, followed by the invasion of France. Certainly the Polish volunteers of the Dabrowski Battalion of the International Brigades (see Alec's photo of May 18, 1937) knew that they were fighting in a conflict that could, and did, lead to all-out war in Europe.

As Alec's account indicates, he worked alongside many volunteers from Germany, in particular those in the Thaelmann Battalion, who saw clearly that they needed to resist fascist expansionism at its trigger point in Spain. The same resistance could also be found in Austria, when Hans Landauer (*nom de guerre* Hans Opperschall) left home to join the International Brigades at age sixteen along with some sixteen hundred fellow Austrians. He was arrested in Paris in 1940, and finally charged in 1941 for conspiracy to commit high treason. He was subsequently interned at the Dachau concentration camp until 1945.[1] He devoted the later part of his life to preserving the legacy of his fellow volunteers. He was one of the last surviving International Brigade volunteers when he died in July 2014.

In addition to the volunteers, there were dissenting German journalists who came to Spain to report on events during the war to draw attention to the plight of the Spanish Republic and to arouse Europe to the dangers of fascism. Often they used

noms de guerre to avoid detection by the Gestapo. Two such dissidents were Willy Brandt (born Herbert Ernst Karl Frahm) and fellow-refugee photojournalist Gerda Taro (born Gerta Pohorylle), who was later tragically killed in the Spanish Civil War at age twenty-seven. Brandt was appalled by what he saw of the persecution and purge of the anarchist-trade unionists, led by the Comintern communists.[2] When in 1969 he became the first socialist Chancellor of West Germany, he advocated anti-communist policies while opening up a dialogue with East Germany with his *Ostpolitik*. He received the Nobel Peace Prize in 1971.

A key witness of revolutionary Civil War Spain was the exiled thirty-six-year-old Austrian writer Franz Borkenau, who made two trips to Spain in 1936 and in 1937. Unlike most of the younger volunteers in their twenties, he along with thirty-three-year-old George Orwell and other older volunteers were able to see beyond the propaganda that influenced many of the younger generation. Like Brandt, Borkenau was highly critical of the role of the Soviet secret police, and on his second visit was arrested by the Spanish police. The experience gave rise to his classic *The Spanish Cockpit*. He later refined his knowledge on totalitarian regimes such as Nazi Germany and the Soviet Union, as well as on the East-West partition characterized by the divided Germany. As Borkenau observed, the Soviet-led secret police, who exerted much control over the Spanish Republic's intelligence services, was a major factor in the defeat of the anarchist revolution in Spain and would

have lasting repercussions on post-WWII thinking.

During the years of the Cold War in North America, the Spanish Civil War remained largely a taboo subject. In North America, most of the Spanish Civil War veterans were treated with relative indifference, sometimes with outright hostility, as they were seen as being leftists. As a result, many veterans felt isolated from the progressive goals which they had found so attractive in Europe. In Canada, the contribution made by the volunteers was little understood, and in many cases their activities were monitored by the police.[3] When individuals lobbied to have the names of the volunteer fighters who died in Spain added to the local cenotaphs they were often rebuffed. At the time, it was generally not recognized that some seventeen hundred individuals had left from Canada (with the largest contingents from Vancouver and Toronto). These volunteers played a significant role, far out of proportion to Canada's population. The last surviving Canadian volunteer, Jules Paivio, died in 2013. Two years before his death, the Spanish government honoured him with full Spanish citizenship for his military service in the Civil War.

In 1947 in New York, based on their previous collaboration with Gerda Taro during the Spanish Civil War, photojournalists Bob Capa, David Seymour and Henri Cartier-Bresson co-founded Magnum Photos. This cooperative was a pioneer in protecting the photo authorship rights of photojournalists. In North American academic institutions, the Spanish Civil War is still an essential subject. American universities have some of the best Spanish Civil War archives in the world and the UBC Library in Canada has a similar collection on the subject, as has the Bibliothèque national de France in Paris.

Many Spanish Republican leaders emigrated after the war, sometimes to the United States but more often to Latin America, where they felt more at ease culturally. Constancia de la Mora, who had been chief of the Spanish Republic's Foreign Press Bureau, spent her exile in the USA and in Mexico where she was an author, a member of the Union of Spanish Women aiding anti-Franco prisoners, and a board member of the Committee for Aid to Refugees. Tragically, like Taro before her, she died early at age forty-four, perishing in a motor vehicle collision in Guatemala. Overall, Central America has largely benefited in numerous fields from the contribution of over one hundred thousand Spanish Republican refugees.

In Britain, many of the returning volunteers took on a leading role in writing about the significance of the Spanish Civil War. One of the most venerated veterans has clearly been George Orwell who had a profound impact on ensuing thought based on his experiences in the Spanish Civil War. In politics, BMU co-founder Dame Leah Manning, when she was a Member of Parliament after the war, focused on educational and social reform. She is remembered in the Spanish Basque country for organizing the evacuation of some four thousand Basque children to Britain. A square in Bilbao is named in her honour. Another British BMU volunteer who continued on with what she had learned in Spain was nurse Patience

Darton (see Alec's photo of April 28, 1937, in Poleñino). In the 1950s, she travelled to Mao's China to apply what she had learned in Spain — a choice reminiscent of that of Dr. Norman Bethune. Her life is recounted by British author Angela Jackson in her book *For us it was Heaven*.

France contributed the largest component of volunteers (approximately ten thousand), with Paris as the staging ground and French as the official language of the international volunteers. France was also the first port of call for the exodus of the hundreds of thousands of Spanish refugees fleeing the country as the Republic was being defeated by Nationalist forces. Living conditions in these camps, many of which were located on the beaches of the French Mediterranean and the Atlantic, were often unbearable.

Psychologically, the effect of the Spanish War, or *Guerre d'Espagne* as the French called it, probably had the biggest impact on the French citizenry. For many French people the war was imbued with personal significance, with family members on both sides of the Pyrenees border. The French people were supportive in numerous ways. Alec describes their assistance during the inaugural trip of the BMU through France (see Alec's photo of August 30, 1936, in Brive-la-Gaillarde). In addition, France took almost half of the twenty thousand Basque children who were temporarily evacuated following the bombing of Guernica in 1937. The balance was absorbed by six other countries. In France, as in Britain, the Non-Intervention Agreement meant that private donors were called on to support the Basque refugee children. In 1996, under President Jacques Chirac, the government implemented a pension scheme for its Spanish Civil War International Brigade veterans. France was the only country to do so.

On the cultural side, France made a large contribution to our understanding of the Spanish Civil War. The writings of Antoine de Saint-Exupéry, François Mauriac, and André Malraux offer some of the best testimonials to the conflict. One of the finest documentaries on the Spanish Civil War is the film *Mourir à Madrid*, shot in 1963 by Frédéric Rossif. The French film director, born in former Yugoslavia, declared the following about his film: "I wanted, above all, to make a film against civil war." Saint-Exupéry, writing for the newspaper *France Soir*, wrote about the siege of Madrid: "*Mais Madrid émerge toujours.*" On the subject of international volunteers he wrote in his newspaper article:

> All volunteers . . . they congregated for the great assembly. They are drawn from a plethora of men. Like grain from a granary, they are thrown like a handful of seeds for planting. [Translated]

As is well known, Italy was the first fascist-led country in Europe. When Benito Mussolini came to power in 1922, the result was a hard and embittered resistance that subsequently had a significant impact on the Spanish Republic. An example is Randolfo Pacciardi who, after being exiled from fascist Italy, founded an Antifascist Legion to fight in Spain. He then headed the Garibaldi Battalion

in the defence of Madrid. This battalion was created in parallel to the Comintern's International Brigades and included Italian socialists and republicans, as well as volunteers from the Balkans. Among these was Albanian Mehmet Shehu who later led the communist partisan movement to free Albania from Nazi occupation. Albanian volunteer and writer, Petro Marko, who wrote the novel *Hasta la Vista*, was inspired by his time as a volunteer in Spain. Numerous Italian veterans returning from Spain had successful political careers on their return, as did their counterparts from the former Italian colony, Albania.

The Soviet Union's involvement in the Spanish Civil War consisted primarily in providing equipment and military advisors. Joseph Stalin soon realized that his own aircraft were no match against those that were tested by the German Condor Legion and that he would need to upgrade his air force. He also became obsessed with the anarchist revolution and was determined to put it down. Overall, the Soviets supplied fewer advisors than the Italians and Germans on the Nationalist side. Moreover, the Soviet advisors were essentially Russian-speaking only, unlike numerous Germans and Italians who also spoke Spanish. A few hundred interpreters (including Liza, whom Alec describes but never mentions her surname) were employed to accompany the Soviet advisors in their tasks. Alec, who was fluent in Russian, English and Spanish, was highly valued by the advisors for his translation abilities.

Where the Soviets were enormously successful was in their numerous propaganda films made with the support of Comintern. These were particularly well organized and most effective in recruiting volunteers for the International Brigades from over fifty countries. In the 1930s, communism was a global venture with international proportions.

Among the Soviet officers, Alexandr Ilych Rodimtsev advised on the defence of Madrid and later applied what he learned there in the defence of Stalingrad.[4] But the Soviet Union was also very suspicious of many of its returning volunteers, and it is known to have purged numerous officers and diplomatic personnel that it had sent to Spain during the conflict. These included Soviet military advisors, ambassadors, journalists and Eastern European generals.

The volunteers who came from farthest afield to participate in the Spanish Civil War were the Chinese. About one hundred Chinese enlisted as humanitarian and military volunteers during this conflict. They were among the oldest and most mature volunteers, having been mobilized at the time of Japan's war on China.

Yugoslav volunteers deserve special mention for their role in the Spanish Civil War. Their losses in the International Brigades and the Spanish Republican Army during the conflict were high: one-third of their 1,775 volunteers.[5] Showing the true global dimension of the conflict is the fact that of these Yugoslav-origin volunteers, five percent came to Spain from Canada, four percent from the USA, one percent from Latin America and five percent from the Soviet Union. These volunteers included over a dozen women, of which three

were doctors and two were nurses. In 1942, Jakov Kranjčević Brado, a medical attendant who had been trained in Spain, co-founded the secret underground hospital in Petrova Gora, which treated over five thousand patients during the Second World War. In post-war Yugoslavia, the *španski borci* (Spanish fighters) had coveted status.

Veteran Yugoslav officers from the Spanish Civil War were instrumental in forging the post-war leadership of their county. Josip Broz Tito, later President for life of Yugoslavia, had led Comintern recruitment in Paris for the International Brigades during the time he was a professional revolutionary with the Soviet Secret Service. Tito and his four veteran generals[6] became famous in the Second World War, applying what they had learned in Spain to fight the Axis powers. Koča Popović, perhaps the most famous of the four, was known as the saviour of the Yugoslav partisans by breaking the German encirclement which had trapped Tito in Bosnia. Although outnumbered by the Axis powers six to one, the partisans organized around twenty thousand soldiers in sixteen brigades to fight off the Germans.[7] This was the turning point of the Second World War in the Balkans, and showed the importance of the lessons learned in Spain. Thereafter, partisan warfare on the Spanish model was applied in many wars of independence such as in Algeria and Indochina (later Vietnam).

Learning from the Spanish conflict, Tito and Popović took as one of their highest priorities the necessity of escaping the yoke of the Soviet Union. Tito had seen first-hand how it operated when he

lived in the Soviet Union, and Popović had observed the Soviet "hand" on the Spanish Republic during his time in Spain. In order to ensure Yugoslavia's independence from the dominance of the Soviet Union as it was practised in the other Warsaw Pact countries, Tito built up the Yugoslav People's Army (YPA). Alec's Barcelona photo of March 14, 1837, of the People's Army of the Spanish Republic comes to mind. However, unlike with the political integration of trade unions and anarchists in Spain, the YPA itself became the military force that integrated all the peoples of the Republics of Yugoslavia into one centralized force dominated by the Yugoslav Communist Party. While Tito was able to give security to his people when he was alive, what followed after his death was, as is now well known, disastrous — lamented by numerous Yugoslav veterans of the Spanish Civil War, many of whom had hoped for autonomy of the various states and peoples.

While many countries were influenced, for better or worse, by the Spanish Civil War, it is the experience of Spain itself, with its new beginnings in the late 1970s and early 1980s after the death of Franco, which is most moving. In the artistic and socio-cultural movements of La Movida Madrileña, one finds a spontaneous outpouring of joy at Spain's new democratic identity, which the people had been denied for long years after the Nationalist victory in 1939. It was also at this time that Spain created a longstanding bond with South Africa, another nation which had denied its people freedom. Following his release from prison, Nelson Mandela described his numerous trips to

Spain as "joyous." After decades of political isolation, the "new" Spain has managed to create a nation with democratic institutions. As Alec Wainman reflected while in Tossa de Mar, with more optimism than seemed possible at the time, the will of the people would always end up victorious. Although Spain still has many economic problems to overcome, there can be little doubt that some seventy-five years after the end of the Spanish Civil War; the country is now following the people's will.

NOTES

1 See Dokumentationsarchiv des Österreichischen Widerstandes, online at www.doew.at.

2 Hugh Thomas, *The Spanish Civil War: New Revised Edition* (London, UK: Hamish Hamilton Ltd., 1977), 657fn1. Historian Hugh Thomas interviewed journalist Richard Bennett about the May 1937 Barcelona uprising, also witnessed by Willy Brandt. Alec describes his stay in the Bennetts' apartment in Chapter 5 (see his portrait of May 14, 1937, of the Bennetts on their Barcelona balcony).

3 Michael Petrou, *Renegades: Canadians in the Spanish Civil War* (Vancouver: UBC Press, 2008), 170–180.

4 Antony Beevor, *The Battle for Spain: The Spanish Civil War 1936–1939* (London: Weidenfeld & Nicolson, 2006), Chapter 18.

5 Yugoslav Association of Brigade Volunteers, "Udruženje Španski Borci 1936–1939," online at www.yuinterbrigade.org. Based on data from 1971, 1988 and 2011. This is the basis for the statistics of this paragraph.

6 Koča Popović, Peko Dapčević, Petar Drapšin, and Kosta Nađ.

7 Richard West, *Tito and the Rise and Fall of Yugoslavia* (London: Faber & Faber, 1996), 154–156.

Biography of Alec Wainman (1913–1989)

• • •

Alec was born Alexander Wheeler Wainman in Otterington Hall, Yorkshire, UK, on March 11, 1913. He moved to British Columbia, Canada, in 1920, with his mother (widowed in the First World War), and three older brothers. They settled on a ranch in Vernon, which was later donated to the church. The flower shop in Vernon to this day still bears the name of the gardener "Harris," who had crossed the Atlantic with the Wainmans in 1920.

The Wainman family returned to Britain in 1928. Later, Alec studied Modern Languages at Magdalen College, Oxford, receiving an M.A. in Russian and Italian. From 1934 to 1935 he served as the Third Secretary at the British Embassy in Moscow. He documented this period with photographs, including the Moscow Underground constructed by women. During this time he lived with the Gan family, who became lifelong friends. They were later severely persecuted in the gulag under Stalin.

Having spent some months during 1935 in Hanover with a German family, amid an awakening Nazism, Alec went on record at Oxford to express his dismay at Western Europe's ignorance of this danger. After the Spanish Civil War broke out in July 1936, Alec volunteered for service as an ambulance driver with the British Medical Unit (BMU). He was motivated by the conviction that Hitler and Mussolini, who were supporting Franco's Nationalists, must be stopped before all of Europe was plunged into war. His qualifications

were that he could drive a car and spoke a little Spanish.

He joined the BMU in Paris in August and drove to Barcelona, arriving in September 1936. Alec worked as an ambulance driver at the Grañén hospital, then as an interpreter at the Elizalde aircraft engine factory, and again with the BMU preparing the hospital at Valdeganga to receive patients. From September 1937, he was head of the English and American Press Department for the Ministry of State of the Republican government, reporting to Constancia de la Mora in the Ministry of Julio Álvarez del Vayo, both in Valencia and in Barcelona. In August 1938, after developing hepatitis, Alec returned to England to recuperate and spent much of the next year assisting the relocation of Spanish refugees.

Alec attended Sandhurst in 1943 and in the Second World War served in the Intelligence Corps of the British Army during the Italian campaign. From 1945 to 1947 he served in the British Element of the Allied Commission for Austria in Vienna, with the rank of major. Alec's intelligence report (which was quoted by Nikolai Tolstoy in his book *Victims of Yalta*) was instrumental in stopping the repatriation of the Cossacks. Those who had already been repatriated to their homeland faced forced labour, torture, or death in Stalin's Soviet Union.

Alec returned to Canada in 1947 to take up a professorship at the University of British Columbia, Vancouver, in the Department of Slavonic Studies. He taught there until 1978. An avid traveller, Alec made numerous trips in North America, Europe, Asia and Latin America, taking many colour photographs. He was also instrumental in helping numerous subsequent refugees to immigrate to Canada. These included the Faculty of Forestry from Sopron University, Hungary, after the failed uprising of 1956, the Czechoslovak refugees in 1967, and Tibetan refugees in the sixties and seventies under the auspices of George and Inge Woodcock. Alec is also remembered near Okanagan Lake with a road named after him: "Wainman Cove" for a property and beach he developed. His passion for languages extended to the Northern Okanagan Indian language, Nsyilxcen, of the Syilx people, where he recorded the three remaining elders who had a fluent command of that language.

On being asked in 1975 for his photo archive for possible publication in London, England, Alec prepared his photographic collection of Civil War Spain, but the publication never materialized. Retiring from the University of British Columbia in 1978, Alec continued his passion for languages. He took courses in Catalan and Portuguese. These would bring him back to his time in Spain, and he decided to write his memoirs of his role in Civil War Spain.

In 1989, after a prolonged illness, Alec passed away peacefully in Saalfelden am Steinernem Meer, Austria, among family and friends. His compassion and benevolence touched many lives. He was a believer in the fellowship of cultures and the quest to understand fundamental truths. His credo was that all citizens of the world, from all walks of life, have much to teach us.

Spanish Civil War Collection of Photographs of Alec Wainman

• • •

Alec's collection of 1,650 black and white photographs of the Spanish Civil War was recovered in September 2013, after having gone missing for almost 40 years. The collection contains 57 rolls of 35mm black and white film all taken on a Leitz Leica camera, including an additional 135mm lens. These black and white rolls of film positives were processed by James A. Sinclair of London, using the British Medical Unit (BMU) / Spanish Medical Aid Committee medical supply channel directly to the UK and back as a conduit. This avoided censorship in the Spanish Republic and ensured good picture processing. Alec's photographs were not taken for publication during the war period but reflect his personal view of what he observed as an amateur photographer. Unlike much front-line war footage, with its photos of atrocities, or streams of refugees, these photos portrayed the human dimension of war and remained the personal collection of Alec.

About two dozen of these photographs have circulated in numerous publications based on paper prints (with the Imperial War Museum and various books about the Spanish Civil War, the international medical volunteers and brigades, etc.). The best known photo is the British Battalion boarding a train at Benicàssim with the Jack Russell mascot of the International Brigade Hospital. The other well-known photo is the Ebro Front hospital train. Since the arrival of the internet age, these photographs have become well-known icons of the period.

Details of the contents of the Alec Wainman collection of 1650 photographs

All were taken on his Leitz Leica camera using AGFA ISOPAN F, AGFA, PERUTZ, GEVAERT Belgium PANCHROMATIL, and KODAK black & white 35mm films.

They are contained in film-roll boxes with the following descriptions written by Alec Wainman:

Aug. 29–31, 1936 • [1936 08 29–31]
BMU en route through France (Fontainebleau, Brive, Cahors, near Narbonne) to Spain

Sept. 7–14, 1936 • [1936 09 07–14]
Departure from Barcelona to Grañén, Aragon Front

Sept. 14–21, 1936 • [1936 09 14–21]
Grañén; Callén; Pompenillos; Aragon Front trenches overlooking Huesca

Sept. 22–23, 1936 • [1936 09 22–23]
Pompenillos; Huesca; Railway Outposts

Sept. 26–Oct. 3, 1936 • [1936 09 26–10 03]
Grañén inhabitants and patient

Oct. 8–25, 1936 • [1936 10 08–25]
Grañén hospital treatment of Nationalist prisoner; soccer match

Nov. 4–Dec. 6, 1936 • [1936 11 04–12 06]
Grañén; Sitges; Hans Beimler Funeral Barcelona

Jan. 17–26, 1937 • [1937 01 17–26]
Arrival of Abraham Lincoln contingent of International Brigade Barcelona; Masnou

Feb. 5–7, 1937 • [1937 02 05–07]
Posters in Barcelona; Tibidabo

Feb. 28–Mar. 21, 1937 • [1937 02 28–03 21]
People's Army Parade, Barcelona; Tossa de Mar

Mar. 21–22, 1937 • [1937 03 21–22]
Tossa de Mar

Apr. 2–4, 1937 • [1937 04 02–04]
Arrival Ambulances in Barcelona; Poleñino BMU Hospital, Aragon Front

Apr. 8–20, 1937 • [1937 04 08–20]
Tossa de Mar; Convoy to Madrid; Torrelodones BMU hospital

Apr. 21–28, 1937 • [1937 04 21–28]
BMU hospital Torrelodones, Madrid, Poleñino

May 14, 1937 • [1937 05 14]
May Uprising, Barcelona

May 18, 1937 • [1937 05 18]
Benicàssim, International Brigade Hospital

May 19, 1937 • [1937 05 19]
Nationalist Bombing of SS *Legazpi* near Benicàssim

May 23, 1937 • [1937 05 23]
BMU hospital Huete; Cuenca

May 23–30, 1937 • [1937 05 23–30]
Valdeganga de Júcar;
BMU Valdeganga hospital

June 6–15, 1937 • [1937 06 06–15]
Valdeganga and Huete

June 15–July 11, 1937 • [1937 06 15–07 11]
Huete and Valdeganga

July 16, 1937 • [1937 07 16]
Harvesting at Valdeganga

July 16, 1937 • [1937 07 16]
Valdeganga and Cuenca

July 31, 1937 • [1937 07 31]
Valdeganga

Sept. 5–15, 1937 • [1937 09 05–15]
BMU station wagon in Chartres France
en route to Spain; Uclés hospital

Sept. 15, 1937 • [1937 09 15]
Uclés tower, hospital, village and patients

Sept. 28–Nov. 11, 1937 • [1937 09 28–11 11]
Alacuas women's prison, near Valencia;
Uclés; Valencia

Jan. 14, 1938 • [1938 01 14]
Pre-military training in Barcelona

Jan. 30–Feb. 6, 1938 • [1938 01 30–02 06]
Woods near Tarrasa

Feb. 6, 1938 • [1938 02 06]
Montserrat

Feb. 11, 1938 • [1938 02 11]
Woodworkers in war industry factory

Feb. 12, 1938 • [1938 02 12]
Blossoms around Montserrat

April 10, 1938 • [1938 04 10]
Planes of Republican Air Force
over Barcelona

April 10, 1938 • [1938 04 10]
Pre-military drill for Ministry of State

May 8, 1938 • [1938 05 08]
BMU mobile x-rays units at Sabinosa;
BMU Sabinosa Hospital

May 8, 1938 • [1938 05 08]
Catalan painter Joaquim Mir

May 22, 1938 • [1938 05 22]
Performance for women executives
in the war industry, Barcelona

May 29, 1938 • [1938 05 29]
Nurse Annie Murray on hospital train
near Lleida

June 15–16, 1938 • [1938 06 15–16]
Barcelona Book Fair

June 27, 1938 • [1938 06 27]
Ministry of State members physical
training instruction

July 1938 • [1938 07]
 Refugee children from Aragon front area,
 Sabinosa

July 28, 1938 • [1938 07 28]
 Country views near Ebro front

Aug. 1938 • [1938 08]
 Medical teams in cave behind
 Ebro front

Aug. 1938 • [1938 08]
 Medical teams on Ebro front

Aug. 1938 • [1938 08]
 Teams at work on Ebro front

Aug. 1938 • [1938 08]
 Work on hospital train — Ebro front

1939 • [1939]
 Spanish Basque country

Identity and Security Passes of Alec Wainman

• • •

Remarkably, Alec Wainman was able to preserve all eighteen of his identification and security passes from the various ministerial, governmental, industrial and trade union authorities. This is exceptional considering the climate of infighting and confusion within the Spanish Republic, especially during the Barcelona May 1937 uprising and the political purges as documented by George Orwell, who describes destroying his documents and having his memorabilia taken by the assault guards.

Alec was known for his discretion and ability to blend in and pass between the lines. For example, in web searches about him in the Spanish Civil War, all that is cited is that he was a Quaker from Britain (he was apolitical his whole life), that he was a driver in Spain and in Moscow. Nothing is mentioned of his education, his work as third secretary with the British Foreign Service, or his family. Masha Williams, one of his Russian translator colleagues with the Allied Commission for Austria, mentions Alec frequently and devotes a chapter in her book *White among the Reds* to him. She portrays the humour and fun-loving side of Alec and reminisces about their "swanning" together through the Soviet Red Army checkpoints. This was the term they used for "traipsing around the countryside."

GENERALITAT DE CATALUNYA

CONSELLERIA DE DEFENSA

BARCELONA **3** SEPTIEMBRE 1936

Autorizamos al compañero *Alex. Weinmann*

para que pueda circular libremente por todo el

territorio de Cataluña y frente de Aragon.

Rogamos a las autoridades y milicianos

les den todad clase de facilidades y les a-

tiendan en todo lo necesario.

EL COMITE CENTRAL DE MILICIAS ANTIFACISTAS DE CATALUÑA

DEPARTAMENTO DE GUERRA

Partido Socialista Unificado de Cataluña

Servicio especial de los
Extranjeros

El portador del presente controlado por nuestro servicio merece la confianza, está autorizado de hacer varios retratos con el fin de propaganda para su ambulancia. Rogamos es todas las autoridades en general y a los milicias en particular de no poner le ningun impedimiento.

resp... por el servicio

11036

[ABOVE] NOVEMBER 11, 1936

The PSUC, Partido Socialista Unificado de Cataluña, Special service for Foreigners, allows the bearer to make ambulance unit promotion photos, requesting that militias, in particular, make no hindrance to him.

[LEFT] SEPTEMBER 3, 1936, BARCELONA

We, the Generalitat de Catalunya, Conselleria de Defensa, allow Alec Wainman free movement in the whole of Catalonia and the Aragon front, with stamps (BMU, PSUC Adherit a la Internacional Comunista, Comitè Central de Milícies Antifeixistes de Catalunya).

LA HISPANO-SUIZA

FÁBRICA DE AUTOMÓVILES

BARCELONA

CARRETERA DE RIBAS, 279

(SAGRERA)

EL COMPAÑERO ALEXANDER WAINMAN ESTA EMPLEADO EN ESTOS TALLERES ASUMIENDO LAS FUNCIONES DE INTERPRETE.

PARA LOS EFECTOS CONSIGUIENTES, AUTORIZAMOS EL PRESENTE DOCUMENTO EN EL DIA 28 DE NOVIEMBRE DE 1936.

POR EL CONSEJO DE EMPRESA

EL SECRETARIO

NOVEMBER 28, 1936, BARCELONA

The Hispano-Suiza automobile manufacturer indicates that Alexander Wainman is an interpreter employee of the factory, stamped Comitè de Fàbrica, CNT-UGT.

ELIZALDE S.A.

PARTICULAR

Se autoriza el pase libre a la Sección de MONTAJE, al Camarada A. WAINMAN.

Barcelona, 5 Enero de 1937.

JANUARY 5TH 1937, BARCELONA

Elizalde S.A. (aero-engine plant), on personal letterhead, allows

A. Wainman free passage in the assembly section.

AVIACIÓN MILITAR

INSPECCIÓN DE FÁBRICAS

BARCELONA

—

Núm.

Por ser de suma urgencia para las ne-
cesidades del Arma de Aviación Militar la
presentación en el Aeródromo de S.CLEMENTE
(Albacete) de los compañeros,Técnicos de
Aviación ALBERT EDWARDS y ALEXANDER WAINMAN
que conducen el coche PLYMOUTH matricula
MU-7699, ruego a todas las Autoridades den
las máximas facilidades al personal citado
por tratarse de servicio urgente de guerra.

Barcelona 10 de Febrero de 1937.
EL INSPECTOR DE AVIACION.
= Luis de Arizón.=

282

Por la presente se autoriza circula-

cion por el muelle hasta la Aeronautica

al compañero A. Wainman.

Barcelona 27 Febrero 1937.

[ABOVE] FEBRUARY 27, 1937, BARCELONA

The present document allows A. Wainman free passage to the
Aeronautical pier, stamped Control Patrulla, Sección Puerto.

[LEFT] FEBRUARY 10, 1937, BARCELONA

Aviation Miltar Factory Inspection states, "Due to urgent Military Aviation
needs, technical aviation colleagues Albert Edwards and Alexander Wainman,
driving a Plymouth, may access Albacete Air Base, all Authorities give
maximum assistance for urgent summoned war service."

GENERALITAT DE CATALUNYA

CONSELLERIA DE DEFENSA

CONSELL DE SANITAT DE GUERRA

E. M.

Secció ___PERSONAL SUBALTERNO___

AUXILIS

| Bagatges | Racions |

RUTA

Registrat al n.º _____98__

A trametre a la Secció d'Intendència
del Consell de Sanitat de Guerra.

Per disposició del Cap de la Secció de _____

___PERSONAL SUBALTERNO___ del

Consell de Sanitat de Guerra, concedeixo passaport

a 1 Sanitario Ingles, Alec Wainman, per

anar a POLEÑINO (Grañen)

el qual farà el viatge per compte de la Generalitat de
Catalunya, i s'haurà de presentar a l'Autoritat del
lloc on passi la nit, la qual li facilitarà els auxilis
anotats al marge, així com els que necessiti i puguin
contribuir al millor servei.

Barcelona 2 d Abril del 1937

Pel C. de S. de G.:
El Metge adjunt a l'E. M.
de la Conselleria de Defensa,

Facilitat passatge per compte de la Generalitat de Catalunya fins a Poleñino (grañen)

Barcelona, 2 d Abril del 1937

Pel C. de S. de G. :
Secció Intendència,

2 ABR. 1937

284

GENERALITAT DE CATALUNYA

CONSELL DE SANITAT DE GUERRA

HOSPITAL DE SANGRE DE
POLEÑINO-Huesca

Pase para trasladarse de
Poleñino a Barcelona por cuenta de Guerra
al Camarada Alec Wainman. Que ha venido a
estad por asuntos de servicio.

El Director Responsable

Hospital de Sangre de Poleñino 5 de Abril de 1937

[ABOVE] APRIL 5, 1937, POLEÑINO

The Generalitat de Catalunya, Consell de Sanitat de Guerra, Hospital de Sangre de Poleñino, allows Alec Wainman to go from Poleñino to Barcelona on account of war, Hospital Blood — Emergency Surgical Centre, Poleñino, First English Health Unit in Spain.

[LEFT] APRIL 2, 1937, BARCELONA

The Generalitat de Catalunya, Conselleria de Defensa, Consell de Sanitat de Guerra, allows the English healthcare worker Alec Wainman to go to Poleñino (Grañén).

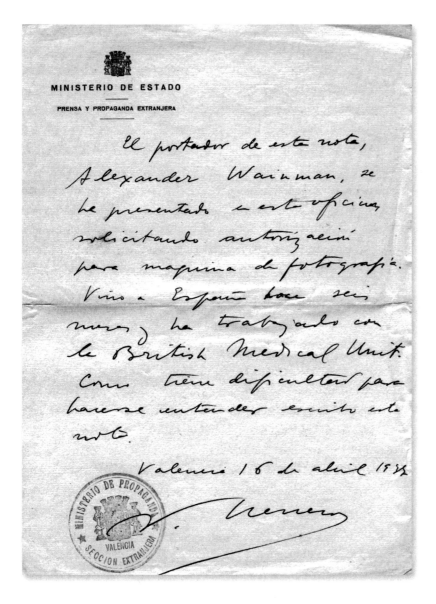

MINISTERIO DE ESTADO

PRENSA Y PROPAGANDA EXTRANJERA

El portador de esta nota, Alexander Wainman, se he presentado en esta oficina, solicitando autorización para maquina de fotografía. Vino a España hace seis meses y ha trabajado con le British Medical Unit. Como tiene dificultad para hacerse entender escrito esta nota.

Valencia 16 de abril 1937

APRIL 16, 1937, VALENCIA

The Ministry of State, Foreign Press and Promotion, indicates Alexander Wainman has come to this office requesting authorization to use a camera. He came to Spain six months ago and has worked with the BMU. Because he has trouble being listened to, I write this note.

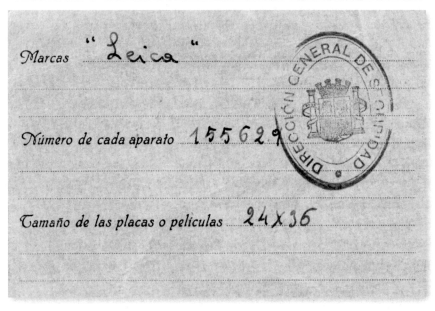

Dirección General de Seguridad

LICENCIA Y USO DE APARATOS FOTOGRÁFICOS

Apellidos Wainman

Nombre Alexander

Residencia Barcelona

Edad 24 años *Profesión* Interprete

Domicilio Paseo de Gracia 33

Valencia 16-Abril-1937

El Director general,

N. Camillo

Número 4111

Marcas "Leica"

Número de cada aparato 155629

Tamaño de las placas o películas 24 X 36

APRIL 16, 1937, VALENCIA

General Directorate of Security photo equipment license:
for Leica #155629, for taking photos of 24 x 36 format.

ESTADO MAYOR DEL MINISTERIO DE LA GUERRA

SECCIÓN DE INFORMACIÓN

SALVOCONDUCTOS

Se autoriza a D. ALEXANDER WAINMAN, miembro de la "British Medical Unit" para que se trasla-de a Madrid con regreso a Valencia, efectuando el viaje en el medio de locomoción que estime conve-niente.- - - - - - - - - - - - - - - - - - - -

sirviendo esta autorización durante QUINCE DIAS.- - -

Valencia, 16 de Abril. de 1937.

El Coronel Jefe de Estado Mayor,

APRIL 16, 1937, VALENCIA

The Ministry of War Chief of Staff, Information Section, allows Alexander Wainman of the BMU a 15-day pass for Madrid, return to Valencia by most appropriate transportation means.

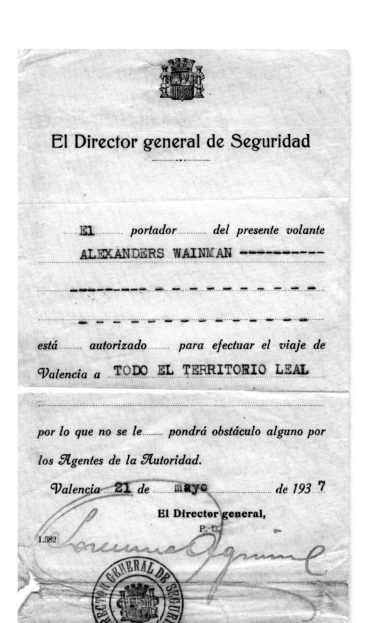

El Director general de Seguridad

El portador del presente volante

ALEXANDERS WAINMAN

está autorizado para efectuar el viaje de

Valencia a TODO EL TERRITORIO LEAL

por lo que no se le pondrá obstáculo alguno por los Agentes de la Autoridad.

Valencia 21 de mayo de 193 7

El Director general,

P. D.

1.582

MAY 21, 1937, VALENCIA

The Director General of Security allows Alexander Wainman trips from Valencia to all jurisdictional territory.

MINISTERIO DE ESTADO

PRENSA EXTRANJERA

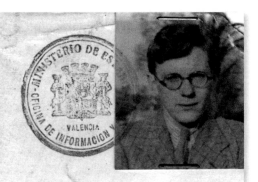

Certifico que ALEXANDER WAINMAN de nacionalidad inglesa, trabaja en esta Oficina de Prensa Extranjera en turnos de ocho horas según las necesidades del servicio.

Valencia, 23 de Septiembre de 1.937

OFICINA DE PRENSA EXTRANJERA

El Secretario.

Valentín Fernández

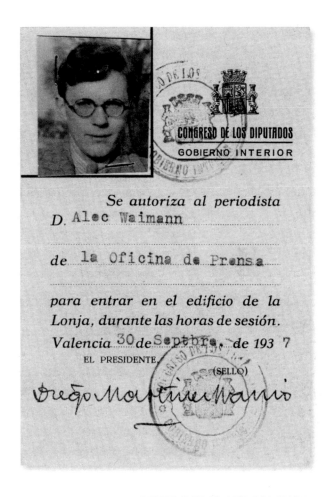

[ABOVE] SEPTEMBER 30, 1937, VALENCIA

The press pass of the Lower House of the Spanish Parliament allows
Alec Wainman of the Press Office access to Lonja building.

[LEFT] SEPTEMBER 23, 1937, VALENCIA

The Foreign Press Department of the Ministry of State certifies
Alexander Wainman, English, works in the Office of the
Foreign Press with 8-hours shifts.

LA FINALIDAD DEL CLUB INTERNACIONAL ANTIFASCISTA

Extracto del 1.er artículo del Estatuto

El Club Internacional Antifascista, quiere ayudar a los antifascistas de todos los países, que actúan para la liberación del pueblo español, a participar en la vida cultural, social y política de Cataluña, obrando entre los extranjeros en el sentido de la política del Gobierno del Frente Popular.

CLUB INTERNACIONAL ANTIFASCISTA

CASA DEGLI ITALIANI
Pasaje Mendez Vigo, 8
BARCELONA

Sección *Angl-Americaine*

Carnet n.º 325

Nombre y apellido del socio

Alexander Wainman

Profesión *Propagandista*

Fecha del ingreso 7 ENE. 1938

El Socio, El Secretario,

	Febrero
Marzo	Abril
Mayo	Junio
Julio	Agosto
Septiembre	Octubre
Noviembre	Diciembre

JANUARY 7, 1938, BARCELONA

Alexander Wainman's membership booklet of the
Club Internacional Antifascista.

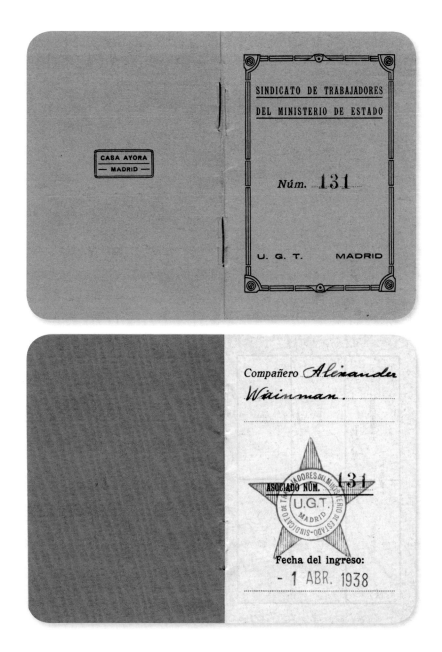

APRIL 1, 1938

Alexander Wainman's UGT Madrid Union member booklet for
workers of the Ministry of State, with monthly stamps.

MINISTERIO DE DEFENSA NACIONAL

Autorizo a ALEXANDER WAIMAN, que
acompaña a la enfermera Winifred Bates,
de la Ayuda Médica Británica, para vi-
sitar los pueblos de Alió, Falset, Tá-
rrega, Montclar y Aguilar de Segarra.
Barcelona, 28 de mayo de 1.938.
El Secretario General,

MAY 28TH 1938, BARCELONA

The Ministry of National Defense authorizes Alexander Wainman to visit
villages Alió, Falset, Tárrega, Montclar and Aguilar de Segarra accompanied
by British Medical Aid nurse Winifred Bates.

Ministerio de Defensa Nacional

mj.

Autorizo a las señoras WINIFRED BATES
y LEAH MANNING, de la Misión Sanitaria Bri-
tánica, para que, acompañados del funciona-
rio de la Subsecretaría de Propaganda ALE-
XANDER WAINMAN, visiten el frente del Este.
Esta autorización tiene un plazo de
validez de quince días.
Barcelona, 25 de julio de 1.938.
El Secretario General,

JULY 25TH 1938, BARCELONA

The Ministry of National Defence authorizes Señoras Winifred Bates and Leah
Manning, of the British Healthcare Mission, accompanied by the civil servant of the
Press Undersecretary, Alexander Wainman, to visit the Eastern front for 15 days.

Bibliography

· · ·

Armengou, Montse, and Richard Belis. *The Spanish Holocaust* (film). Barcelona: TV de Catalunya — Sky Electronic, 2002.

Baker, Simon, and Shoair Mavlian (eds.). *Conflict, Time, Photography*. London: Tate Publishing, 2014.

Bartoli, Josep. *La Retirada: Exode et exil des républicains d'Espagne*. Arles, France: Actes Sud, 2009.

Basque Children of '37 Association UK. Online at www.basquechildren.org.

Baxell, Richard. *Unlikely Warriors: The Extraordinary Story of the Britons Who Fought in the Spanish Civil War*. London: Aurum Press, 2012. www.richardbaxell.info.

Beevor, Antony. *The Battle for Spain: The Spanish Civil War 1936–1939*. London: Weidenfeld & Nicolson, 2006.

———. *The Spanish Civil War*. London: Orbis, 1982.

Capa, Robert, and Philippe Séclier. *Robert Capa*. Arles, France: Actes Sud, 2008.

Chomsky, Noam. *American Power and the New Mandarins*. New York: Pantheon Books, 1969.

Graham, Helen. *The Spanish Republic at War 1936–1939*. Cambridge: Cambridge University Press, 2002.

Hemingway, Ernest. *For Whom the Bell Tolls*. 1940; London: Arrow Books, 1994.

Hopkins, James K. *Into the Heart of Fire: The British in the Spanish Civil War*. Redwood City, CA: Stanford University Press, 1998.

Imperial War Museum London UK. Online at www.iwm.org.uk

International Brigade Memorial Trust. Online at www.international-brigades.org.uk

Jackson, Angela. *For us it was Heaven. The Passion, Grief and Fortitude of Patience Darton*. Eastbourne, UK: Sussex Academic Press, 2012.

Kowalsky, Daniel. *Stalin and the Spanish Civil War*. New York: Columbia University Press, 2004.

Lefebvre, Michel, and Rémi Skoutelsky. *Les Bri-

gades Internationales: Images retrouvées. Paris: Seuil, 2003.

Nelson, Cary. *The Aura of the Cause: A Photo Album for North American Volunteers in the Spanish Civil War*. New York: Abraham Lincoln Brigade Archives, 1997.

Orwell, George. *Homage to Catalonia*. London: Secker and Warburg, 1938.

Palfreeman, Linda. *¡Salud!: British Volunteers in the Republican Medical Service during the Spanish Civil War, 1936–1939*. Eastbourne, UK: Sussex Academic Press, 2012.

Pemán, José María. *Comentarios a Mil Imágenes de la Guerra Civil Española*. Barcelona: AHR, 1967.

Petrou, Michael. *Renegades: Canadians in the Spanish Civil War*. Vancouver: UBC Press, 2008.

Preston, Paul. *Doves of War: Four Women of Spain*. London: HarperCollins, 2002.

———. *La Guerra Civil: Las fotos que hicieron historia*. Madrid: JdeJ Editores, 2005.

———. *The Spanish Civil War: Reaction, Revolution and Revenge*. London: HarperCollins, 2002.

Rossif, Frédéric. *Mourir à Madrid* (film). Paris: Miroir Films, 1963. DVD of 2006 by Editions Montparnasse.

Rossif, Frédéric, and Madeleine Chapsal. *Mourir à Madrid*. Paris: Editions Seghers, 1963.

The Spanish Civil War. London: Granada Television Productions, 1983.

Taro, Gerda. *Gerda Taro*. Göttingen, Germany: Steidl/ICP, 2007.

Thomas, Hugh. *The Spanish Civil War: New Revised Edition*. London: Hamish Hamilton, 1977.

Twigg, Alan. *Tibetans in Exile: The Dalai Lama and the Woodcocks*. Vancouver: Ronsdale Press, 2009.

Young, Cynthia (ed.). *The Mexican Suitcase: The Legendary Spanish Civil War Negatives of Robert Capa, Gera Taro, and David Seymour*. Göttingen, Germany: Steidl, 2010.

Wainman, Christine Ledlie. *Personal Diaries and Visitor's Book 1936–1940*. Shipton-under-Whychwood, UK, unpublished.

West, Richard. *Tito and the Rise and Fall of Yugoslavia*. London: Faber & Faber, 1996.

Williams, Masha. *White among the Reds*. London: Shepheard-Walwyn, 1980.

Index

• • •

British Medical Unit (BMU), 1, 5, 6, 11, 13, 18,
 20–23, 34, 37, 43, 44, 46, **51**, **54**, **176**, **196**, **225**,
 231, 261, 265, 266, 272–275, **278**, **286**, **288**;
 hospital, 10, 29, 33, 34, 37, 45, **76**, **78**, **79**, **81**,
 112, **113**, **114**, **117**, **124**, **130**, 153–157, 177–181;
 nurses, 17–19, 21, 33–35, 37, **113**, **114**, **122**, **123**,
 128, **132**; volunteers, 37, 41, 45, **50**, **52**, **55**, **66**,
 74, **78**, **81**, **82**, **110**, **111**, **120**, **121**, **152**, **197**, 263,
 265, 271
British War Office, 17
Brive-la-Gaillarde, 10, **50–52**, 266, 282
Brunete, Battle of, 29, **63**, **141**

Cahors, 10, **53**, 274
Canadian Blood Transfusion Unit, 6
Capa, Robert, 3, 5, 262, 265
Caproni bombers, 15, 18
carpet bombing, 5, 119
Carritt, Lisl, 18, **63**, **68**
Cartier-Bresson, Henri, 265
Casa de Campo, 29
Chim, *see* Seymour, David
Chirac, Jacques, 266
Clarke, Sybil, 41
Comintern, 6, 264, 267, 268
Comitè Central de Milicies Antifeixistes de
 Catalunya, **278**
Commune de Paris Battalion, **75**
Companys, Lluís, **198**
Condor Legion, *see* German Condor Legion
Confederación Nacional de Trabajo (CNT), 14,
 38, **68**, **280**
Congreso de los Diputados, **291**
Cornford, John, 19, **75**

Dabrowski Battalion, **142**, 264
Dachau Concentration Camp, **83**, 264
Darton, Patience, **132**, 262, 266
Davson, Rosita, 16, **113**, **128**, **132**
de la Mora, Constancia, 24, 262, 265, 272
Dobson, Harry, **236**, **239**

Ebro Front, 3, 10, **226–233**, **240–251**, 273, 276;
 Battle of, 6, **226–229**; cave field hospital, 10,
 45, **232**, **234–239**
Edwards, Albert, 22, 24, 37, **85**, **86**, 282
Estruch, José (Pepe), 2, **46**, **262**

Farr, Frank, 21, 22
fascist Italy, 5, 266
Fedeli, 22
Federación Anarquista Ibérica (FAI), 14
First World War, 2, 5, 12, 271
France, pilots from, **195**
Franco, Francisco, 2–7, 13, 14, 27, 32, 35, 38, **50**,
 53, **67**, **103**, **107**, **150**, **252**, **253**, 261–263, 265,
 268, 271
French African Troops, 53
Front Populaire in France, 13

García Lorca, Federico, 46, 262
Garibaldi Battalion, 267
Gellhorn, Martha, 6, 30
German Condor Legion, 5, 6, 26, 263, 267
German Luftwaffe, 263
Grañén, 5, 10, 16, 20, 22, 28, 34, **56–66**, **73–81**,
 208, 272, 274, **284**
Green, George, **229**
Green, Nan, **229**